INGRES *in Fashion*

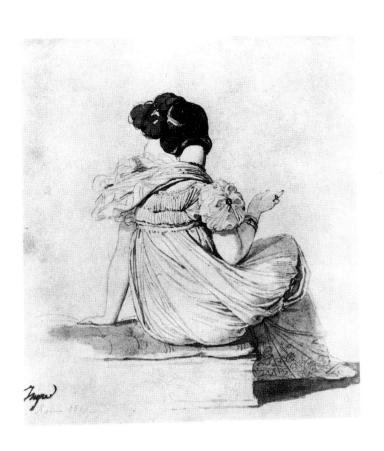

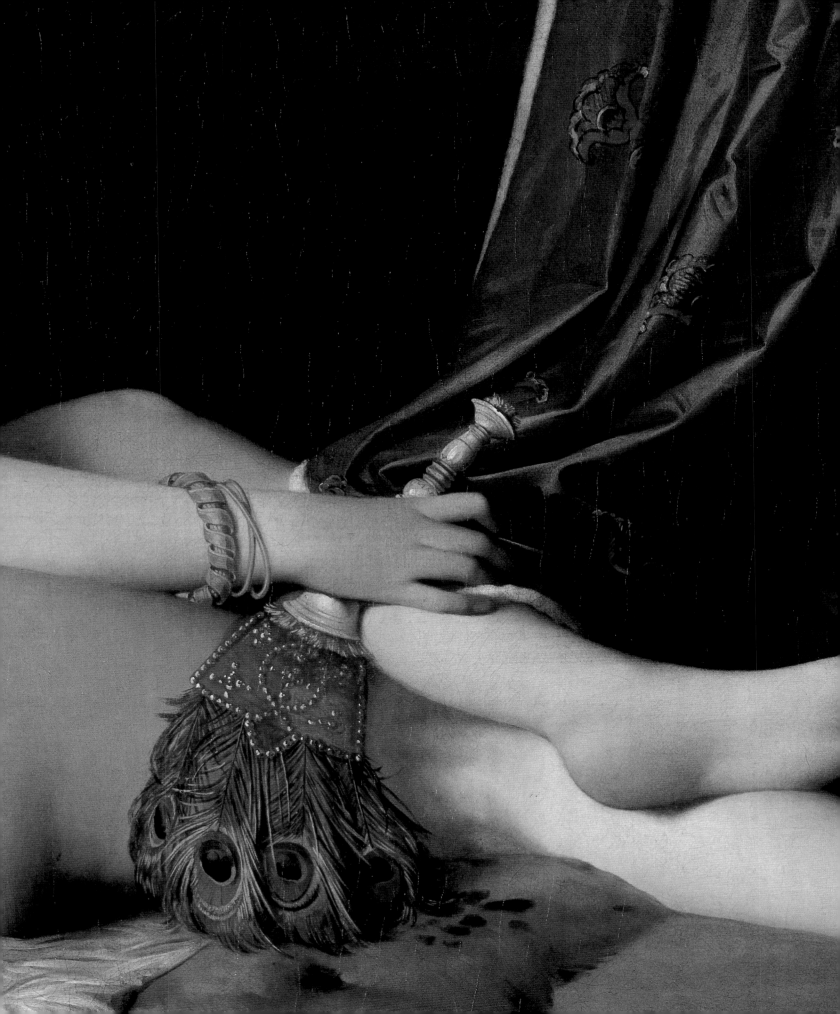

AILEEN RIBEIRO

INGRES *in Fashion*

Representations of Dress and Appearance
in Ingres's Images of Women

YALE UNIVERSITY PRESS
New Haven & London

Designed by Gillian Malpass

Printed in Singapore

Library of Congress Cataloging-in-Publication Data

Ribeiro. Aileen, 1944–
 Ingres in fashion : representations of dress and appearance in
Ingres's images of women / Aileen Ribeiro.
 p. cm.
 Includes bibliographical references and index.
 ISBN 0-300-07927-3 (cloth : alk. paper)
 1. Ingres. Jean-Auguste-Dominique. 1780–1867–Criticism and
interpretation. 2. Women–France–Portraits. 3. Fashion in art.
4. Costume in art. I. Title.
ND1329.I53R53 1999
759.4–dc21

 98–47308
 CIP

A catalogue record for this book is available from
The British Library

Page i Ingres, *Seated Woman*, 1807. Private collection.

Frontispiece Ingres, *La Grande Odalisque* (detail), 1814.
Oil on canvas. Musée du Louvre, Paris. (See plate 185.)

Contents

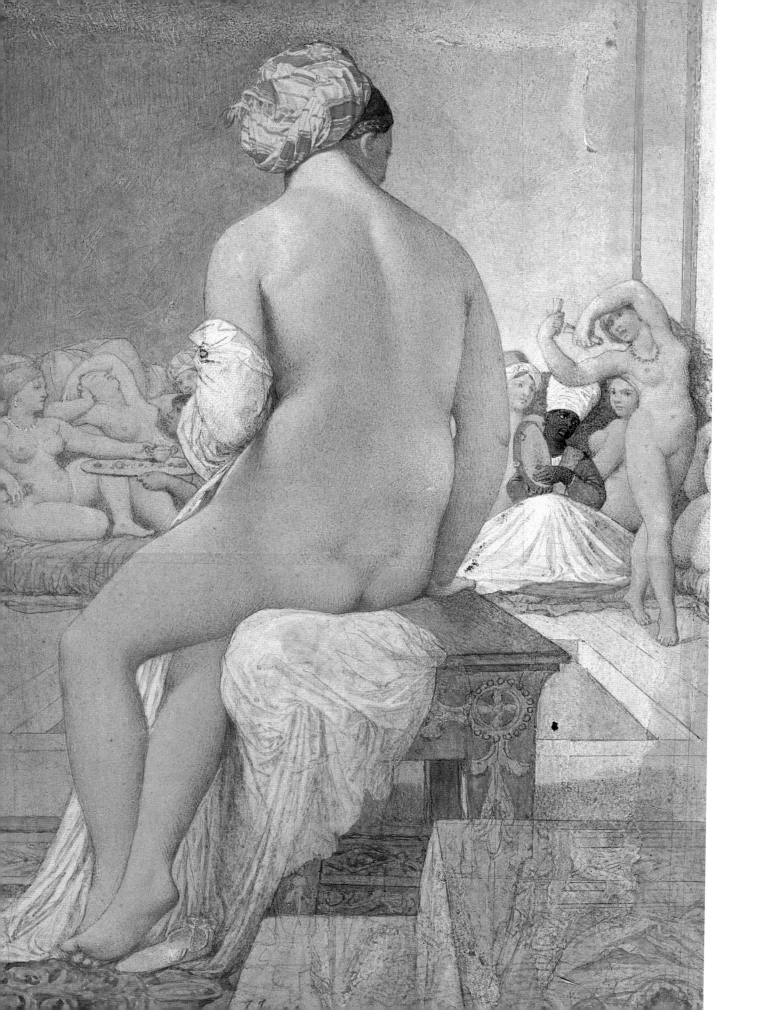

Acknowledgements

A BOOK OF THIS KIND could not have been contemplated without the opportunity to study as many of Ingres's images of women – portraits, bathers, odalisques – as possible, face to face. I am most grateful to the British Academy for their award of a research grant which enabled me to look at Ingres's work in France, North America and The Netherlands. I have managed to see the majority of the works by Ingres illustrated in this book, and I owe thanks to the many curators, art dealers and private owners who facilitated my research and supplied me with photographs. Particular thanks are due to the following: in France, the Musée Ingres in Montauban, the Musée Bonnat in Bayonne, and the Cabinet des Dessins of the Louvre; in The Netherlands, the Rijksprentenkabinet of the Rijksmuseum in Amsterdam, and the Boijmans Van Beuningen Museum in Rotterdam; in the United States, the Fogg Art Museum at Harvard, the Walters Art Gallery in Baltimore, the National Gallery of Art, Washington, and, in New York, the Frick Collection and the Metropolitan Museum of Art. I would like to record my thanks to the following in London: the National Gallery, the printrooms of the British Museum and the Victoria and Albert Museum, and the Rothschild Archive. Information and access to nineteenth-century women's clothing and accessories came from a number of helpful institutions such as the Victoria and Albert Museum (Department of Textiles and Dress, and the Indian Section), the Museum of London, the Fashion Research Centre in Bath, the Philadelphia Museum of Art (Department of Costume and Textiles), and the Costume Institute at the Metropolitan Museum of Art. For sharing their expertise I would like to thank Tina Levey, who identified some of the lace in Ingres's female portraits, and to Diana Scarisbrick, who discussed with me the jewellery worn by Ingres's sitters. A profitable afternoon was spent at the Fan Museum in Greenwich where Hélène Alexander showed me the kind of fans that Ingres depicts in his work. At the Courtauld Institute I would like to thank, once again, the helpful staff of our libraries, particularly of the Witt Library. Thanks are due also to the Photographic Survey of Private Collections and the Photographic Department of the Courtauld Institute. At Yale University Press I am indebted to the meticulous copy-editing of Celia Jones, and to the enthusiasm, wise advice, design skills and sheer hard work of my editor, Gillian Malpass.

1 Detail of pl. 182.

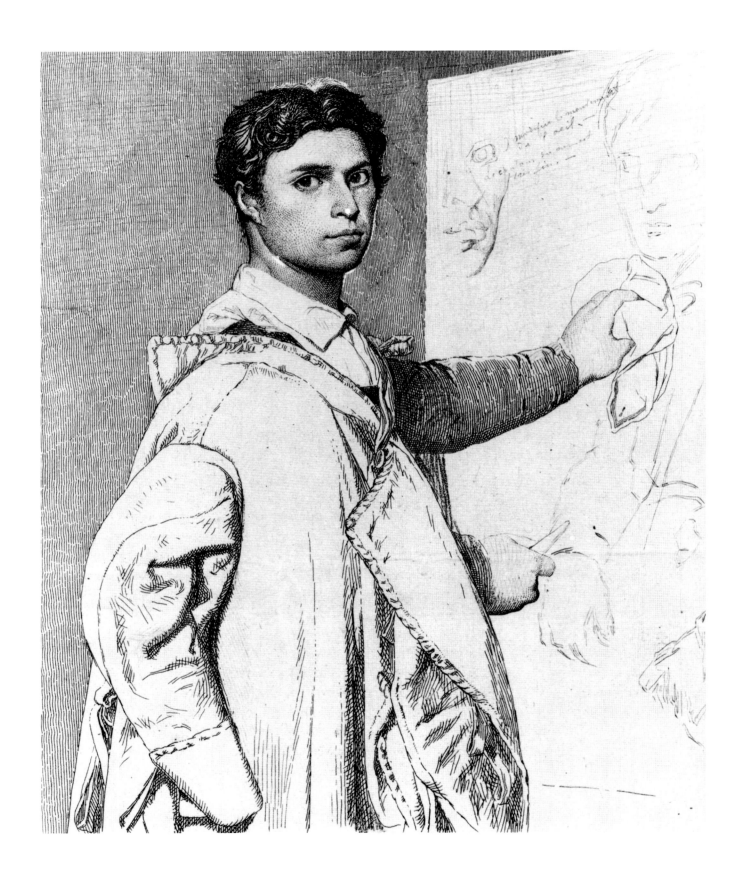

Fashionable Lines

Tournez.... Tournez ces jolis yeux.... là bien:
nous y voilà.

1 Fashion, the Critic and the Artist

> After the desire to sparkle and to please, to appear agreeable and young, and to eclipse one's rivals, the greatest pleasure of women is to have their portrait painted. But how should the portrait be painted?
>
> Nothing is more delightful than the preliminary discussions in confidence with the artist. Above all, show me as I am, claims each woman. This really means, if it's an old woman, 'take twenty years off my age'; for the faded blonde, 'I insist on a fresh complexion'; the redhead says, 'make my hair a beautiful blonde'; the woman with a yellow skin wants it white; the hunchbacked woman cries, 'don't forget to hide my hump'.
>
> 'Le Peintre à la mode',
> from *Les Folies parisiennes* (1820), p. 149

FASHION IN PORTRAITURE has been regarded as both a blessing and as a curse, particularly in the nineteenth century when the ever-changing styles of women's dress (compared to the relatively unvarying sobriety of male clothing) could provide inspiration on one hand, distracting detail on the other. The problem was the perennial one of how to paint women as more than mere fashion plates; how was the artist to depict what one critic in 1846 called the *dessous* rather than the *dessus* – the substance rather than just the surface of the sitter. Writers and critics as well as artists engaged in lively debate on this question, but while identifying the problem, they could not arrive at a solution. The critic and novelist Stendhal remarked apropos the Salon of 1824 that it was vanity only that produced so many indifferent portraits, most of which would be forgotten in time, although he made an exception for the *finesse* that he admired in Ingres. It was important, Stendhal claimed, for artists to paint souls as well as bodies, and to this end he wished the costume in a portrait to be under-emphasized; and unlike Balzac, Stendhal followed his own advice in his great novels. A more ambivalent attitude, however, can be seen in his *De l'Amour* (1822), a typical Stendhalian concoction of theory, aphorism, anecdote and *jeux d'esprit*, in which he claims 'bad taste consists in confusing fashion with lasting beauty', and in the same paragraph he notes that 'there is nothing so frightful as an outmoded fashion'.[1]

A similar ambivalence can be seen in Hippolyte-Adolphe Taine's writings on fashion in art. In his popular *Notes on Paris* (1867) he says:

> A perfect toilette is equal to a poem. There is a taste, a choice in the placing and the shade of each satin ribbon, in the pink silks, in the soft silvered satin,

4 'Le peintre à la mode'. Coloured engraving from *Les Folies parisiennes*, Paris 1820. British Library, London.

in the pale mauve, in the tenderness of the softer colors, still more tender beneath their coverings of guipure, their puffings of tulle, and the ruches which rustle with every motion. Shoulders and cheeks wear a charming tint in this luxurious nest of blonde[2] and lace. This is the only poetry left to us, and how well they understand it.[3]

This hymn of praise to feminine dress, which might be a description of the lustrous *toilettes* seen in Ingres's portraits of such *grandes dames* as the comtesse d'Haussonville (pl. 117), the baronne de Rothschild (pl. 125), and the princesse de Broglie (pl. 130), is sharply reversed when Taine speaks as professor of the history of art at the Ecole des Beaux-Arts in Paris in his 1870 publication *The Ideal in Art*. Addressing his students, he warns them that too much detail in dress in female portraiture will produce work of the 'lowest rank' which will not pass the test of time. On the subject of such fashionable portraits, he complains

Illustrated reviews are full of them; they might almost be called fashion plates; every exaggeration of costume is therein displayed . . . the artist is heedless of the deformity of the human body. That which gives him pleasure is the fashion of the moment, the gloss of stuffs, the close fitting of a glove, the perfection of the chignon . . . Numbers of portraits in our annual exhibitions are nothing but portraits of costumes.[4]

Certainly art was chic in the nineteenth century, and it was no longer the élite only who had their portraits painted, but the aspiring middle classes also (Stendhal, in his review of the 1834 Salon blamed the 1830 Revolution for encouraging a rash of run-of-the-mill portraits). The Salons and other art exhibitions were places for fashionable women to be seen not only on the canvas, but also in the flesh, as spectators; the modish *toilettes* of the portraits, which Taine so deplored, served as advertisements for couturiers and dressmakers.

If *haute couture* was to be avoided in portraiture, what should take its place? Some artists settled for a range of historical costumes, others for the equal masquerade of 'picturesque' working-class clothing. Among the second group was Etienne-Jean Delécluze, Ingres's fellow-student in David's studio, who claimed that the most durable portraits of women showed them in various types of working and occupational costume, which tended to reveal the natural body shape, rather than the excess and artifice of high fashion.[5] When at the 1855 Universal Exhibition in Paris Delécluze saw Winterhalter's famous picture of the Empress Eugénie surrounded by her ladies-in-waiting (Château de Compiègne) his immediate thought was how the 'affreux et intolérables déguisements' of the costumes created by the couturières served only to degrade the picture.[6]

In some ways, however, fashion and art were closely alike. An *haute couture*

5 Detail of pl. 130.

10

2 Ingres's Feeling for Fashion

Ingres turns modern dress to wonderful account — his portraits of women attest the fact.

Théophile Gautier, *Portraits contemporains* (1874)

A portrait of a woman! Nothing in the world is more difficult, it's impossible.

Ingres, quoted by his pupil Amaury-Duval, *L'Atelier d'Ingres* (1878)

THERE ARE SOME PERIODS in history in which there are particularly close links between art and fashion. The early twentieth century comes to mind when we think of the fruitful collaboration between the designer Paul Poiret and such artists as Matisse and Dufy, or the way in which the couturière Schiaparelli worked with the Surrealist artist Salvador Dali. At other times artists try to 'reform' fashion, either in portraiture (Sir Joshua Reynolds is an example) or in reality (David's 'republican' costume for citizens and officials during the French Revolution).[1] Reforms in dress that run counter to the prevailing aesthetic of the time are doomed to failure, like trying to capture quicksilver, but there are periods, rare though they may be, when the intellectual discourse on elevating costume to the noble heights of a supposedly perfect era in the past — such as classical antiquity, or the Renaissance — goes hand in hand with clothing in real life. One such period was the end of the eighteenth century and the beginning of the nineteenth century when the classical past, which had for some years been advocated by artists and critics as a source for women's dress of an ideal kind, suddenly became the vogue in art, fashion and design generally. A detailed knowledge of the arts of antiquity became a *sine qua non* for artists; if we are to believe such fashion journals as *Les Délices de la mode et du bon goût* (1805) artists were called to assist at the *toilettes* of stylish *élégantes* as arbiters of taste ('comme les vraies arbitres du goût'). As the nineteenth century progressed, art was no longer such an influence on mainstream fashion; unfettered by artistic taste which had some claims to produce a simple, natural line in dress, women's costume was increasingly seen as capricious, luxurious and elaborate. Artistic input into fashion by the mid-nineteenth century moved outside the mainstream and into the realms of historical and fancy dress.

Firm in his theories regarding art, Ingres does not seem to have involved himself in the intellectual debate surrounding the appropriate costume for

6 Detail of pl. 94.

portraiture, although he had strong views about the choice of dress in his own paintings. His empathy with fashion was innate, albeit largely unarticulated; his talent was to transmit fashion rather than to theorize it. If one looks at contemporary fashion plates and surviving costume of the period, Ingres's affinity with the style and detail of dress is remarkable. This is particularly so when one examines the changing panorama of women's dress revealed in his portrait drawings, which are imbued with a sensitivity and modernity not often to be found in similar work by his contemporaries. The meticulous detail of dress and accessories heightens the liveliness of the drawings, so that, in the words of the fashion curator Madeleine Delpierre, 'the costume seems to move on the person it clothes'.[2] The portrait drawing expressed Ingres's preference for clearly observed outlines, and the crisp lines of contemporary fashion suited his way of working.

While few artists could rival Ingres with regard to the portrait drawing, opinions differed about Ingres the portrait painter. Baudelaire thought that he concentrated on detail at the expense of the harmonious whole, but the critic Edmond About stated that this very quality made him a great portraitist. While his great rival Delacroix succeeded best at the general effect ('un peintre d'ensembles'), Ingres highlighted the individual. Delacroix's art is dramatic, Ingres's is contemplative; Delacroix's art reveals poetry in movement and action, while Ingres's work shows poetry in posture and attitudes.[3]

A sense of poetry in literary and verbal descriptions of women's dress at this period is often noted. Baudelaire and Gautier use prose poems to describe the appearance of women; Gautier in particular (and it must be remembered that he was trained as a painter) conjures up the kind of images – the rustling silk taffetas, the shine of satin, the softness of fur, the polished and gleaming shoulders of a woman in evening dress – that could come straight from the canvases of Ingres.

The same poetic relish in clothing, the styles, colours, the very names of garments enrich the novels of Balzac, who refers to himself in the preface to *Eugénie Grandet* (1833) as a 'peintre littéraire'. From the 1820s in particular – with the relatively late arrival of Romanticism in France – there were increasingly close relations between art and literature.[4] One recent writer on 'Balzac, Ingres and the Art of Portraiture' claims that both men used clothing as a language, with the 'same belief that the distinctive detail was the interpretative key to the unique complexity of the whole'.[5] None the less, as Ingres's pupil Amaury-Duval pointed out in an article in *L'Artiste* (1856), his master was attacked for the detail in his portraits, whereas Balzac's novels were praised for their attention to fashions and furnishings. It is perhaps a paradox that in the late twentieth century it is harder to understand the written references to costume and interiors in Balzac than to appreciate Ingres's depiction of such physical facts of nineteenth-century life.

'Il faut être de son temps' was Courbet's famous phrase when defending the

realism in his art, and it is this sense of the here and now that dominates Ingres's portraits and submerges the classical and Renaissance quotations that he took such pains to incorporate:

> Although certain of Ingres's contemporaries complained that his classicism interfered with the truthfulness of his portraits, and although the painter turned to ancient classical models as well as to Raphael for the poses he gave to such contemporary figures as Madame Moitessier and Madame d'Haussonville, his concern with the individual in his contemporary context remained supreme.[6]

It was through attention to the detail of dress and accessories that Ingres sought to retrieve the individual. Modern writers on Ingres are perhaps more appreciative of this skill than the artist's own contemporaries, for time transmutes the most unlikely and bizarre styles of dress into timeless beauty. Thus, Michael Levey finds Ingres 'a poet of the most unpoetical styles of costume, absorbed by . . . monstrously ruched dresses, wide belts, and glossy piles of curls'.[7] Robert Rosenblum has an excellent description of how Ingres looked

> through a lens of magical intensity and clarity . . . [at] the tiniest details that might pinpoint a unique perception for all time. A wayward strand of hair, the transparency of black tulle, the irregular fringe on a cashmere shawl, the gleam of light reflected on gold, porcelain, pearl or mahogany – nothing escaped his searching eye and nothing transcended his power to translate it into paint on the canvas.[8]

Gautier noted that as well as being able to paint the folds of ancient Greek drapery, Ingres was no less happy in arranging a cashmere shawl.[9] Trained in the traditional and academic way, Ingres's studies of drapery, both classical and contemporary, confirm his love of line; there is a drawing at Montauban (pl. 7) in which the shining dress (as yet unrelated to a specific portrait and probably dating from his first stay in Italy) almost flows off the paper.

Ingres brought to his portraits of women the almost mystical absorption and even a sense of spirituality that is lacking in his history paintings. The creative tension between Ingres's notions of the ideal (the 'history-painting' part of his nature) and his robust sense of the reality of the sitter in front of him, produces portraits that are true likenesses of face, figure and clothing, but which also have an edge and force that are the result of the artist's agonising struggle for perfection.

Many contemporary critics found it difficult to come to terms with what they construed as warring and irreconcilable elements in Ingres's work. Admitting that the artist loved women, Baudelaire commented: 'M Ingres is never so happy or so powerful as when his genius finds itself at grips with the charms of a young beauty', but he declared that his use of colour ('M. Ingres

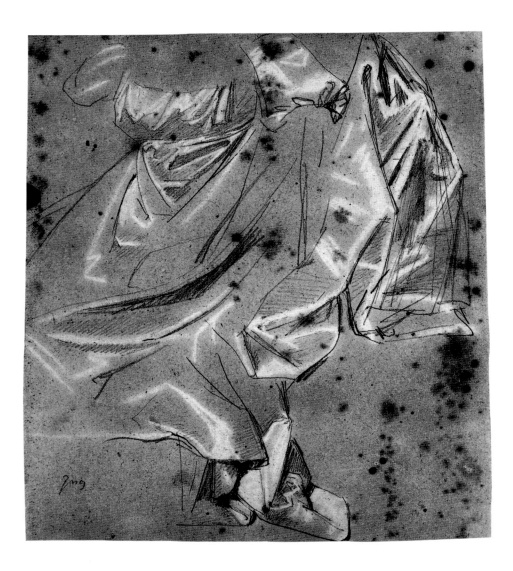

adores colour like a fashionable milliner') was often unsubtle, and even 'bitter
and violent'.[10] Elsewhere, however – and Baudelaire was clearly baffled by
much of Ingres's work – the poet and critic attacked those who thought Ingres
was grey. With reference to the portraits of Louis-François Bertin (pl. 10) and
Madame d'Haussonville (pl. 117) exhibited at the Bazar Bonne Nouvelle in
1846, Baudelaire cries, 'Open your eyes, you nation of boobies, and tell us if
you ever saw such dazzling, eye-catching painting, or even a greater
elaboration of colour'. Such paintings, were 'real portraits, in other words, ideal
reconstructions of individuals'.[11]

Ingres's reliance on line as well as his often striking use of colour play their
part in the defining and elaboration of costume. It is the line and the detail –
almost abstract at times in the love of form – that produce the harmony of the
finest of Ingres's portraits. A recent writer on the artist has noted how Ingres's
taste for the perfection of line is more sensual than intellectual, and can be

reconciled with his love of the colour and tactility inherent in luxury fabrics and precious objects.[12]

One of the contradictions that many critics and fellow-artists claimed to find in Ingres was that between his undoubted skills in the depiction of sumptuous female clothing and accessories, and his own unstylish appearance and curmudgeonly manner. Théophile Silvestre, no lover of Ingres, famously evoked the artist's appearance, late in his life, as 'ce petit éléphant bourgeois', with his short and stubby physique, his choleric visage with grizzled hair parted in the middle, a fanatical, stubborn and authoritarian man.[13] Even those who admired him as an artist remarked on his often intemperate and naive opinions, his rage when crossed (or when a mildly critical comment on his hero Raphael was voiced – Ingres believed, like Goethe, that 'Raphael is always right') and his tyrannical teaching methods.

Such comments, however, were made when Ingres was an old man, full of honours and the embodiment of the *ancien régime* of academic art. If, on the other hand, we look at his early self-portrait of 1804 (pl. 8), we see a young man, almost swashbuckling in appearance with his greatcoat slung over his shoulder like a Renaissance mantle.[14] Exhibited in 1855 the portrait impressed the critic Edmond About:

> This beautiful portrait, the liveliest and most colourful in the gallery, represents a small, swarthy, intelligent and obstinate man. His vigorous black hair is tousled with remarkable independence . . . This small man, planted in his coat in front of an easel, white pencil in hand, seems to say to those watching him, 'I will be a great artist because I *wish* to be'. He has kept his word. Willpower, hard work, study, stubbornness, patience, these are the elements which make up M. Ingres's talent.[15]

Gautier, too, found this a compelling portrait, noting how the eyes seemed to follow the spectator; full of ardent faith, courage, obstinacy and opinionated genius, the image of the artist as a young man reminded the poet and critic of a young Italian monk of the Middle Ages destined for a cardinal's hat or a papal tiara.[16] Such sartorial flair, it must be admitted, did not last long, and the presiding image of Ingres as a man in a tightly buttoned dusty black suit, overcoat and top hat dates from his middle years and old age. What the early self-portrait does show is a sense of style in the arrangement of clothing, which he put to intelligent use in his portraits of women as well as men.

It is impossible to know whether Ingres inherited an interest in costume (his paternal grandfather was a tailor in Toulouse and his maternal grandfather a master wigmaker), or if it arose from necessity in his capacity as portraitist. His undoubted acuity of perception must have been furthered by his first marriage in 1813 to Madeleine Chapelle, a milliner from the small town of Guéret in the Limousin; no doubt she helped to teach him the factual vocabulary of the fashions. A placid, matronly figure whose round face and simply arranged hair

8 Ingres, *Self-portrait*, 1804. Oil on canvas.
Musée Condé, Chantilly.

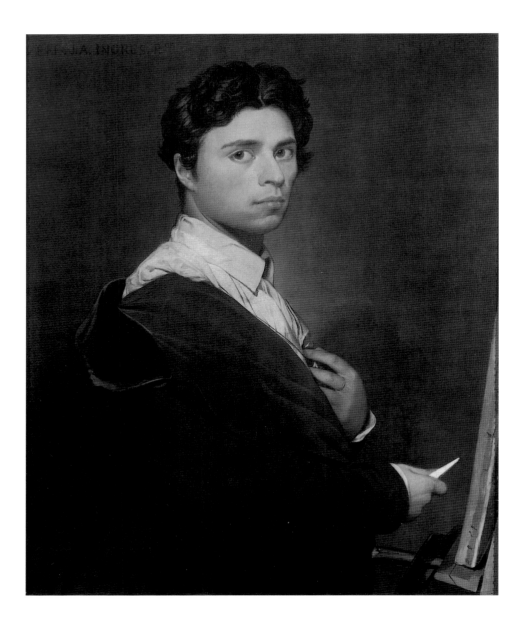

9 Ingres, *The Artist and his Wife*, 1830.
Pencil on paper. Private collection, New
York.

with central parting must have been a distant echo of Ingres's beloved Raphael madonnas, she gazes out of many of his early portrait drawings. In one such portrait of 1830 (pl. 9) her features are emphasized by a vast, round-brimmed hat, while a slightly tetchy Ingres hovers behind her shoulder. The marriage, although childless (to Ingres's particular distress, something that may lie behind his tenderness in the depiction of children in his work), was comfortable, and Madame Ingres took charge of the practical side of the couple's affairs.

In spite of her background in fashion, she does not seem to have been a stylish woman, and on occasion Ingres must have compared her unfavourably with the elegant and *soignée* women whose modish *toilettes* he captured in his portraits. Robert de la Sizeranne in his work on Ingres records the story that at

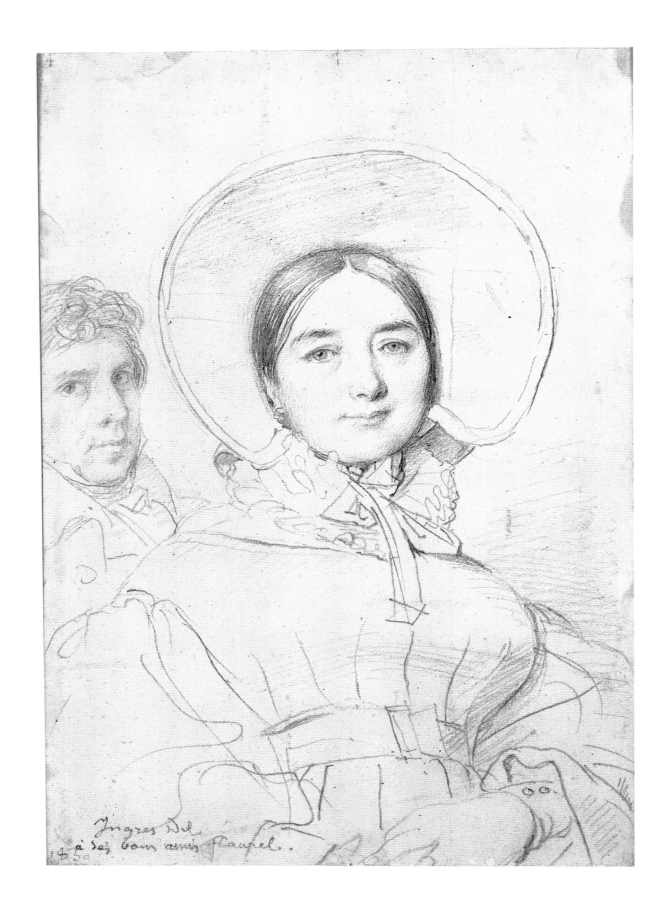

Ingres Del.
à ses bons amis Flaupel.
1850

an official reception for which the artist had composed his wife's outfit, he suddenly flew into a rage, denounced her appearance as ridiculous and insisted that they leave. The tale was told some days later by Madame Ingres herself, no doubt used to and unruffled by her husband's choleric temper.[17] Ingres could appreciate a well-dressed woman but was powerless to produce the same effect in his wife.

The pursuit of female beauty was no easier on the painted canvas, and Ingres often expressed his frustration at the difficulties involved in portraits of women. '"How I suffer painting this dressed-up monkey", said he one day while doing the portrait of a woman celebrated for her opulence.'[18] This bad-tempered remark – probably not too far from the truth – was attributed to Ingres by his old enemy Silvestre in his argument that the artist disliked painting modern costume and was forced to do so against his will. It may be that Ingres underlined his occasional despair at the problems involved in portraiture and the slowness of their execution, but there is no proof that he hated modern dress – on the contrary, the resulting portraits justify his attention to the detail of costume, which he laboured over with painful concentration.

Silvestre's comments about Ingres's supposed antipathy to modern dress, applied mainly to men's dress in portraiture. According to this hostile critic, it was only the pleasure of painting rich embroideries on official costumes that consoled Ingres for the pain of portraying men, and cited in this context is Ingres's portrait of the marquis de Pastoret (1826; Art Institute of Chicago).[19] The marquis, depicted as a foppish young man with a disdainful face, is shown in the costume of Councillor of State, a superb rendition of black silk embroidery on black cloth. To his pupil Amaury-Duval Ingres claimed that if the embroidery had been coloured, he would have refused to paint it, conveniently forgetting that in 1811 he had happily portrayed Hippolyte-François Devillers (Bührle Collection, Zurich) in a splendid civil uniform of black and cream, glistening with silver embroidery. What was acceptable in an empire, was, however, regarded as too flashy a decade or so later, when men's dress had begun to assume the sobriety that was to distinguish it for the rest of the century. In the Pastoret portrait, Ingres's touch of genius was to send for the cream kid gloves (which lie on the chair) as a perfect foil to the otherwise overwhelming black of the uniform. In just the same way Delacroix's portrait of baron Schwiter of the same year (National Gallery, London) has his black suit set off by a judiciously chosen pair of similar gloves. Neither of these men in black, elegant as they are, has the gravitas of Ingres's most famous male portrait, that of Louis-François Bertin, the heavyweight founder of the political *Journal des débats*, painted in 1832 and now in the Louvre; plate 10 is a study for the portrait. The lived-in, rumpled and almost slovenly costume only serves to emphasize character and intelligence. Reacting to the critics who claimed to be bored with the funereal and unpicturesque appearance of male clothing, Gautier claimed that the very understated nature of modern menswear laid

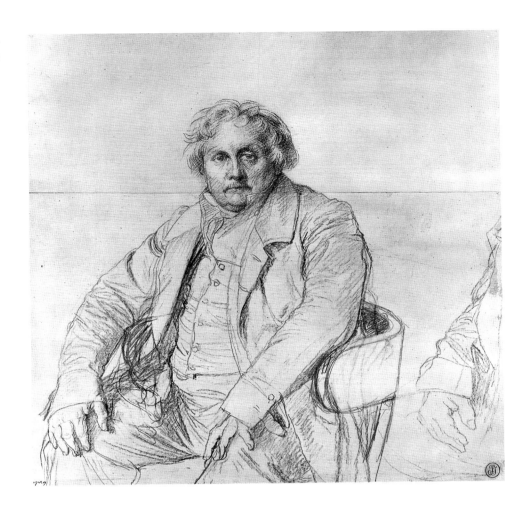

greater stress on the head and hands and underlined the essence of the man portrayed. Citing the portrait of Bertin, Gautier poses the rhetorical question, 'Are not the folds of the coat and the trousers as solid, noble and pure as the folds of a Greek mantle [*chlamys*] or a toga? Does not the body live under its mundane clothing like that of a statue under its drapery?'[20]

The loving and intelligent depiction of this costume, averred Gautier, gave the lie to those artists and sculptors who blamed modern fashion – 'des habits noirs, des paletots et des crinolines' (black suits, overcoats and crinolines) – for their inability to paint masterpieces; after all, he commented, in the past such artists as Titian and van Dyck created great works of portraiture with the clothing of their own time.[21] In the same vein the critic Louis de Loménie said that Ingres's portrait of Bertin disproved the need for the lace and velvet of Flemish or Venetian artists and was a triumphant vindication of modern dress. With the aid of a plain chair and a simple coat, the true beauty of the soul reflected in the face was fixed eternally on the canvas.[22] The critic and art historian (also a writer on dress) Charles Blanc, who knew Ingres in the last years of his life, went into raptures about the portrait:

The interrogative expression of his piercing eye, the slight disorder of the hair, the slack knot of the cravat, the ample waistcoat over the expansive chest, the form of the vast coat which betrays the gross body, the large sleeves from which emerge podgy hands with tapering and delicate fingers.[23]

Although critics could not decide whether they disliked men's costume for being boring and colourless, or approved of it for being relatively unchanging and free from frivolity, there was a general agreement that on the whole modern portraits should be clothed in a modern way. Earlier in the century Hegel had stated in his *Aesthetics* that, 'If, today, a portrait is to be made of an individual belonging to his own time, then it is essential that his clothing and external accessories be taken from his own individual and actual environment'.[24] This is perfectly the case with Ingres's portrait of Bertin. Having talked to those who had known him, Amaury-Duval claimed that the image of this 'bourgeois Caesar' (Gautier's words) was more than a living portrait, it was a vivid exploration of an age in the character of one man; Ingres, said his pupil, had conquered the 'tedious costume of our time'.[25]

If the sign of a good portrait was to reveal the soul as well as the surface, how far was it permissible to idealize the image? According to About, the artist could slightly exaggerate the personal mannerisms of the sitter – even his clothes – to achieve a breathing likeness; Ingres's portraiture, he believed, was not about 'servile imitation' but about 'an original interpretation of reality'.[26] Ingres himself claimed that to express character, a certain exaggeration might be necessary, 'but above all when it is a question of emphasizing the beautiful'.[27] In the case of the Bertin portrait – and judging from contemporary comment on the man and his habitual mannerisms – Ingres had no need to exaggerate, merely to draw attention to such details as the overlapping edges of the waistcoat, the baggy trousers and the ill-fitting and voluminous coat, which signalled a character impatient with dress and formality.

Like all great portraitists Ingres was acutely conscious of how personalities could be expressed through clothes. It was precisely because men's character could be gauged by their costume that they were easier to paint; menswear in its simplicity and sobriety provided a freedom denied to women, and moreover masculine status could often be identified with various forms of official and occupational clothing. Citing the Bertin portrait, the Goncourt brothers claimed that Ingres was better at painting men, for their faces and their costume usually proved less infected by fashion. So Ingres, like many other artists, found that it was harder to paint women, for their clothes could too easily become a barrier beyond which character could hide. The kind of crumpled untidiness seen in Ingres's portrait of Bertin could not be contemplated in his portraits of women, who wished to be depicted neatly and elegantly, whether they were intimates of his own artistic circle, or grand society ladies.

The simple and informal *toilettes* seen in many of the portrait drawings of Ingres's friends attracted far less attention than the elaborate formal costume of

become a painter)? Henri Delaborde argued that for Ingres the truth of a painting lay in a complex relationship of body contours, and that a too-strict concern with anatomical accuracy would result in banal verisimilitude. Despite his expertise the possibility that Ingres occasionally had technical difficulties in fitting various parts of the body together should not be discounted – for example the drawing of Madame Guillon Lethière (pl. 25) shows her arm set oddly into the shoulder – and this weakness would manifest itself in the more revealing images of women than in the clothed male portrait. Another argument, especially in connection with the painted portraits of women, is that slight bodily distortions could emphasize the lines of the body and the garments enfolding it, and at the same time distract attention from the all-too-real and substantial clothing and accessories that might overwhelm the image. Like other artists, Ingres objected to the obsession that some women displayed about their appearance in a portrait, and to their frequent inability to sustain a pose, being impatient to see themselves on the canvas. Blanc records how

> they were continually getting up to see the progress of their portrait, lightly touching the easel with their silk gowns, or giving an extra touch to their appearance as it was being created on the canvas. In a moment of impatience he said to one of them: 'I would like to be able to give you five francs, madame, and you would then be forced to keep your pose like the poor models whom we pay for this purpose'.[37]

Once the final pose and dress had been chosen, the sitter herself was needed, for she alone could imprint her character on the clothes; the size of her body, the shape of the limbs and the way she wore her clothes determined the way in which the costume appeared in the portrait. It was then up to the artist's intense gaze, for, although the accessories to the costume could be displayed on a lay figure, it was the conjunction between dress and sitter in front of him, which created the portrait. The relationship between Ingres and his sitters could help the artist create his magical alchemy: 'A lock of hair, the precise shape of a finger-nail, the fold of a cravat, the twist of a piece of lace – nothing was indifferent to him, nothing was useless in the accentuation of character'.[38]

13 Detail of pl. 117.

3 Women and the World of Fashion

La toilette est tout à la fois une science, un art, une habitude, un sentiment
(Dress is at one and the same time a science, an art, a custom, a feeling).

Honoré de Balzac, *Traité de la vie élégante* (1830)

Everything that adorns woman, everything that serves to show off her
beauty, is part of herself; and those artists who have made a particular study
of this enigmatic being dote no less on all the details of the *mundus
muliebris* than on Woman herself.

Charles Baudelaire, 'The Painter of Modern Life' (1863)

IN THE CULTURAL CODES of dress created by Balzac and by Baudelaire,
fashion was a sign of modernity as well as the mirror of society; it was both
tyrannical and liberating. The tyranny arose from the age-old notion that
women were in thrall to the caprice and novelty inherent in the concept of
fashion. 'Fashion reigns like a despot over the civilized world', began the writer
Auguste Debay in his book *Les Modes et les parures* (1857), and clearly with the
rakish court of the Second Empire in mind, and the rise of the *grandes
horizontales*, the courtesans hymned by Baudelaire and the brothers Goncourt,
he continues 'it laughs at goodness, mocks reason, upsets the established order
by overturning the great and uplifting the unworthy, it makes and demolishes
reputations, it gilds ugliness, makes vice acceptable and clothes the false in the
colours of truth'.[1]

It was this sense of subversion, the mockery of convention as well as a new
interest in the subject of fashion itself, that appealed to many artists and writers
in the nineteenth century, from Delacroix and Guys to Balzac and Baudelaire.
Fashion was irrational and frivolous; it was aspired to by women of all social
classes and all reputations – the great couturier Worth dispensed his creations
to anyone who could pay for them, society lady or *grande cocotte*. Fashion was
thus, in a sense, democratic, being an essential part of the market forces that
dominated nineteenth-century society, and which are reflected so accurately in
the novels of Balzac, a world of getting and spending. Fashion also offered
women the chance to transform themselves through a series of constantly
changing images; it cannot exist without the woman who wears it, but it can
construct and define the wearer, as Baudelaire knew, and described in his essay
'The Painter of Modern Life'.

14 Detail of pl. 94.

It was Balzac, however, in his *Traité de la vie élégante* (1830), who was the first to link fashion, hitherto regarded as frivolous and superficial, with the deeper concerns and aspirations of society. Balzac's treatise is mainly about men, and a discussion of the new concept of elegance in clothing and behaviour which supplemented – and in some instances replaced – the *ancien-régime* insistence on luxury. Nevertheless, his general comments on costume apply to women as well, notably the value placed on the 'luxury of simplicity', an understated elegance created through grace, manners and education, which Balzac viewed as the key to the new order of society. The newly fashionable trinity was harmony, simplicity and propriety, and relied as much on the way clothes were worn as on the correct, stylish and appropriate outfits for every occasion. The wardrobe did not need to be opulent, Balzac has much fun at the expense of the vulgarity of the *nouveaux riches* in his novels, but good taste was essential.

Balzac, like Ingres, was a provincial in the capital city of France; a healthy mockery of the excesses of the fashionable world was allied, sometimes uneasily, with a provincial awe of Parisian standards of taste and elegance in dress and manners. Much of Balzac's ambivalence towards the world of fashion, which is reflected in his life and his writings, no doubt had echoes in Ingres's visual record of the same world. Balzac's eye for the manifold details of costume and furnishings is enthusiastic and yet acerbic, but although such details serve to amplify both plot and character, they mean less to the modern reader than they would have done to a contemporary. He or she could appreciate the merits, for example, of types of muslin, the nuances of woven as distinct from printed stuffs, the choice and positioning of lace and ribbons in the cap, and the skills of tailors, dressmakers and suppliers of fashionable accessories who are often named and praised – this not only was acceptable publicity (and may have served to pay off debts of one kind or another) but added the essential element of modernity to the novel. An understanding of Balzac's novels is enhanced through the visualization of the clothing described in such detail, and it is through images by Ingres that the modern reader can 'see' the role of dress in a society that was both materialistic and elegant; Balzac describes 'la vie élégante' as the 'perfection of exterior and material life'.[2] It is something of a paradox that although the very notion of fashion is transience – what Roland Barthes calls the 'amnesiac substitution of the present for the past' – Ingres fixes it for all time in his portraits, which convey not just the necessary representation of dress but its *im*mutability on canvas and paper.[3]

The way that women marked out their lives by dress which is such a feature of contemporary novels, is also remarked on by the writer Alphonse Karr. His not unsympathetic study *Les Femmes* (1853) notes how fashion was one of the few things, apart from home and family, that society allowed to women; it was their direct link with a world outside immediate domestic concerns. Thus, he claims, a woman will mark the rites of passage in her life through dress; for example, she will note what she wore when meeting her future husband for

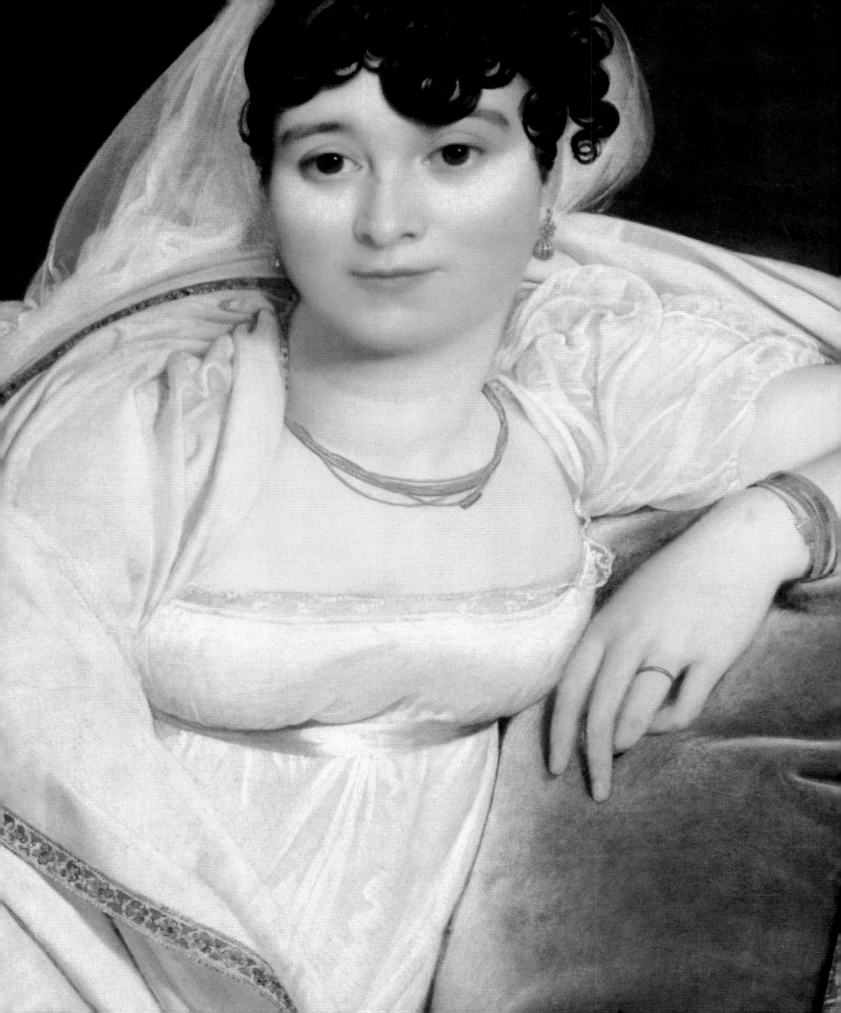

He was conscious of the warmth of her body, of the smell of perfume, and heard the slight creak of her corset as she breathed. He saw not her marble beauty forming a single whole with her gown, but all the fascination of her body which was only veiled by her clothes.[19]

Ingres is always aware of the body (the inside) beneath the clothes (the outside) of the women he depicts; even when they are fully dressed there is the consciousness of the flesh on which the corset forces its imprint, creating the shape of the sitter, moulding it into form. More than any other garment, the corset has erotic overtones; it draws attention to the breasts while it subdues and restrains them.[20]

In the second quarter of the nineteenth century, with the waist returning to its normal place, corsets became more streamlined (the invention of metal eyelets in the late 1820s enabled much tighter lacing) and more elaborate in construction and decoration. They assumed an even more prominent role in the life of a fashionable woman, and the fashion journals and etiquette manuals devoted an increasing amount of space to the different types of corset for each occasion, even for riding and for pregnancy. To their practical function of supporting the breast, the torso and the hips, an erotic fetish was added; the act of lacing and unlacing the corset became a performance of sexual implication. In *Cousin Bette* (1847), Valérie Marneffe, Balzac's paradigmatic chic and sensual Parisienne, has her corset laced up by her lover:

It is at such moments that a woman who is neither too plump nor too slender, like the finely made, elegant Valérie, seems more than ordinarily beautiful . . . The lines of the body, then so lightly veiled, are so clearly suggested by the shining folds of the petticoat and the lower part of the stays, that a woman becomes quite irresistible . . .[21]

By the time that Balzac had published this novel, the services of a lover (or of a maid) in helping a woman of fashion with her corset were not strictly necessary; the invention of 'lazy-lacing' corsets (two laces replaced the traditional single lace) enabled women to lace and unlace themselves. When on one occasion, Emma Bovary met her lover Monsieur Léon, so urgent was their encounter that 'she snatched off her dress and tore at the thin laces of her corset which whistled down over her hips like a slithering adder'.[22] Flaubert's use of the sound of dress here is as erotic – in a different sense – as Tolstoy's reference to the 'creak' of Hélène Kuragin's corset created by her breathing and the movement of her breast. By the middle of the nineteenth century corsets (which were now often front-fastening) had become more substantial, perhaps to cope with the embonpoint that fashion found attractive. The boning in corsets (steel as well as whalebone) made them almost objects of engineering; they could, so to speak, stand up on their own as a kind of rigid husk, a mimicked human torso. In practical terms this development meant that

shoulder-straps were unnecessary, and thus women could wear evening dress cut increasingly low, as can be seen in Ingres's portraits of Madame de Rothschild (pl. 125), Madame de Broglie (pl. 130) and Delphine Ingres (pl. 140).

Rigorously boned and tightly laced corsets were, however, denounced by doctors (on medical grounds) and by some artists and critics of modern dress (on aesthetic grounds). Auguste Debay for example, in his *Les Modes et les parures* (1857) published a list of medical problems arising from the wearing of corsets, describing them as the equivalent of Chinese foot-binding; he claimed that, though the French might laugh at Turkish women for having thick waists, it was the Turks who had the last laugh and pitied Frenchwomen for being crushed by their corsets.[23] The anti-corset lobby had a taste for hyperbole in their denunciation of tight-lacing, which the statistics do not support; nevertheless, they helped to create the myth (which occasionally resurfaces even today) that corsets seriously endangered health and created sex-objects of Victorian women. In every period the fashion victim is a relatively rare creature, and in the nineteenth century most women were content to wear modestly supporting and confining corsetry, which did not radically distort the natural shape of the body. In Ingres's portraits of fashionable women, there is no sense of an unnatural or artificial body shape of the kind that the fashion magazines promoted.

Reading contemporary fashion journals, it is interesting to note how the sense of fun at the expense of fashion and its excesses that one finds in the early years of the nineteenth century, gives way as the century progresses, to an increasingly humourless litany of costume detail as well as the kind of advice spawned by a growing number of etiquette manuals. For example in the *Almanach de la mode parisienne* (1817) the description of the *toilette* of 'Delphine', 'une femme à la mode', and the progress of a typical day – rising at eleven, spending hours on make-up and dressing, followed by a hedonistic round of visits, gossip and entertainment – reads remarkably like an equally satirical account of her eighteenth-century predecessor. The only real difference is a new emphasis placed on shopping, the latest luxury pastime, especially for underwear and accessories. Neo-classical fashions promoted the 'natural' shape of the body, but nature often needed to be helped out by art in the shape of the *corsetière*; Delphine's corsets, we are told, give her the rejuvenating appeal of a convent girl. Her love of accessories is itemized (the names of the suppliers are often mentioned) – ankle boots of white merino wool, chamois gloves and straw hats decorated with feathers, just the kind of detail that Ingres fastens on in his portrait drawings of the period.[24]

By the 1830s fashion journals no longer contain much in the way of satire, but are preoccupied with details of dress and textiles and an increasingly complex hierarchy of formal occasions at which the correct costume was required. Whereas the dividing lines between formal and informal dress had been blurred during the years following the French Revolution, with the

Restoration came the more varied and elaborately choreographed day of the women of fashion; different styles of dress and their matching accessories became necessary for a wider range of social events.

Within the framework of changes in style of dress during the first half of the nineteenth century, certain conventions remained relatively unaltered, notably that dress should be simple in the morning, more formal during the afternoon and most elaborate for such evening occasions as theatre-going, the opera, dinners and balls. To help women through the minefields of public life, a plethora of advice was offered to them in the form of etiquette books. These were curious compilations of the practical (useful hints on looking after clothes, or recipes for cosmetic creams) and the absurdly dictatorial. One such publication, the *Manuel des dames* of 1827 (one of a series of popular manuals written by Elisabeth-Félicie Celnart) can be taken as typical of the genre. The sensible advice included tips on, for example, making sure that the shift (*chemise*) was not too large so that it did not form folds under the corset and chafe the skin. It was suggested that women should wear their hair in curl-papers until midday, hidden under a cap; after that time women were seen outside the confines of informal *déshabillé*, on public view inside the house, or visiting friends, and the hair had to be properly dressed in the kind of elaborate curled styles that Ingres so faithfully records in his portrait drawings of the late 1820s.

Advice of a dictatorial kind listed the appropriate types of dress for each minute of the day. On getting up in the morning, for example, a woman was told to wear over her shift a kind of half-corset (*ceinture du matin*), then a corset-cover or *camisole*, and then a cotton or linen *chemisette*, which was a collared attachment to the chemise and served to cover the décolletage; the appropriate dress round the house was a wrapping gown (these often feature in Ingres's portrait drawings) which had to be fine wool merino in winter, and printed cotton in summer – silk or fine muslin in this context were signs of laziness and worldly vanity. [25]

Muslins and silks were, however, suitable for such afternoon excursions as walking in the Tuileries Gardens or the Champs Elysées, or paying formal visits. The consensus of the fashionable world dictated that certain times of day were 'correct' for women to be on public view; the *Journal des dames et des modes* (1824), for example, decreed that it was at three o'clock that the most stylish women walked in the Tuileries Gardens: 'It's there that an elegant woman can be admired for her taste in the design of her printed muslin, for the trimming or embroidery of her dress of Indian muslin . . .'[26]

Later in the afternoon more elaborate *toilettes* were on display as women rode in their carriages in the Bois de Boulogne; greater luxury and more fragile dress fabrics and accessories were permitted for carriage costume than for the occasions when women went on foot. The most sumptuous outfits of all were those worn at evening parties, especially at balls, where shoulders were

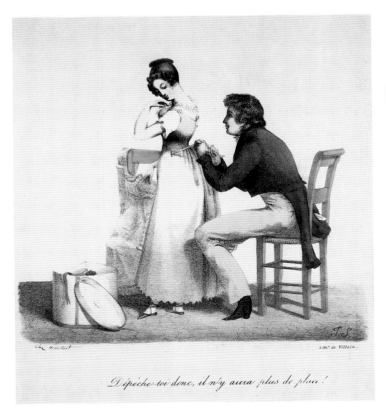

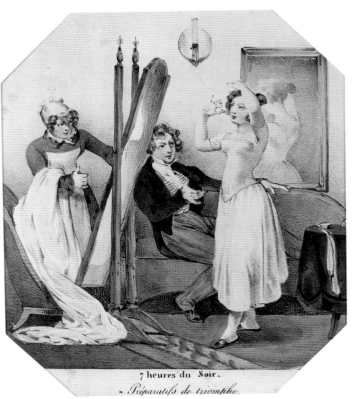

7 heures du Soir.
« Préparatifs de triomphe.

Dépêche-toi donc, il n'y aura plus de place!

17 and 18 'Dépêche toi donc, il n'y aura plus de place', *c.*1825, and '7 heures du soir. Préparatifs de triomphe', *c.*1828. Coloured engravings. The Fashion Research Centre, Bath. Dressing under an admiring male gaze is a stock motif in the imagery of fashion. These coloured engravings of the 1820s reflect the new importance given to the corset in the formation of the fashionable female figure.

uncovered and necklines were low. Evening coiffures involved elaborately curled and pomaded hair, decorated with lace, ribbons, feathers and jewelled ornaments.

Whereas fashion journals tended towards the more factual in terms of information on dress, the etiquette manuals were concerned with making the 'right' choice of costume on every occasion. They offered advice on what colours and styles of dress to wear to suit age, status, income, figure and complexion, treading a careful line between the Scylla of too much opulence, and the Charybdis of affected simplicity, which could too easily be construed as miserliness. Discrimination was to be applied to the choice of accessories as well as to dress; for example girls and unmarried women were urged to wear pearls and semi-precious stones such as opals and turquoises, whereas older, married women were allowed more expensive jewels, notably diamonds. By the middle of the century the custom of wearing many rings (as in Ingres's portrait of Madame de Senonnes; pl. 107) was declared by the etiquette books to be hopelessly vulgar, and only one or two rings were permissible, on the third finger of the left hand.

Furthermore, the etiquette manuals strove to tell women how to cope with their clothes in any given situation – a necessary aid as costume became more

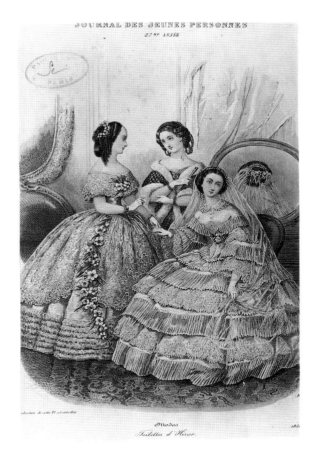

19 (*above left*) Fashion plate from the *Journal des jeunes personnes*, 1858. Victoria and Albert Museum, London. These evening dresses by Worth demonstrate the vast size of the fashionable crinoline elaborately decorated with lace, silk flounces and flowers.

20 (*above right*) Fashion plate from the *Moniteur de la mode*, 1857. British Museum, London. These *toilettes*, one evening dress and one day dress, are made from fabrics sold at the fashionable silk merchant Gagelin. The evening gown on the left has a bodice similar to that worn in Ingres's *Madame Moitessier* of 1856 (pl. 135).

complicated as the century advanced. Women were told how to manage, sartorially speaking, with formal visits – what outer garments they could remove (cloaks and over-shoes), and what to keep on (shawls and headwear, although with more familiar friends the latter could be taken off); how to sit down with a graceful manner (this could be tricky when wearing a crinoline), and how to stand and move with ladylike gentility. Women were even entreated to consider harmonizing their costume with the rooms they were in, as though they were part of the general decoration; this was an artistic consideration not always easy to achieve. As Philippe Perrot points out in his seminal discussion of the clothing of the bourgeoisie in nineteenth-century France, the purpose of such etiquette manuals was to emphasize the consumption of time and money on the appearance of the woman who aspired to fashion: 'Underlying the aesthetic rationalizations advanced, these techniques and practices, inspections and verifications had but one aim: to show that useless labor had taken the place of utilitarian work'.[27]

Such 'useless labor' involving vast expense and time laid waste, was a key argument in the 'luxury' debate, which forms the background to the discussion of fashion in the nineteenth century, particularly during the Second Empire. Unlike Great Britain or the United States, France was not on the whole an

4 A Narrative of Fashion: Ingres's Portrait Drawings

L'attention la plus patiente, la plus délicate, avec une précision religieuse, avec amour.

<div align="right">Charles Blanc on Ingres's drawings</div>

Ce dessin que vous admirez, je l'ai trouvé tout fait dans la nature: je n'y ai rien changé.

<div align="right">Ingres to Charles Blanc about his drawing of the Forestier family (1806;
Louvre, Paris): C. Blanc, Ingres: sa vie et ses ouvrages (1870)</div>

INGRES ONCE SAID to his pupil Raymond Balze that if he had to have a sign above his studio door, it would be 'Ecole de dessin', school of drawing;[1] a good portrait drawing was not just mere outlines but ought to capture and hold the soul of the image. 'Le dessin est la probité de l'art'.

Like all the best drawings, those of Ingres seem effortless, containing what Gautier called 'such holiness of lines, such religion of form'.[2] The English artist John Flaxman is often invoked as an influence on Ingres's particular purity of line, but it is clear also that Ingres was attracted to the delicacy of Watteau's drawing;[3] the great artist from Valenciennes not only produced beautiful costume studies in connection with his painted canvases, but also some of the earliest true fashion drawings. Ingres's drawings, the early portraits in particular, have a limpid quality, like Schubert's Impromptus, and must have given the artist the same private pleasure.

Throughout his life Ingres produced portrait drawings (some 450 are extant); they include his family, friends and relations, and also the paid commissions of his first stay in Italy when he was in urgent need of money in the aftermath of the collapse of the Napoleonic Empire. Although the portraits range in date from the early years of the nineteenth century to the 1850s, they are far more numerous in Ingres's earlier career, and appear only irregularly in his later years.

Ingres's portrait drawings were done from life, and took no more than a few hours; the subjects were posed in a casual way, either standing or – as was usually the case with women – seated, and with the minimum of background detail. There was neither time nor – presumably – the inclination to alter the clothing of his sitters, although he may have changed the angle of a hat or the draping of a shawl. Often the heads are given extra attention, a natural emphasis in a portrait likeness drawn in a limited time; Ingres sometimes indicates the lines of the dress and not its detail, or roughs out a pattern without further

21 Ingres, *'Barbara Bansi'*, c.1800. Pencil on paper. Cabinet des Dessins, Musée du Louvre, Paris.

elaboration. Sometimes the figures have a curious sense of elongation (see *Madame Augustin Jordan and her Son Gabriel*, pl. 28), as though the artist has viewed them from below; might Ingres have seen this kind of stylization in contemporary fashion plates? As with the painted portraits, there are some anatomical infelicities, for example the clumsily joined arm to the shoulder in *Madame Guillon Lethière* (pl. 25) and in *Madame Ingres* (pl. 139).

Among the portraits of his first stay in Italy are rough sketches of his models and servants, and a number of his friends dressed in the picturesque costume of the Roman Campagna. Ingres drew Hortense Haudebourt-Lescot, an artist friend, in the dress of Frascati in 1814; with scrupulous detail he depicts the characteristic embroideries, tied-in bodice sleeves and lace headdress skewered with a jewelled pin.[4] Many foreign residents in Italy, especially women with an interest in the arts and in local colour, adopted elements of Roman costume, such as the popular filigree jewellery, striped shawls and variations on peasant kerchiefs for head- and neck-wear.

Ingres's main concern, however, was with fashionable French dress, and particularly the freedom and scope offered by everyday costume, the kind of clothes in which his sitters could relax. Perhaps the most attractive and sensitive of his portrait drawings record the dress he knew as a young man, the high-waisted muslin gowns of the First Empire which seemed so charming to Baudelaire half a century later as he contemplated the fashion plates of the period: 'It is still possible today for the spectator's imagination to give a stir and a rustle to this "tunique" or that "schall" [shawl].'[5]

With Ingres's reverence for antiquity, it is not surprising that the neo-classical styles of early nineteenth-century dress would appeal, especially as they revealed the natural body shape enhanced by the sculptural effect of the flowing lines of draped muslin. One of Ingres's most impressive portrait drawings is that of a seated woman who may be the artist Barbara Bansi (pl. 21) of *circa* 1800. This is an early, and virtuoso exercise in Ingres's power to create a sense of the feel of costume and textiles even within the limitations of a pencil drawing. The sitter is depicted in a light cotton dress caught in under the bust; the softness of the fabric is indicated by the way the shape of the thigh is revealed, with the folds of the gown caught up under the seated figure. With painstaking detail Ingres indicates the tactility of the short sleeve with its pattern of tiny round tufts woven into the fabric (a dimity or figured muslin). With the same heightened sensitivity to detail, Ingres shows how soft the fine leather of the shoe is, in the way it is pleated into the sole. The antique look of the costume (underlined by the Assyrian relief on the parapet on which Bansi sits) is created not just by the fluid lines of the dress but also by the draping of the fine cashmere shawl, which – a typical Ingres touch – is arranged so that the underside can be seen. Further classical notes can be discerned with regard to the flat-heeled shoes with straps imitating ancient Greek sandals, and the way the hair is bound round the head *à l'antique*.

The use of drawstrings at the neck and under the bust of the high-waisted Empire-line dresses helped to arrange the fine cotton in graceful folds, as can be seen in Ingres's drawing of the Harvey sisters of 1804 (pl. 22), Elizabeth Norton and Henrietta Harvey (both artists), who settled in France in about 1802 after a stay in Italy. Their neo-classical gowns make the sisters look like elegant nymphs from a Greek vase, a feeling echoed by their hair, which is arranged in 'classical' curls. Even the fashionable three-quarter length pelisse coat or sleeved mantle worn by the sister on the right is draped so that it looks like a shawl; the sister on the left does wear a shawl, probably of printed cotton, which falls from her shoulder like a Greek *chlamys* or cloak.

The main garments in the fashionable female wardrobe at this time were, as Baudelaire states, the *tunique*, and the *schall* or shawl. The tunic was a simple dress, usually of fine cotton, with short sleeves and a low neckline; the bodice fastened in various ways – drawstrings, 'bib' fronts, side flaps, buttons and ribbon tapes – which can often be identified in Ingres's drawings, so sensitive is he, especially in the early years, to the detail of fashion. The back fullness of late eighteenth-century dress was retained in the early Empire line, with a small pad sewn at the back of the bodice, under the skirt, so that the fabric of the gown fell gracefully in fan-like folds, as in Ingres's portrait of Miss Harvey of about 1807 (pl. 24).[6] As one contemporary noted at the time: 'One must no more say . . . "How well dressed am I", or, "How well attired is Madame such an one", but only sigh out: "How well draped am I!", or "God, how well Madame X portrays herself!"'[7] One of the sisters discussed above (their identities have not been visually established), sits sketching on a small folding stool, her neck protected from the sun by a scarf; the stylish small-brimmed hat trimmed with ribbon looks very similar to the neat cloche hats of the 1920s. Miss Harvey's dress shows how the seeming uniformity of the neo-classical style could be varied according to how the fabric – usually a voluminous muslin – was arranged; here the use of drawstrings creates a kind of smocking, which adds interest to a portrait image seen from the back.

Such a drawing, as well as being a portrait, is also the best kind of 'fashion plate'; it describes the dress in an informative and witty way. It – and many other Ingres portrait drawings of this period – has the appeal of a fashion plate by Horace Vernet in its charm and delicacy.[8] In Vernet's fashion plates, modish young women known as *élégantes* or *merveilleuses* (pl. 36) step out in exquisite muslin dresses, incredible plumed, ribboned and flowered bonnets, and tiny pumps. Vernet and Ingres are certainly soul-mates when it comes to the appreciation of the light and airy *toilettes* of the First Empire.

However, whereas Vernet depicts the ideal image towards which the woman of fashion strives, Ingres had to come to terms with reality. His portrait of Madame Guillaume Guillon Lethière (pl. 25) of about 1808, depicts a plump middle-aged woman whose embonpoint sits uneasily with a style of dress seen to best advantage on a slim, youthful figure; tactfully, perhaps, he hides her

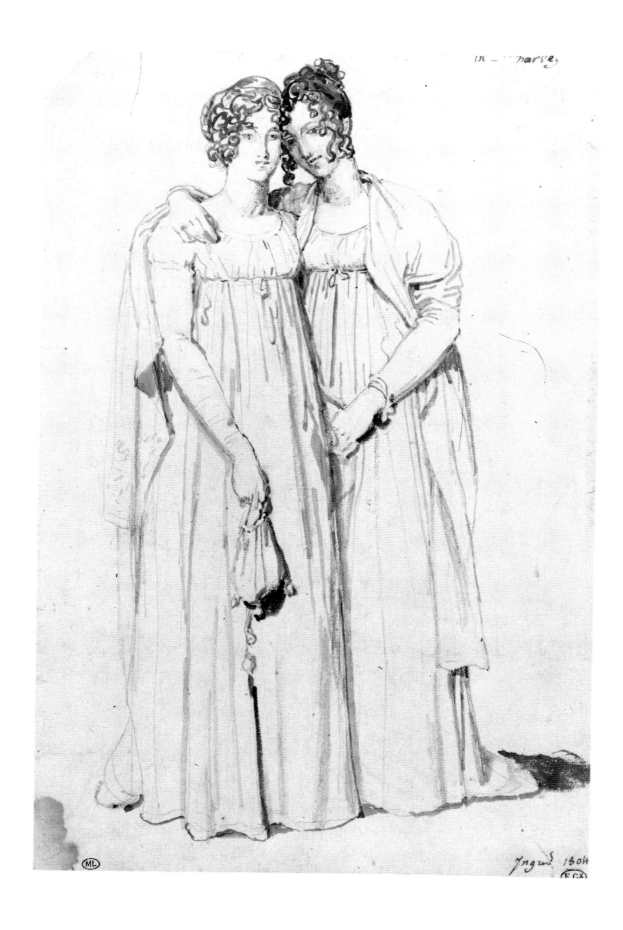

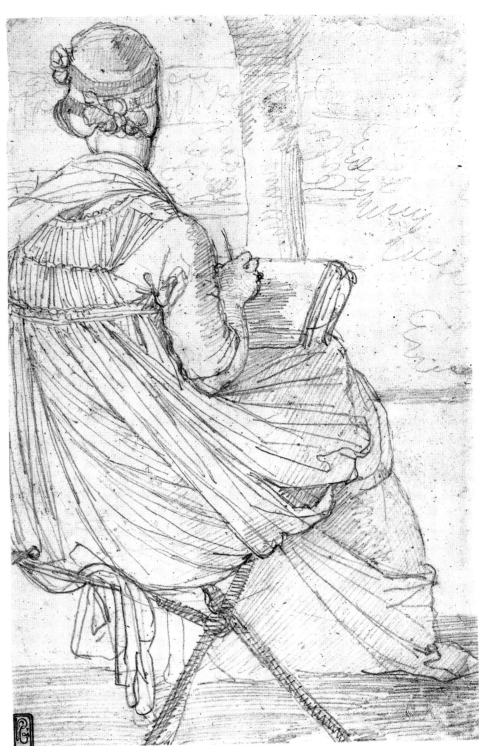

23 Dress of fine striped muslin trimmed with bobbin lace, openwork embroidery and silk ribbon, *c.*1804. The Costume Institute, The Metropolitan Museum of Art, New York, Gift of Michael E. Lane, 1983.

24 Ingres, *Miss Harvey Sketching*, *c.*1807. Pencil on paper. Museum Boijmans Van Beuningen, Rotterdam.

22 (*facing page*) Ingres, *Elizabeth Norton and Henrietta Harvey*, 1804. Pencil on paper. Cabinet des Dessins, Musée du Louvre, Paris.

beefy arm under the folds of her shawl, although he draws attention to her
fleshy neck and hands by the jewellery she wears. The artist depicts the precise
way in which the bodice of the dress is constructed, front-buttoning at the
centre over a horizontal band of pleated fabric which covers the décolletage;
the long ends of the skirt drawstrings fall into her lap. Notwithstanding Ingres's
cool and dispassionate gaze at Madame Guillon Lethière, there are charming
details of dress and accessories, such as the delicate fluted trimming to the hem
of the muslin dress and the straw hat decorated with ostrich plumes.[9]

Madame Guillon Lethière was the wife of the Director of the French
Academy in Rome, and her status is reflected in Ingres's formal drawing of a
woman with pretensions to high fashion and a kind of portly dignity. More

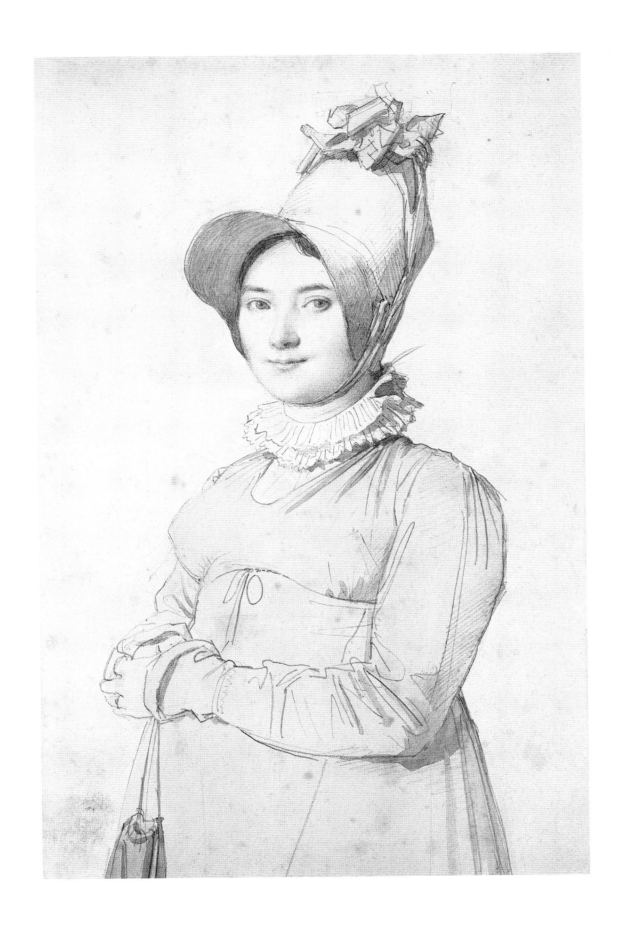

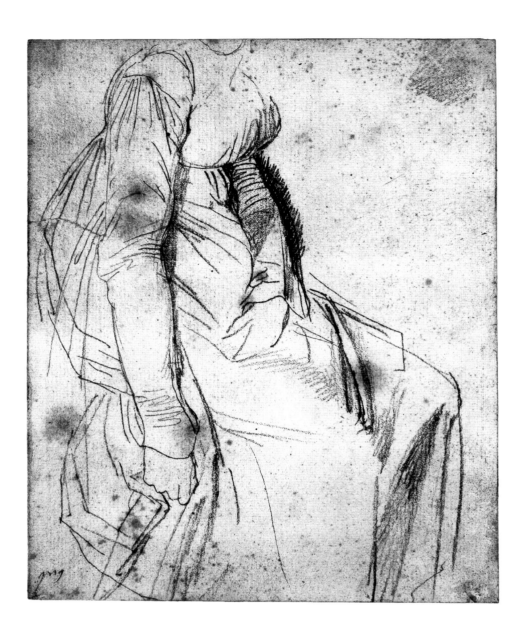

32 Ingres, study for the dress in *Paolo and Francesca*, *c*.1814. Pencil on paper. Musée Ingres, Montauban.

because, when exhibited at a later date, they were primarily regarded as fashion plates. There is certainly a sense of the fashion plate in Ingres's *Madame Destouches* of 1816 (pl. 35), one of the best-known portrait drawings. Ingres drew her as a fashionable young bride, recently arrived in Rome with her architect husband; she sits on a striped sofa, a cashmere shawl draped over one end of it, in a dress of such fine muslin that her arms can be seen through the loose, transparent sleeves tied with ribbons at the wrist. The bodice of the dress and the edge of the ruffled sleeves are trimmed with broderie anglaise, as is the lightly starched collar of the chemisette (*guimpe*); the spectator's eye travels down, as Ingres intends, from the chic feathered hat to the impossibly high bust-line 'waist' of the period, and the long line of the widening skirt trimmed

33 Ingres, *Unknown Woman*, 1814. Pencil
on paper. The Metropolitan Museum of Art,
New York, Bequest of Grace Rainey
Rogers, 1943.

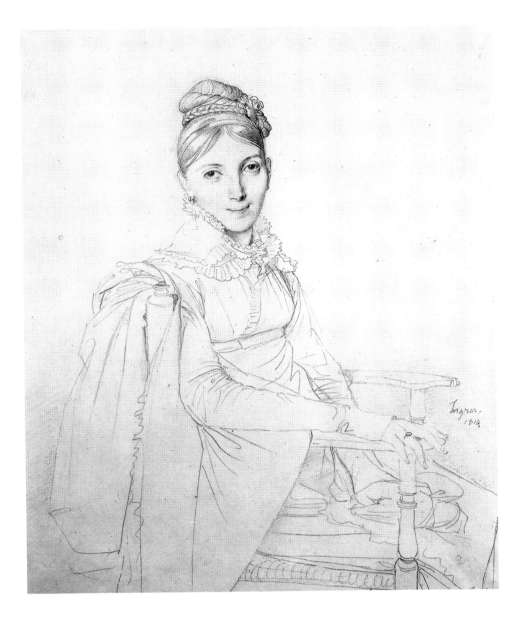

with flounces. The critic Charles Blanc wondered how Ingres was able to make
such fantastic styles of dress acceptable, 'par quel secret l'artiste nous fait-il
accepter, sans peine, sinon sans étonnement, ce que les vieilles modes ont de
plus fantasques?'[13] Blanc's question was posed in the late 1860s, when the
fashions of some sixty years earlier would have seemed absurd (compare this to
the speeding up process in the late twentieth century when the styles of even
the previous decade seem delightful . . .). He was, none the less, clearly seduced
by Madame Destouches, even by her 'head caparisoned in impossible plumes'.

 In 1905 Jules Momméja was less critical of the dress in general, and positively
in raptures about the hat – 'c'est tout un poème' – which, rather oddly,
reminded him of the feathered hats worn by Spanish cavaliers in the engravings

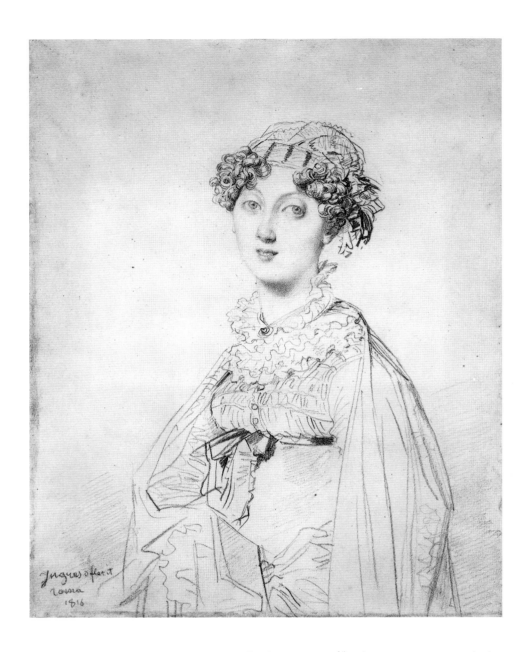

of the seventeenth-century artist Abraham Bosse.[14] The great Ingres scholar Henri Lapauze, while finding the hat delightful, wondered if Ingres had turned it round so that the sitter's face could be more clearly seen. This seems unlikely, because this is not the era of face-hiding bonnets (that came later), and although there is that odd, piquant point to the brim, it does not relate to a hat turned on its side; furthermore, the ribbon ties fall down, as might be expected, in the natural place, and the feathers stay in their right place. It is likely that this is a real hat, worn as intended, and not rearranged according to the capricious whim of the artist.[15]

During the second decade of the nineteenth century the vogue for classical simplicity was fading and there was a move towards more elaborate dress and

35 Ingres, *Armande Charton, Madame Destouches*, 1816. Pencil on paper. Cabinet des Dessins, Musée du Louvre, Paris.

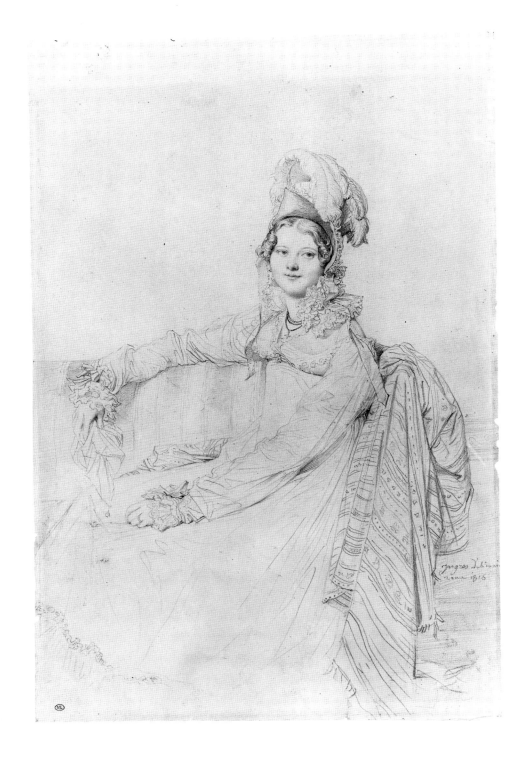

coiffure; it is a period in particular of wonderful hats, as can be seen in Vernet's fashion plates and Ingres's portrait drawings. Compared to the rest of the costume, the hats often look strikingly modern, as in Ingres's drawing of Elizabeth Vesey, later Lady Colthurst, depicted with her mother in a portrait of 1816 (pl. 38). The portrait of Mrs Vesey and her daughter opens a sequence

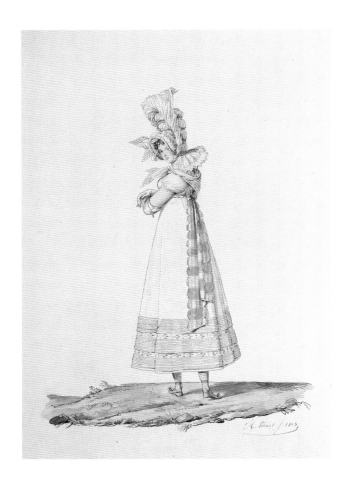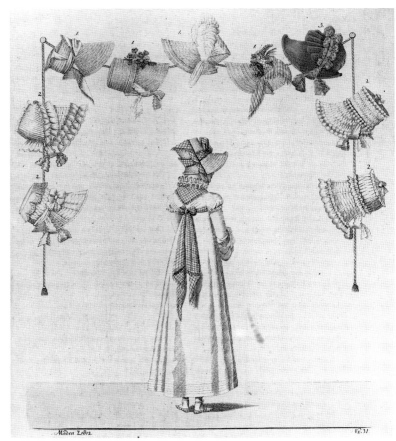

36 (*above left*) Original watercolour by Horace Vernet of a *merveilleuse*, 1813. Private collection (photograph, Hazlitt, Gooden and Fox, London). One of a series of fashion images engraved under the title *Incroyables et Merveilleuses* and published between 1810 and 1818, this *merveilleuse* wears a white cotton dress, and a headdress of cotton trimmed with a gauze scarf ('capote de perkale surmonté d'un fichu de gaze').

37 (*above right*) Fashion plate from *Moden Zeitung*, 1812. Victoria and Albert Museum, London. A fashionably dressed young woman in a white cotton dress and straw hat – her costume is decorated with scarves of the popular Scottish plaid – stands beneath a display of trimmed bonnets similar to those featured in Ingres's portrait drawings.

of identified British sitters drawn by Ingres in 1815 and 1816; these were difficult years for the artist, forced to rely on such commissions for his survival,[16] but whatever private resentment he may have felt, it did not affect the technical skill and character analysis seen in the accomplished portraits of this period. With the Vesey mother and daughter, for example, Ingres has perfectly underlined the different generations in terms of their dress. The elderly Mrs Vesey, descended from a French Huguenot family, is a solidly corseted woman in a silk dress with a somewhat fussy arrangement of headwear – a lace veil over a frilled cap – and the air of a rather bundled-up valetudinarian. In contrast, her daughter looks more relaxed in her simpler costume of coloured skirt and white smocked cotton chemisette, which fastens with a frilled jabot like a man's shirt.

Some of Ingres's sitters were his neighbours, such as Margaret Campbell, Mrs Charles Badham (pl. 39), whom he drew in 1816; they both lived in the same street, the via Gregoriana. Mrs Campbell, a cousin of the poet Thomas Campbell, was known for her beauty, and Ingres has placed her in a suitably artistic background, the Villa Medici, home of the Académie de France. As an inhabitant rather than a tourist, she looks relaxed in her silk dress and striped Roman shawl with its deep fringe; instead of being tied under the chin, the

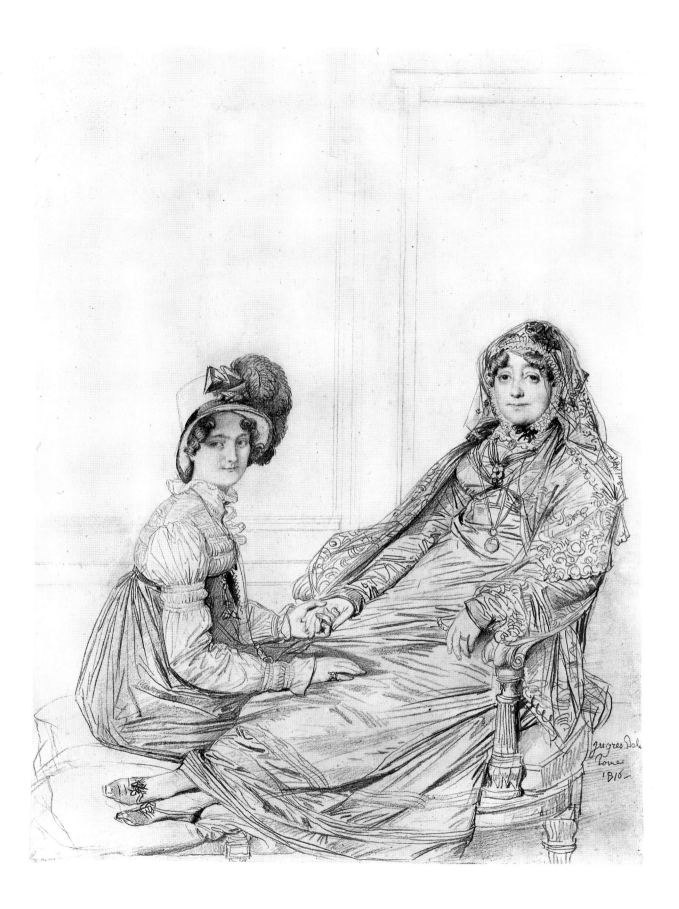

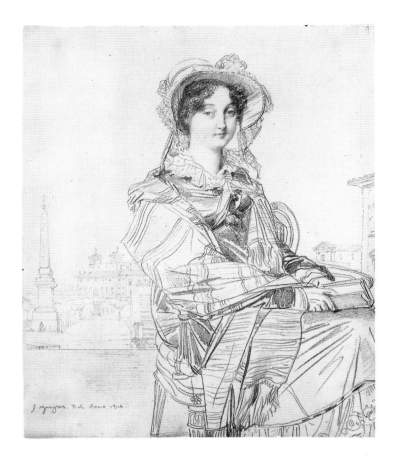

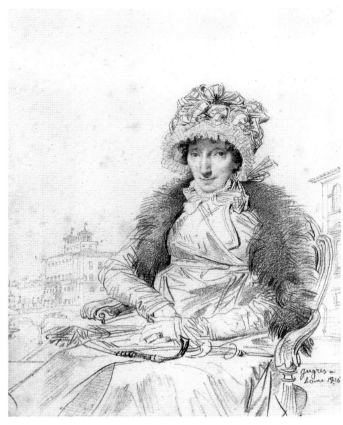

39 (*above left*) Ingres, *Margaret Campbell, Mrs Badham*, 1816. Pencil on paper. National Gallery of Art, Washington, The Armand Hammer Collection.

40 (*above right*) Ingres, *Dorothea Sophia Deschamps, Mrs Mackie*, 1816. Pencil on paper. Victoria and Albert Museum, London.

41 (*facing page*) Ingres, *Lady Mary Cavendish Bentinck*, 1815. Pencil on paper. Rijksprentenkabinet, Rijksmuseum, Amsterdam.

38 (*previous page*) Ingres, *Emily La Touche, Mrs Vesey, and her Daughter Elizabeth, later Lady Colthurst*, 1816. Pencil on paper. Courtesy of the Fogg Art Museum, Harvard University Art Museums, Bequest of Grenville L. Winthrop, 1943.

ribbons of her wide-brimmed English bonnet are thrown over her shoulders. In contrast, the elderly Mrs Mackie (pl. 40) drawn in the same year and with the same background, looks much more muffled up in her wide-lapelled pelisse coat, her fox stole – the fur has an almost electric quality – and her firmly clutched umbrella. Ingres allows himself a touch of wry amusement as he contemplates Mrs Mackie (the daugher of a French Protestant clergyman who had settled in London in the mid-eighteenth century), and especially her frilled and ribboned cap.

Ingres's feeling for fur (he depicts it with the same meticulous care found in Wenceslaus Hollar's famous studies of muffs) can also be seen in his drawing of Lady Mary Cavendish Bentinck of 1815 (pl. 41) in her sable-trimmed pelisse gown; one can see how the small pelts of fur are sewn together to make up the edging to the coat. These coats were more practical garments than shawls, and equally expensive when trimmed with such costly fur; they echoed the fashionable columnar line of the figure. Lady Mary's aristocratic hauteur (she was the daughter of the first Earl of Gosford, and in 1803 married William Henry Cavendish Bentinck, whose military and diplomatic career took him to Portugal, Sicily and India, where he became Governor of Bengal in 1827) is emphasized by her rather formal pose, handkerchief in one hand, the other

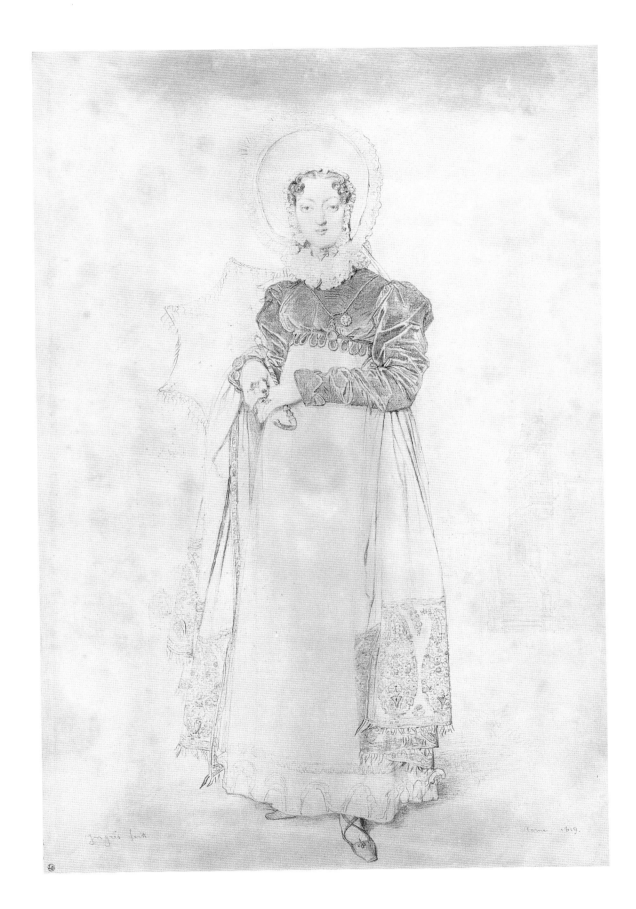

Ingres fecit Roma 1819

46 (*right*) This figure, dressed to resemble a fashion plate of about 1820, wears a pelisse gown of brown silk with short puffed oversleeves and a padded hem; it is close in style to Ingres's *Countess Antoine Apponyi* of 1823 (pl. 48). The straw bonnet is English, as are the figured silk shawl and the silk parasol with mother-of-pearl handle. Victoria and Albert Museum, London.

47 (*far right*) Fashion plate from the *Journal des dames et des modes*, 1821. British Museum, London. The caption to this plate informs the reader that the dress is a *redingote* of silk (*gros de Naples*), trimmed with plaited satin; the crepe hat is decorated with satin and bunches of lilac. Although shawls were no longer needed for their warmth once long-sleeved gowns came into fashion, they remained objects of luxury and conspicuous consumption, and were often worn draped over the arm, as can be seen in Ingres's *Countess Antoine Apponyi* (pl. 48).

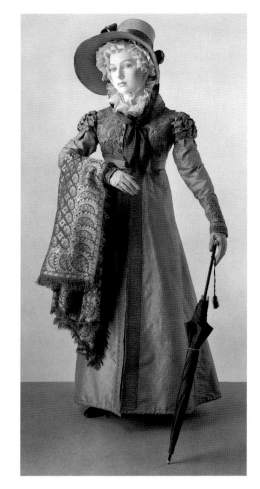

45 (*previous page*) Ingres, *Marie-Louise Bichot, Madame Bénard*, 1818. Pencil and watercolour on paper. Musée Bonnat, Bayonne.

48 (*facing page*) Ingres, *Teresa Nogarola, Countess Apponyi*, 1823. Pencil on paper. Courtesy of the Fogg Art Museum, Harvard University Art Museums, Bequest of Grenville L. Winthrop, 1943.

noting how elegantly Countess Apponyi holds her parasol in her gloved hand; this was a feminine art of the outdoors, with flirtatious possibilities, just as the fan, used indoors, spoke the language of coquetry.

After the high waists that had dominated women's dress for the first twenty years of the nineteenth century, a more natural waistline began to creep back from around 1820; in that year Delacroix wrote to his sister, 'When you come back to Paris, you won't recognize ladies' shapes, their waists grow longer every day'.[19] This is something of an exaggeration, for an examination of both fashion plates and Ingres's portrait drawings, reveals no sudden, dramatic alteration; however, to people accustomed for many years to the waist right under the bust, any dropping of the waistline must have seemed worthy of comment.

During the 1820s there was a new focus also on the sleeves. Long sleeves were *de rigueur* for daytime, although short sleeves were retained for evening wear, sometimes – as in Ingres's painting of Madame Leblanc (1823; pl. 94) – covered with transparent oversleeves. By the mid-1820s the sleeves had begun

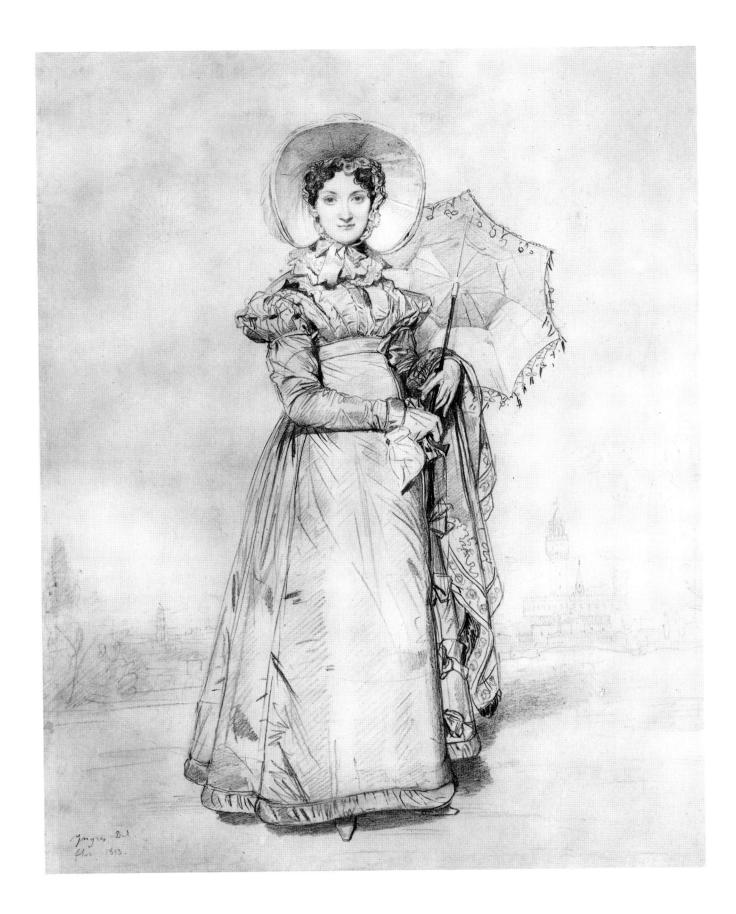

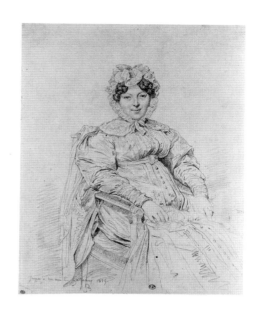

49 Ingres, *Louise-Rosalie Anfrye, Madame Gatteaux*, 1825. Pencil on paper. Cabinet des Dessins, Musée du Louvre, Paris.

to form a *gigot* (leg of mutton) shape, and were sometimes cut on the cross to give an extra-large sleeve-head; increasingly the top of the sleeve needed to be supported by 'cages' of whalebone or buckram, or large down-filled pads – this is certainly the case, for example, in Ingres's portrait of Madame Raoul-Rochette of 1830 (pl. 50). Day dresses were often quite simple from the mid-1820s into the 1830s, and a popular style was the front-fastening pelisse gown, or its slightly more structured variant, the *redingote*. These dresses, usually made of silk or such wool/silk mixtures as challis and *barège*, appealed more to Ingres's taste for the line and sculpture of clothing than the printed cottons that were made into back-fastening informal gowns. The comfort of the pelisse gown can be seen in Ingres's portrait of Madame Gatteaux (1825, pl. 49), a sympathetic if not particularly flattering image of the mother of his friend the engraver Edouard Gatteaux; Madame Gatteaux had a salon where concerts were held and where Ingres, a lover of music, was a frequent visitor.

The pelisse gown, with its wide collar and sleeves, did not always compliment the fuller figure, as Ingres's portrait of Madame Gatteaux makes clear. One might recall also the artist's drawing of Madame Bertin (1834), in the Louvre, a mountainous woman, whose dress with its *gigot* sleeves emphasizes the monumental horizontality of her appearance; her gown is high-waisted, partly because as an old woman she is old-fashioned in her costume, and partly because of her protruding stomach, clear evidence that she has abandoned heavy-duty corseting.

A stylish contrast to Madame Gatteaux is Ingres's portrait of Madame Désiré Raoul-Rochette wearing a *redingote* with wide revers, firmly belted at the natural waist (pl. 50). The sitter, the daughter of the sculptor Houdon (she had been painted as a young girl in Boilly's *Atelier de Houdon* of 1804; Musée des Arts Decoratifs, Paris), gazes confidently out at the spectator, with one hand gloved and the other bare, in an echo of Baroque portraiture; even her slightly absurd hairstyle with its ribboned knot does not detract from her calm elegance.

Among Ingres's portrait drawings of the period, that of Mme Raoul-Rochette stands out for its accomplishment and the way it engages the viewer's attention. Many of Ingres's drawings made after his return from Italy in 1824 do not have the same sense of commitment and confidence. The artist was preoccupied with establishing himself in Paris and with a number of important commissions, history paintings as well as formal portraits; teaching also took up much of his time. It may very well be that as he grew older, capturing the changes in female fashions through portrait drawings interested him less, and from the mid-1820s the sequence becomes intermittent. It is less easy for the dress historian to follow the chronology of costume through the medium of Ingres's drawings on their own, and where such portraits do exist, they often show only a muted appreciation of clothing and accessories.

It may also be the case that Ingres did not particularly like the fashions of the

50 Ingres, *Antoinette-Claude Houdon, Madame Raoul Rochette*, 1830. Pencil on paper. The Cleveland Museum of Art, Purchase from the J.H. Wade Fund, 1924.

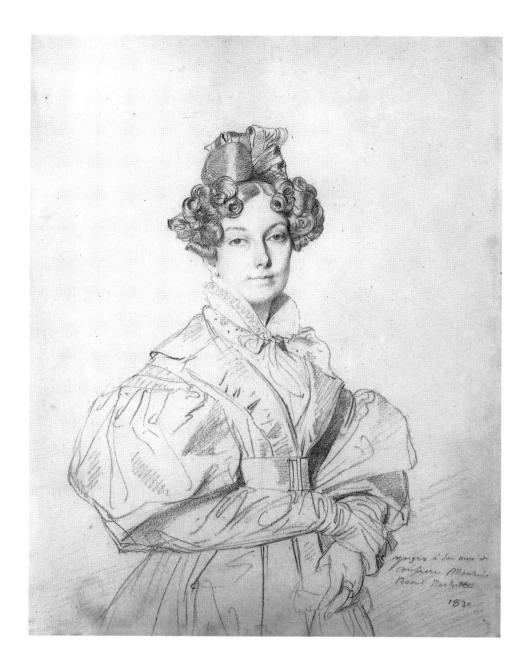

later 1820s and 1830s. In his portrait of Madame Isaure Place (1834; pl. 51), the daughter of his old friend Madame Leblanc, whom he had painted in 1823, it is clear that while he appreciated the young woman's face with her slanting eyes and sleek, centrally parted hair (she may have reminded him of his favourite Mademoiselle Rivière), the costume looks bulky and somewhat bundled. What Madame Place wears over her gown is a large shoulder mantle called a *pelerine*, which had wide ends falling down the front, and which gives her a slightly ecclesiastical appearance. The *pelerine* was light-weight so that it did not crush the sleeves beneath, which by this time were enormous; Madame Place's

51 Ingres, *Isaure Leblanc, Madame Place*, 1834. Pencil on paper. Musée Bonnat, Bayonne.

52 (*above*) Fashion plate from the *Petit Courrier des dames*, 1833. British Museum, London. The wide sleeves of the gown and the matching *pelerine* cape invoke the style of dress worn in Ingres's *Madame Place* of 1834 (pl. 51).

sleeves are of the style known as *à la folle* (like a madwoman's), large and full to the wrist. They could also signify an interest in the past – such sleeves recalled the dress of the late sixteenth century in a vague but romantic way.

It is impossible to know what Ingres thought about the craze for historicizing fashion, which his history paintings had helped to encourage, as had operas by Rossini, Bellini and Donizetti, and novels by Scott and Hugo. Unlike the portraits and fashion drawings of his contemporary Achille Deveria (pl. 55), Ingres evidences only the lightest touch of the historical in his named images. It is as though he separates the real (i.e. contemporary costume) from

the unreal (i.e. historical dress), even when the latter is a strong influence on fashion. He certainly prefers, for example, the elaborate creations of lace, ribbons and flowers (of the kind we see his wife wearing in her portrait of 1830; pl. 56) to the more 'artistic' medieval or Renaissance styles promoted by such women as Madame Victor Hugo, and which Balzac satirizes in *Lost Illusions*.[20]

With so much emphasis on millinery of one kind or another, it was probably natural that Ingres preferred to depict relatively simple styles of dress which could act as a foil to the face and headwear of his portrait drawings. Two portraits dated 1828, one believed to be of Madame Brazier and the other of Madame Joseph Balze (pls 53 and 54), show sitters in modest day dresses.

53 Ingres, *Madame Brazier*, 1828. Pencil on paper. Musée des Arts Décoratifs, Lyon.

54 Ingres, *Marie-Anne-Adélaïde Samat, Madame Balze*, 1828. Pencil on paper. Collection Jan and Marie-Anne Krugier-Poniatowski.

55 Achille Deveria, *Adèle Foucher, Madame Victor Hugo*, 1828. Pencil on paper. Musée Victor Hugo, Paris. The feathered beret and the dress with its rounded sleeves and large stylized floral pattern *à la renaissance* echo early sixteenth-century costume, as does the *ferronnière* on her brow. The jewelled cross was another popular Renaissance-style motif and can be seen, for example, in Ingres's *Madame de Senonnes* (pl. 107).

Madame Balze's dress is a check fabric, fitting fairly tightly to the figure, and Madame Brazier as a younger woman wears an informal, looser-fitting gown known as a *blouse*. According to *Le Règne de la mode* (1823) such *blouses* were usually made of muslin or percale (a fine cotton cambric); 'ces jolies blouses font le bonheur des pères et des maris, le désespoir des couturières et des brodeuses' – they were cheap and simple to make, and thus the delight of fathers and husbands, but the despair of dressmakers and embroiderers.[21]

Although women's informal dress of this period has a kind of Biedermeier demureness, it did, as already noted, have very large sleeves; thus, to avoid the head looking too small for the body, hairstyles and headwear became particularly elaborate. Women of the most fashionable sort arranged their hair in sausage-like curls with a large bun on top of the head, known as an Apollo knot; *Madame Raoul-Rochette* (pl. 50) is a good example of the style. Indoors, around the house, women wore caps of linen or cotton trimmed with lace and ribbons; in Ingres's portrait of Madame Brazier, the sitter's cap of filmy starched muslin trimmed with ribbon frames her face in such a way that the head seems almost to be divorced from the body. The wonderful cream-puff confections that both Madame Brazier and Madame Balze wear on top of their prominent curls, serve to give the impression of heads rather too large for their accompanying bodies; this may reflect either Ingres's concentration on the face and its immediate surroundings, or the particular attention devoted to hairstyles and headwear in the fashion plates of the period.

More elaborate than a cap and less structured than a hat is the style of headwear worn by Madame Ingres in the celebrated portrait drawing of 1830 (pl. 56).[22] The dress, with its large frilled collar, and the shawl over her arm are barely sketched in, in comparison with the nimbus of lace, ribbons and flowers that encircles her head. Madame Ingres's preference (or perhaps Ingres's?) for the sober madonna-like hairstyle she always wears, appears as a startling contrast to the frivolity of her headwear; this is not the only portrait by the artist of his wife during these years to indicate her love of millinery, a professional interest from the days before her marriage. At the Musée Ingres there is an account book kept by her for the years 1835 to 1841, when they were in Rome; among the household expenses are listed payments for hats and caps, no doubt a sign of 'la passion (professionelle) de Mme Ingres pour les chapeaux'.[23]

By the end of the 1830s the huge sleeves had disappeared, and shoulders were narrow and sloping, moving the centre of gravity, so to speak, down to a pointed waist, which was sometimes emphasized by V-shaped pleating at the front of the bodice. At the Boijmans Museum in Rotterdam there is a fine drawing (pl. 58), once attributed to Ingres but now thought to be by a pupil, and dated 1837. The details of dress are clearly delineated: the chemisette with its small frilled collar and the bodice of the dress with its wide shallow neckline, falling slightly to one side; it is not a very skilful piece of home dressmaking, and one can see on the shoulder how the fabric is pleated and then seamed in

56 Ingres, *Madeleine Chapelle, Madame Ingres*, 1830. Pencil on paper. Musée Municipale, Guéret.

57 Detail of a fashion plate from the *Petit Courrier des dames*, 1829. British Museum, London. The large *bonnet* of silk lace (Caen lace, as in Ingres's portrait of Madame Gonse, pl. 101), decorated with ribbons and flowers, is similar in style and mood to Ingres's portrait of his wife (pl. 56).

58 (?) Ingres, *Unknown Woman*, 1837. Pencil on paper. Museum Boijmans Van Beuningen, Rotterdam.

place. The rounded fullness of the sleeve of the earlier 1830s has gone, replaced by two frills at the elbow – perhaps a reference to a revival of eighteenth-century style. With the typical sartorial eclecticism of the period, the sitter has her hair arranged in in a style that the fashion journals called *à la Sévigné*, bunches of curls at the side of the face inspired by the hairstyle worn by the famous late seventeenth-century writer (although any hairstyle with central

parting and side curls or ringlets could, in the fashion vocabulary of the time which is no more precise than today, be labelled *à la Sévigné*).

During the 1840s there are few portrait drawings of ultra-fashionable women by Ingres; Ingres was occupied with his painted portraits of society ladies such as the comtesse d'Haussonville, and the baronne de Rothschild, and with large-scale allegorical works for the duc de Luynes at the château of Dampierre. The continuing sobriety in the dress of the period did not always bring out the innovative and inspirational in Ingres's portrait drawings of young women, and it is in the images of older women, such as *Madame Hennet* (1842; pl. 60), that Ingres makes his more profound statements. In this drawing of an old woman (her son Alphonse was a pupil in Ingres's studio)[24] there is little hint of the new fashion aesthetic, but a preference for familiar and established styles of dress, such as the large sleeves pleated uncomfortably to the wrist, the old-fashioned cap with its wide ribbon streamers and the broad collar trimmed with broderie anglaise. Images of older women often allow for more penetrating character studies (for example the tough, unsentimental and quizzical portraits by John Singleton Copley of many of his elderly American sitters from the 1760s and early 1770s), and Ingres's Madame Hennet is shown as alert and intelligent through the muffling layers of her clothing.

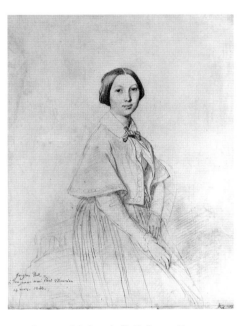

59 Ingres, *Mademoiselle Palmyre Granger*, 1843. Pencil on paper. Musée Victor Hugo, Paris.

The more fashionable streamlined and pared-down look of the early 1840s can be seen in two portrait drawings by Ingres, *Mademoiselle Palmyre Granger* of 1843 (pl. 59) and *Madame Mottez* of 1844 (pl. 61). Mademoiselle Granger, known as Myrette, was the daughter of a friend of Ingres (whom he had drawn in Rome in 1810); she was part of an artistic circle, and on her marriage to Paul Meurice, to whom the drawing is inscribed, the ceremony was witnessed by Victor Hugo, Alexandre Dumas and Ingres himself. In a letter to his old friend Gilibert in 1842 Myrette was described as a 'jeune et jolie et bonne et digne mademoiselle'.[25] The drawing does not, perhaps, indicate good looks (the face has an almost *garçonne* appearance), but suggests a kind of modest charm, which the costume – a long-sleeved day dress under a small embroidered cape – emphasizes. Her hair is parted in the centre, and looped over the ears in a style popularly if erroneously equated with the whole Victorian period. Indeed, the appearance of women during the 1840s is often seen as symbolic of dull, humdrum bourgeois virtues, as the following quotation from the historian Eric Hobsbawm suggests:

> bourgeois girls, like non-bourgeois ones such as the odalisques and nymphs which anti-Romantic painters like Ingres brought out of the romantic into the bourgeois context, increasingly conformed to the same fragile, egg-faced, smooth-hair-and-ringlet type, the tender flower in shawl and bonnet so characteristic of the 1840s fashion. It was a long way from . . . the emancipated neo-Grecian girls in white muslin whom the French Revolution had scattered across the salons . . .[26]

60 Ingres, *Elisabeth-Pierrette Fromantin, Madame Hennet*, 1842. Pencil on paper. Musée Bonnat, Bayonne.

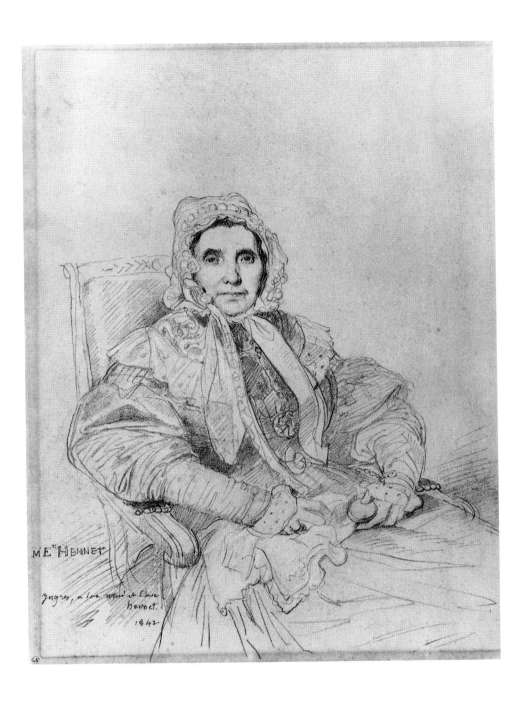

Hobsbawm clearly dislikes what he perceives Ingres to be – essentially bourgeois, anti-Romantic and anti-progressive, but it is too much of a simplification to equate relative freedom in dress (those 'neo-Grecian girls in white muslin') with corresponding emancipation in life-style, and vice versa. The fashion aesthetic during the first half of the nineteenth century was too strong and unified to tolerate much deviation from the norm, and for most of the time intellectual and 'feminist' women (even George Sand whose occasional adoption of trousers made her notorious) wore the modest, even

61 Ingres, *Julie-Colette Odevaere, Madame Mottez*, 1844. Pencil on paper. Present whereabouts unknown.

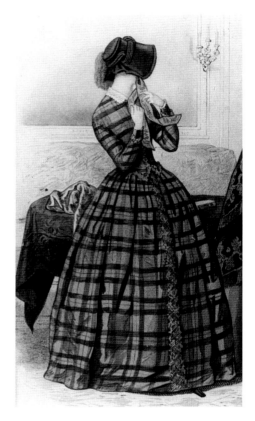

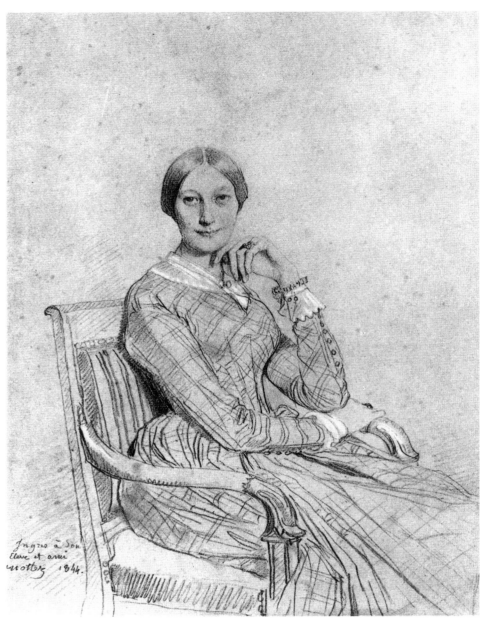

62 Detail of a fashion plate from the *Petit Courrier des dames*, 1846. British Museum, London. The modest plaid silk day dress echoes the simplicity of the costume worn in Ingres's *Madame Mottez* (pl. 61), and *Madame Gonse* (pl. 66).

dainty styles of the period. Hobsbawm's description of the appearance of women – 'fragile, egg-faced, smooth-hair-and-ringlet . . . tender flower in shawl and bonnet' – may be true in fact, but not in implication. Such values were established in the nineteenth century, as was the notion that a dark suit for a man indicated a serious mind, and that light-coloured and luxurious clothes for women were signifiers of frivolity. It is difficult today to reject these constructions placed on appearance, even though in the context of the late twentieth century they have become less relevant; even in the period under discussion the situation was more complex than historians sometimes imagine.

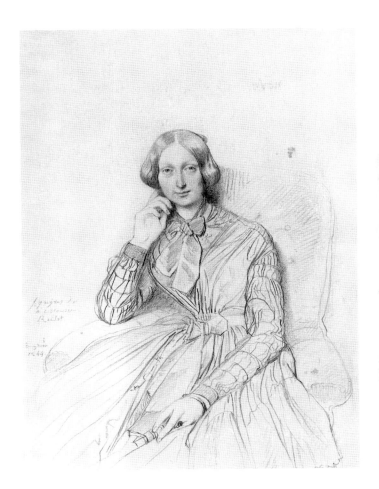

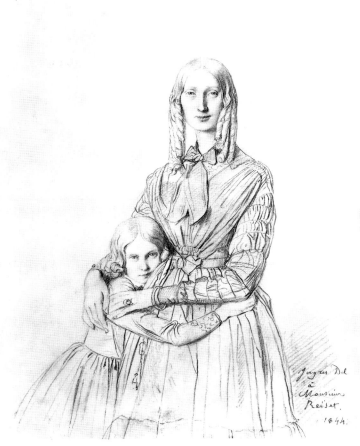

63 (*above left*) Ingres, *Madame Hortense Reiset*, 1844. Pencil on paper. Sir Brinsley Ford.

64 (*above right*) Ingres, *Madame Hortense Reiset and her Daughter Marie*, 1844. Pencil on paper. Museum Boijmans Van Beuningen, Rotterdam.

Conventional dress did not always indicate a conventional mind, even though it may have helped to make a less-than-conventional existence more acceptable. So, for example, Marie d'Agoult, mistress of the composer Franz Liszt (who introduced her to Ingres at the Villa Medici in 1839) was drawn by the artist (the portrait is now in a private collection in Paris) some ten years later in a high-necked modest day dress not unlike that shown in the *Madame Mottez* of 1844. In the latter we can see the creation of a new 'feminine' shape, with more focus on the bust and the use of darts to create a tight, pointed bodice that emphasized the waist. Another way to draw attention to the torso and to a fashionably small waist was to incorporate some form of pleated drapery into the bodice, as in Ingres's two portrait drawings of his great friend Hortense Reiset (pls 63 and 64). The two drawings were done at the same time, judging by the identical dress with its pleated bodice with tied bow and ruched sleeves, but perhaps not on the same day, as the hair is arranged differently.[27]

Fashionable outfits in the 1840s often consisted of a skirt with two bodices, one with long sleeves for day, and the other with short sleeves for evening; skirt and bodice had to be stitched together each time they were worn, and the style was known as a *robe à transformation*. By the mid-1840s, however, many women

Ingres, *Joséphine-Eléonore-Marie-Pauline de Galard de Brassac de Béarn, Princesse de Broglie*, *c.*1848–9. Pencil on paper. Private collection.

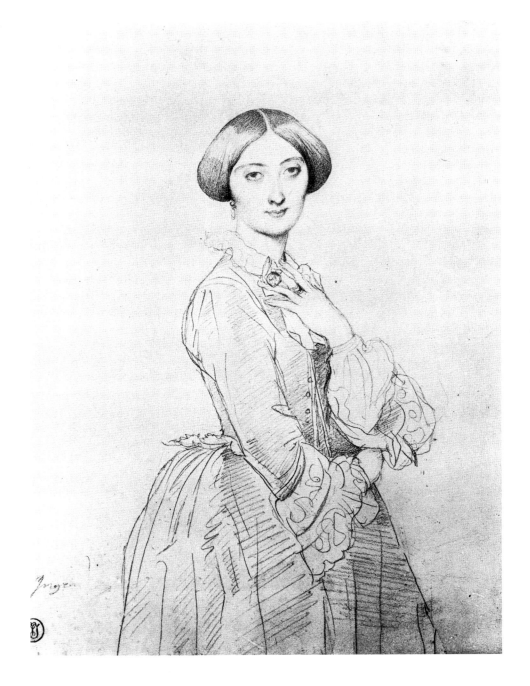

had adopted an overt bodice-and-skirt style of dress, made to be seen as two separate garments. Two informal day-time versions of this type of costume can be seen in Ingres's portrait of Madame Gonse (1845; pl. 66) and in the *Princesse de Broglie* of the late 1840s (pl. 65); both women wear simple front-buttoning bodices with small, neat whitework collars. By the end of the decade, the bodice-and-skirt style of dress was the rule for most occasions, although the one-piece dress, usually of light silk or cotton, continued to be worn for informal summer wear.

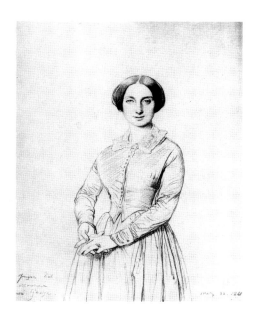

66 Ingres, *Caroline Maille, Madame Gonse,*
1845. Pencil on paper. Private collection.

Compared to the relaxed, layered look of dress in the 1830s, fashion in the 1840s demanded a more disciplined body shape with a taut line to the torso created by a seamed, often boned bodice, and tighter corsets; the size of the waist could also be visually diminished by the widening skirts of the decade. Aids to widen the skirts included hip pads and small bustles, but most important were the 'jupons en crinoline' or petticoats lined or woven with horsehair;[28] these provided fashionable bulk to the skirt as did petticoats of whalebone. Extra width could also be produced by adding flounces to the skirt; Ingres has sketched a large flounce in the portrait drawings of Madame Reiset. The fashion journal *Le Follet* noted in 1847, 'Flounces. Flounces. Flounces still, is the express direction given to the dressmaker at the present time; flounces in lace, or of the same material as the dress, either pinked, embroidered, or festooned with gymp.'[29]

Dresses were made increasingly luxurious and elaborate for evening wear, with a multiplicity of trimmings: 'lace is as necessary to female dress as the air is to flowers and birds', claimed the fashion magazine the *Petit Courrier des dames* in 1848, shortly after the first uprisings which marked the revolution of that year.[30]

In 1830 the July Revolution had not produced much change in dress, as one dynasty merely replaced another. But in 1848 the monarchy collapsed, and some commentators wondered if, as had been the case in 1792, there would be a new direction in dress towards republican simplicity. The situation was summed up by the *Lady's Newspaper* in March 1848:

> In Paris it seems to have been generally expected that the recent political changes would be followed by changes in fashion similar to those which attended the first downfall of the French monarchy. Indeed a revolution in costume has already been attempted by several of the leading Paris milliners; but the attempts have failed, and the object is confessed to be more difficult of attainment than the overthrow of a reigning dynasty. Fashion is, by common consent, allowed to be the most mutable of all sublunary things. This is true to a certain extent; but a very little reflection will suffice to demonstrate that the so-called *changes* of fashion are, in most instances, merely modifications of some particular style of dress that has been worn for a series of years . . . The Paris milliners have discovered that the bouleversement of an established regime in female dress requires more time than the overthrow of a monarchy.[31]

And so it turned out. In spite of a few half-hearted attempts to introduce what the *Lady's Newspaper* calls 'the hideous costumes of 1793' (these are not described), the fashion industry was so well entrenched in the nation's culture that no serious effort to introduce 'democratic' styles of dress in response to the current ideology could be contemplated. The *Petit Courrier des dames* may have noted an 'absence of luxury' and an 'elegant simplicity' in women's dress, but

the 'simple robe de tulle' worn by a woman of fashion would be made by Palmyre, one of the most famous *modistes*.[32]

Ingres's last series of portrait drawings, of the 1850s, reflects with renewed vigour the details of fabric, dress and trimmings in a period of luxury and extravagance in female costume. No doubt his second marriage in April 1852, to Delphine Ramel, encouraged a revival of interest in fashionable *toilettes*, for his wife was a relatively young woman. Looking at Ingres's beautiful portrait of his wife (pl. 67) drawn in the year of their marriage, the artist's pride in her comely appearance is apparent; Ingres's taste was for plump and maternal female beauty, and the second Madame Ingres was close in physique and temperament to his first wife. The 1850s was a decade when a full, rounded figure was in vogue, and Ingres's shining portrait of his new wife celebrates the generous proportions of her body clothed in a simple morning dress of lightweight silk (note how the line of the corset shows through it) and a fringed shawl. Ingres dwells on his wife's face and the glistening wings of her hair, and on the jewellery he may have bought her – touches of watercolour highlight her brooches, bracelet and rings.

Drawn with equal concentration – and with a sense of wry amusement – is the portrait of his mother-in-law, Madame Ramel (pl. 68). Well-upholstered like her daughter, Madame Ramel's dress is strained so tightly over her bosom that it creates horizontal creases which Ingres carefully delineates. Touches of white highlight her shrewd eyes, her firm humorous mouth and her prominent nose; they also add interest to such details of the costume as the lace cap tying with ribbons under the chin, the undersleeves of the bodice and the handkerchief she holds in her lap. As the skirts of fashionable dress grew wider in the 1850s, moving and sitting became more difficult to achieve with elegance, whether a woman was wearing flounced skirts, or the new cage crinoline of steel patented in 1856.[33] The critic Alphonse Karr denounced the excessive use of flounces as vulgar (because of the consumption of additional yardages of fabric and trimming), and time-consuming (because, he claimed, women spent ages adjusting and rearranging their skirts in case they became crushed).[34] Those (and there were many) who disliked the crinoline, claimed that it led also to a wasteful extravagance of materials; moreover, as Marie-Elisabeth Cavé complained, it disfigured the body, restricted a woman's movements and was uncomfortable to wear: 'All amiability and feeling disappears before this iron citadel, which settles itself on your feet, and scrapes your legs even when it doesn't rear up to graze your elbow.'[35]

The greater the fashionable distortion of the body through a hugely distended skirt (earlier examples include the late Elizabethan farthingale, and the mid-eighteenth century hooped petticoats) the harder it is to be at ease; Madame Ramel, for example, does not look at all relaxed in her vast dress, the flounces of which spill over the arms of her chair. The new massive appearance of fashionable women (massive in size but not in weight, for the steel frame of

67 Ingres, *Delphine Ramel, Madame Ingres*, 1852. Pencil and watercolour. Musée Bonnat, Bayonne.

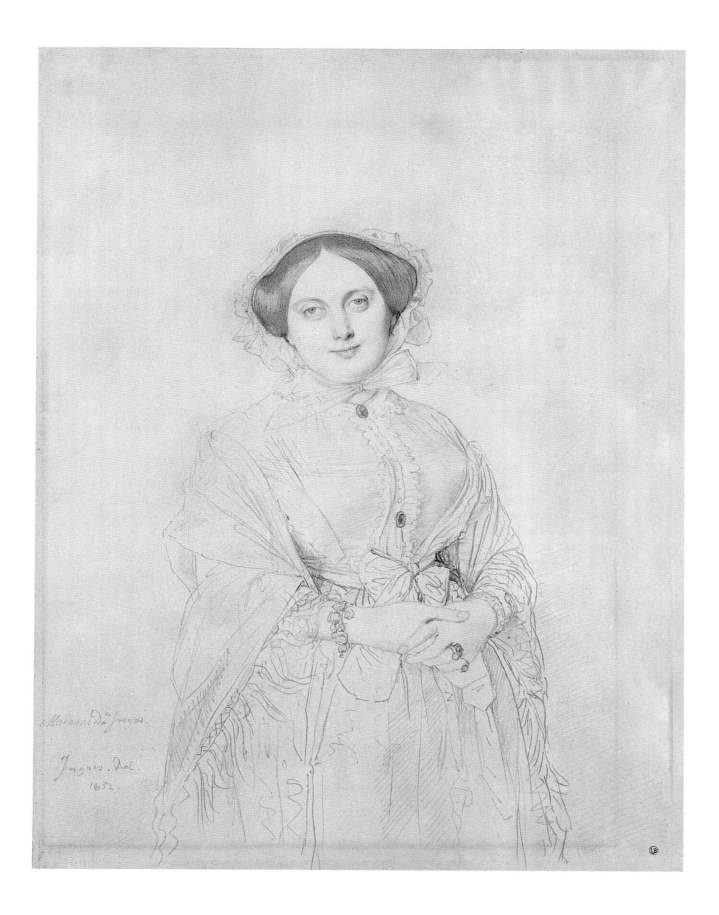

Madame D.... Ingres.

Ingres. Del.
1852.

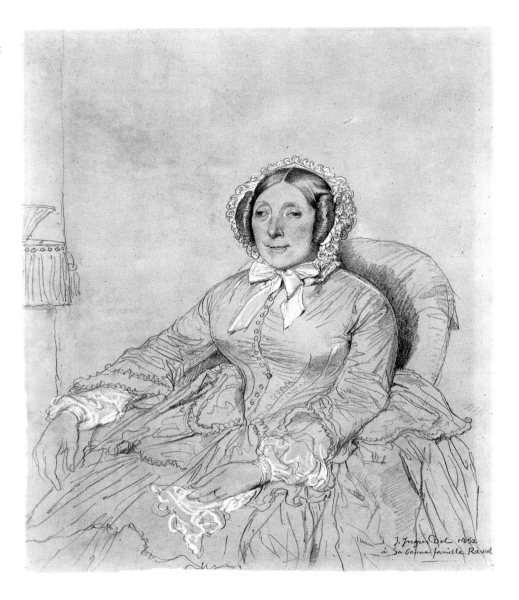

68 Ingres, *Delphine Bochet, Madame Ramel*, 1852. Pencil on paper. Courtesy of the Fogg Art Museum, Harvard University Art Museums, Bequest of Grenville L. Winthrop, 1943.

69 Ingres, *Nathalie Bochet, Madame Gallois*, 1852. Pencil and watercolour. The Metropolitan Museum of Art, New York, Robert Lehman Collection, 1975.

the crinoline dispensed with the need for horsehair petticoats) led to a rearranging of domestic and public spaces; doors needed to be widened as did carriages, and the circular sofa was introduced, and the ottoman, a padded seat with no back or arms on which women could perch like great overblown roses without crushing the fragile layers of their silk, tulle or organdie dresses.

Knowing how to control one's dress became a necessary art, and it was all too easy to be overwhelmed by the extravagant styles of the period, both in life and in art; in many of Winterhalter's portraits the fashionable *toilettes* dominate their wearers. In Ingres's beautiful drawing of Nathalie Bochet, Madame Gallois (pl. 69) there is no danger of this, for the sitter commands her stylish ensemble with ease. Posed with her right arm extraordinarily long (this is Ingres's slight fetish here again), she wears a flounced dress open at the bodice

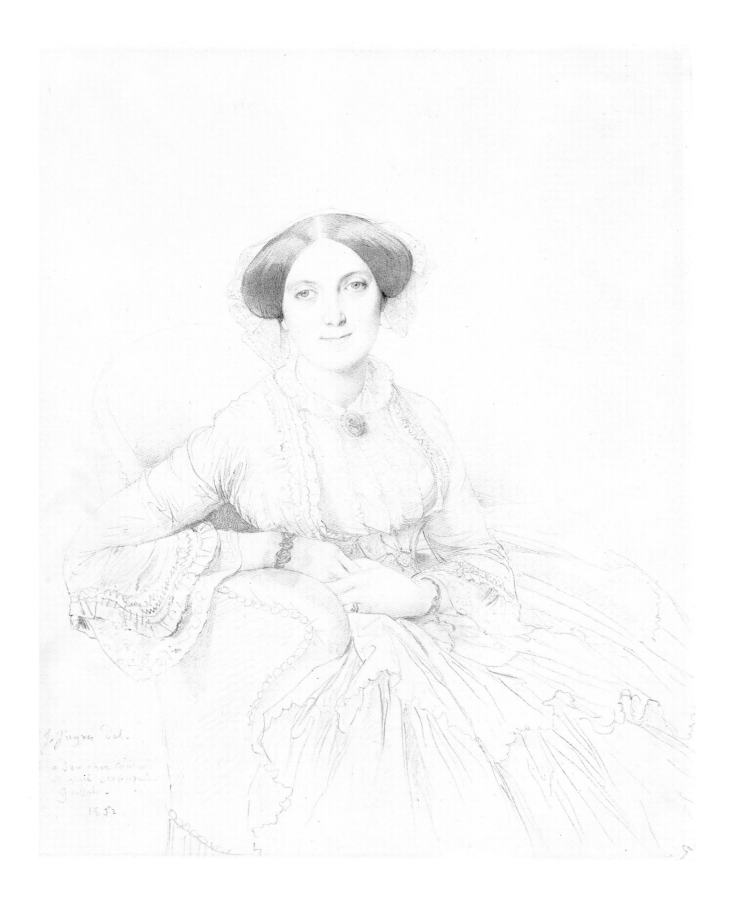

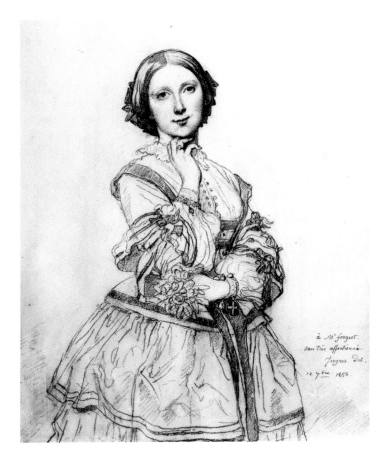

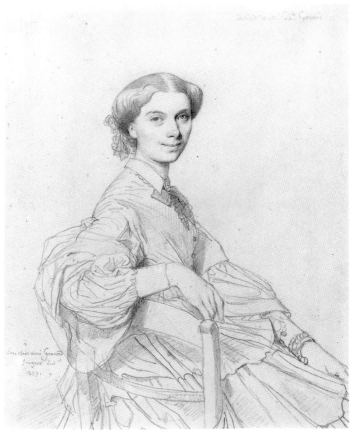

70 (*above left*) Ingres, *Cécile-Marie Panckoucke, Madame Tournouër*, 1856. Pencil on paper. The Detroit Institute of Arts, Founders Society Purchase, Anne McDonnell Ford Fund and Henry Ford II Fund.

71 (*above right*) Ingres, *Anna Zimmerman, Madame Gounod*, 1859. Pencil on paper. The Art Institute of Chicago, Gift of Charles Deering McCormick, Brooks McCormick, and Roger McCormick, 1964.

to reveal a kind of blouse (here the word is used in the English sense) trimmed with broderie anglaise; this new garment, according to the fashion journals, was known as a *gilet-fichu*.[36] In a style that was meant to evoke the eighteenth century, the sleeves of her dress flare out below the elbow (*à la pagode*, like a pagoda) over a lace under-sleeve. Another type of under-sleeve, pleated into a cuff at the wrist, can be seen in Ingres's portraits later in the decade, such as *Madame Tournouër* and *Madame Gounod* (pls 70 and 71).

By the late 1850s skirts were approaching their maximum width (this apotheosis was to be reached around 1860), particularly for evening wear. On such occasions, according to Gautier in *De la mode* (1858) women looked superb, their heads and shoulders emerging from a mass of rich materials, such as trailing cascades of antique silk moiré, or taffeta with double skirts and multiple flounces. Dressed like this, a fashionable woman, claimed Gautier, was 'aussi belle et aussi bien costumée que possible'.[37] The crinoline, which Gautier admired, was promoted by the couturier Worth and his most important customer, the Empress Eugénie; with its swaying, seductive motion, it features prominently in the work of such artists as Guys, Boudin and Monet, who revelled in movement – in women walking along the boulevards of Paris,

striding on the beach at Trouville or floating gracefully in tree-shaded gardens.

Ingres is not an artist for whom action is important; his metier is stillness, in capturing moments of repose and quiet contemplation. In his portrait of Madame Anna Gounod of 1859 (pl. 71), the wife of the composer (to whom the drawing is dedicated) turns right round in her chair to engage the attention of the spectator or in reaction to something the artist might be saying to her. She wears a modest and decorous version of the flounced and crinolined mode; the only touches of decoration are a small brooch fastening a ribbon tie at her neck and the coiled bracelet on her left wrist. A more elaborate outfit is worn by Cécile-Marie Tournouër in 1856 (pl. 70), the grand-daughter of Madame Panckoucke whom Ingres had painted almost fifty years before; the drawing was probably done just after her marriage. This is a costume suitable for paying formal visits on return from honeymoon; it is a stylish silk bodice and skirt trimmed with ribbons and velvet braid. The sentimental jewellery – the bracelets with a heart and a cross – would be thought appropriate to a new bride. One writer has commented on 'the quiet richness of her gown and the arch grace of her glance', claiming with some justification that this is one of Ingres's most beautiful and delicate drawings: 'In this portrait we find the essence of simplicity, the reserve and the lack of expressiveness which Ingres and his contemporaries so admired in antique sculpture, and which his society adopted as its ideal of femininity'.[38] Although some exceptions could be made to this statement (portraits, usually, of older women where character is the dominant feature) this is a judgement to agree with. In the way that books of etiquette, and indeed fashion plates, seek to present and define society as the sum of conventional behaviour and cultural aesthetics in which the individual is subservient to the general, so Ingres in his portrait drawings searches for the perfect and ideal woman. But as well as the idea of Woman, Ingres has to concern himself with the individual woman; over more than fifty years he uses fashion, either in detail or lightly suggested, to create the transitory as well as the eternal. In so doing, Ingres provides an intelligent survey of the modes of his time, the costume that was actually worn.

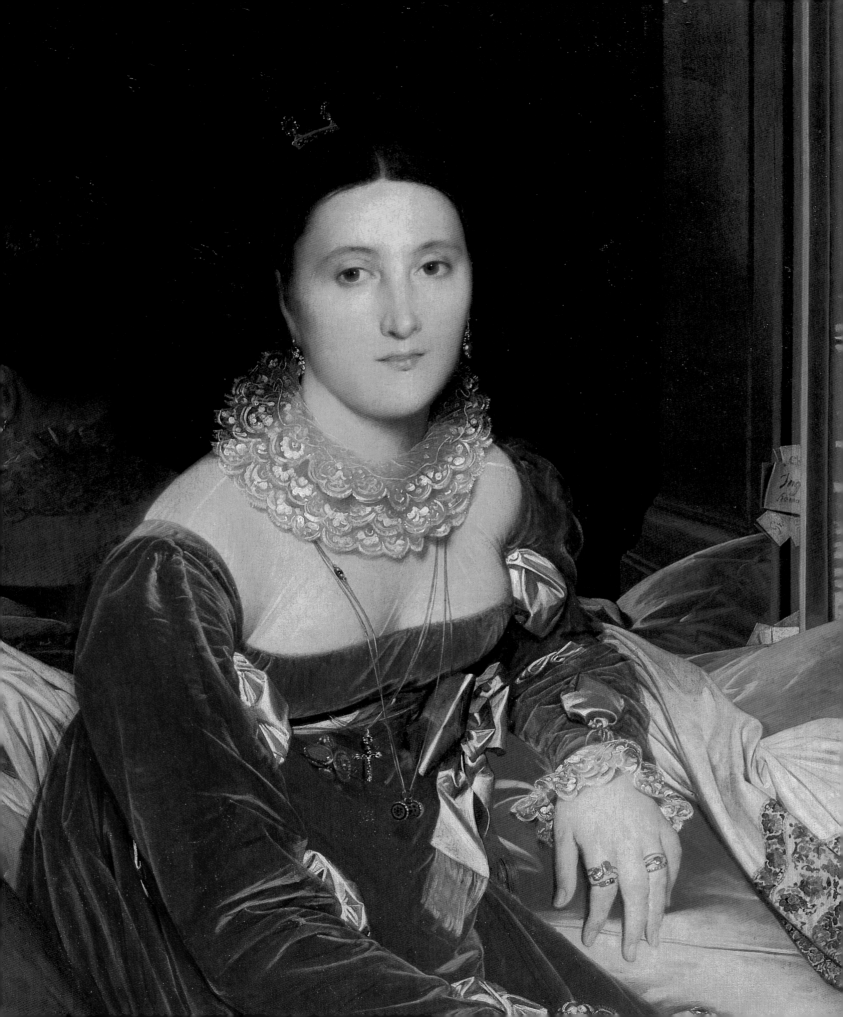

Painted Ladies

HAVING LOOKED AT THE PORTRAIT DRAWINGS to illustrate the radical changes in fashion over Ingres's long career, it is time to turn from the artist as draughtsman to the artist as colourist, and in particular to the painted portraits, which describe in a far more sustained and concentrated way the individual woman and her appearance.

As a logical extension to a discussion of Ingres's drawings, many of which in his early years depict 'women in white', the first chapter of this part looks at painted portraits of fashionable sitters in white. White and black were the two crucial colours in the female wardrobe in the nineteenth century (Maison Worth, for example, had a room devoted to just black and white textiles) and marked key moments in the lives of girls and woman. Black, however, was not seen simply as a mourning colour, but as high fashion, and under the heading 'women in black', Ingres's use of black is discussed.

We have seen how Ingres's use of colour was criticized in his work and how many critics unthinkingly followed the conventional thinking that the artist's talents were not those of colour but of line. But Ingres in his portraits of 'women of the world' reacted instinctively and with sensual appreciation to the wide range of colours and fabrics in fashion throughout the period, from First Empire to Second Empire.

Finally, as Ingres was an artist with a remarkable sensitivity to the ways in which the female appearance was enhanced by accessories, which were not only luxury objects in their own right but also contributed to pose and gesture in portraiture, the last chapter briefly regards the 'still lives' of such items as gloves, shawls, fans and jewellery which played their part in the fashionable female existence.

72 Detail of pl. 107.

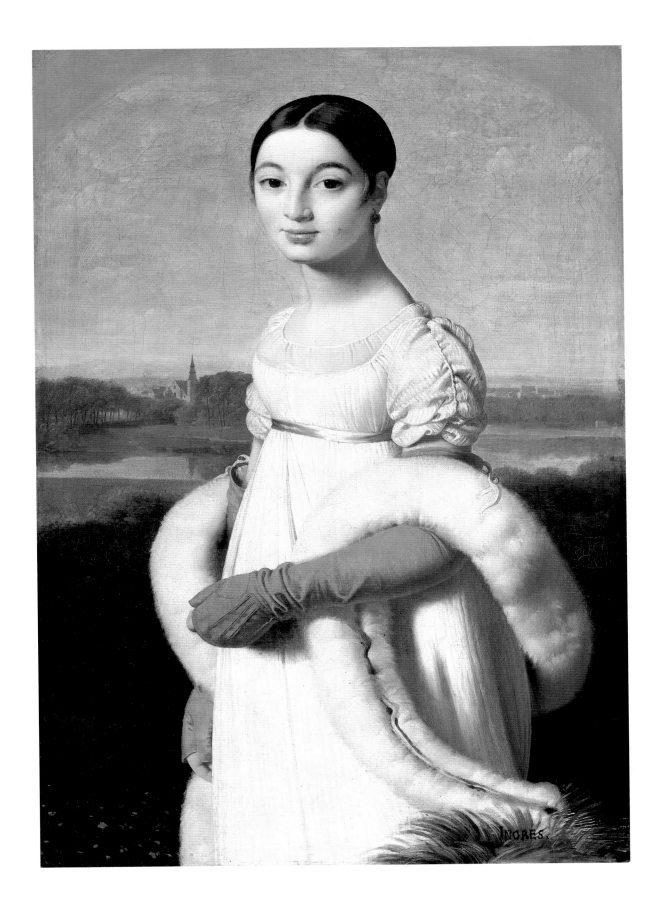

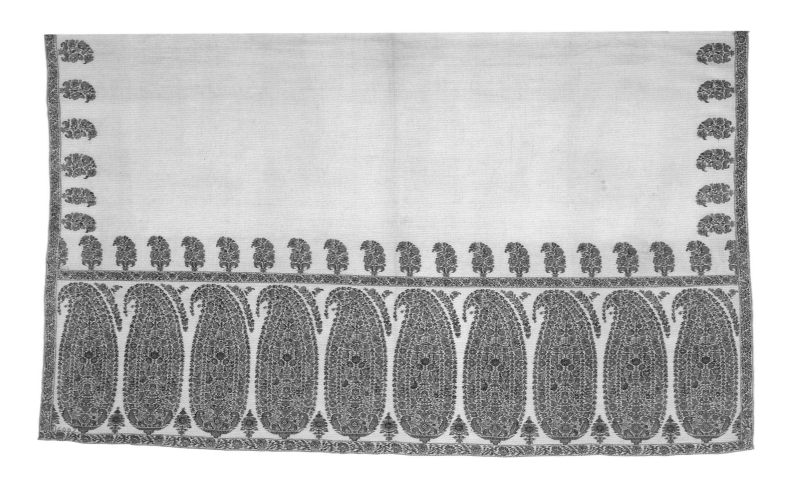

77 Detail of the border of a cashmere shawl of about 1815. Department of Costume and Textiles, Philadelphia Museum of Art: Gift of Miss Lena Cadwalader Evans. The predominently red and green pattern on a cream-coloured ground is similar to that seen in the shawls worn in Ingres's *Madame Rivière* (pl. 78) and *Madame de Tournon* (pl. 105).

78 Ingres, *Marie-Françoise Beauregard, Madame Rivière*, 1806. Oil on canvas. Musée du Louvre, Paris.

of the sofa, the silk gauze of her over-dress which can best be seen where it forms a puffed sleeve on her left arm, and the satin of her under-dress which matches the ribbon girdled under her bust; note also the tiny detail of the fine embroidery edging her shift, which can just be seen at the neckline.

The stylish dress and the graceful pose of Madame Rivière is made even more explicit by the wonderful cashmere shawl encircling her body. When the portrait was bought by the State in 1870 it was known as 'la femme au châle'; it is the shawl, as Jean Alazard points out, which 'becomes almost the soul of the painting'.[7] 'What a shawl!', exclaimed Lapauze, the first that Ingres committed to paint, and 'just one verse of the long feminine poem which vibrates throughout Ingres's work'.[8] The shawl is a pale biscuit-coloured Indian cashmere with a woven pattern down the sides, and a deep border depicting the popular 'pine-cone' motif; the predominant colours of the design are shades of red, which heighten the whiteness of the dress and the sitter's glowing complexion. Hélène Toussaint has recently noted that among the items listed on the inventory of Monsieur Rivière's possessions (he was an ambitious lawyer and civil servant whose attractiveness – and self-appreciation – is demonstrated in the portrait by Ingres also exhibited in the 1806 Salon) were

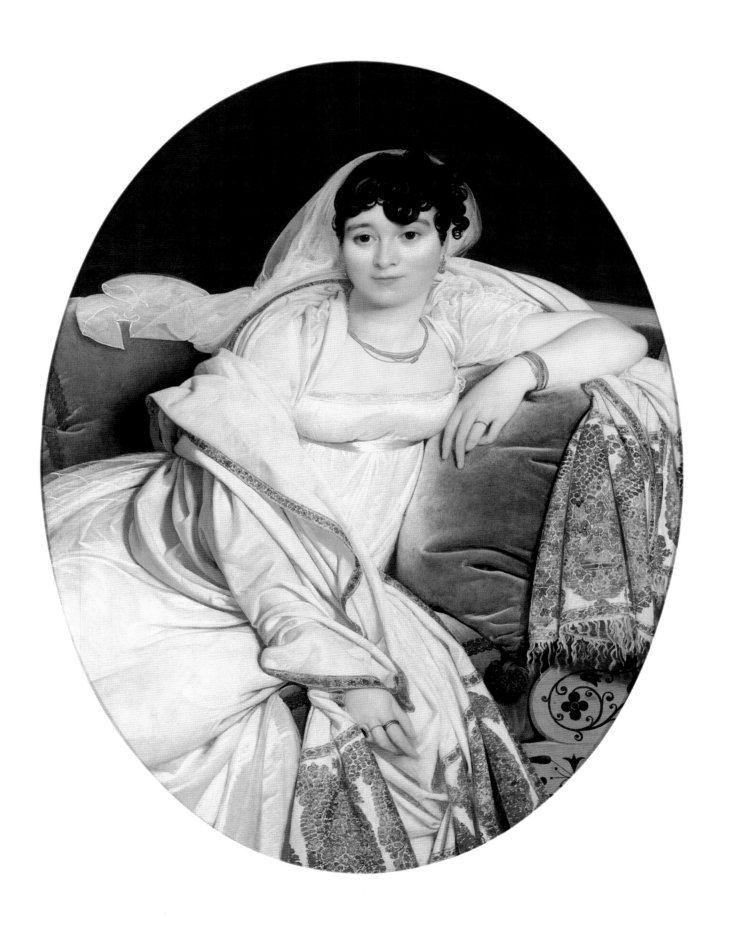

'schalls de cachemire blancs et ponceaux' (white and poppy-coloured cashmere shawls); Toussaint suggests that these shawls may have been intended as gifts to his wife, possibly to compensate for his infidelity.[9]

This can only be speculation, and certainly in her portrait Madame Rivière looks composed and stylish as she sits lapped in luxury while Ingres records all the details of her appearance, not just her dress, but her hairstyle (coiling black curls, lightly oiled and arranged *à l'antique*)[10] and also her jewellery. In 1806, when the portrait was exhibited, it was only a few years since the Terror of the French Revolution, when any sign of ostentation in dress and adornment was politically imprudent at best, and dangerous at worst; so women evolved a dress whose white simplicities spoke of heroic times and classical virtues, and where jewellery, if worn, consisted of modest and understated designs. Madame Rivière conforms to the prevailing neo-classical orthodoxy in her jewellery – a necklace of thin plaited gold entwined with another, longer chain of fine gold where the clasp has been brought round to the front; her bracelets are very fine gold links, and her rings are narrow bands of gold (including her wedding ring) and fashionable black enamel inscribed in gold.

A few years only separate *Madame Rivière* from *Madame Panckoucke* of 1811 (pl. 80), but Ingres has moved from the sumptuous to the simple, from the sensuous appreciation of a pretty woman surrounded by *objets de luxe*, to an image of a plainer sitter with a correspondingly stark background; the pose – one hand fingering the other, gloved, hand – looks as though it has been borrowed, perhaps not too successfully, from a male portrait. Ingres has chosen not to seek refuge from potential anatomical troubles by covering Madame Panckoucke's neck and bosom (the awkward join of Madame Rivière's left arm to her shoulder is disguised by the transparent sleeve of her dress); the spectator is left viewing a curious lop-sided bosom and an exaggeratedly sloping shoulderline.

Yet the concentration by the artist on the details of dress and accessories is, if anything, more intense than in the earlier portrait. The dress, which Madame Panckoucke has just put on (it retains the creases from where it has been packed in a drawer or a chest), is of thick, heavy, lustrous satin; Ingres's by now increasingly expert eye for the telling details of dressmaking, records how the silk has been pleated unevenly into the edge of the puffed sleeve, and the way in which the bodice must be lined inside to help create the lightly puckered 'compartments' for each breast. It is a style of dress that emphasizes such feminine characteristics as the bust and the swelling stomach of a pregnant woman, the latter effect easily created by the high waistline and the shining expanse of fabric stretched over the rib-cage and belly. As a foil to the relative simplicity of the dress, the sitter is shown carrying a cashmere shawl striped in cream and coral, and wearing coral jewellery – pendant earrings, one necklace worn in the conventional place, and another wound round her wrist as a bracelet, perhaps at the suggestion of the artist.

79 Fashion plate from the *Journal des dames et des modes*, 1810. British Museum, London. The striped shawl, probably cashmere, is similar to that in Ingres's *Madame Panckoucke* of 1811 (pl. 80).

80 (*facing page*) Ingres, *Cécile Bochet, Madame Panckoucke*, 1811. Oil on canvas. Musée du Louvre, Paris.

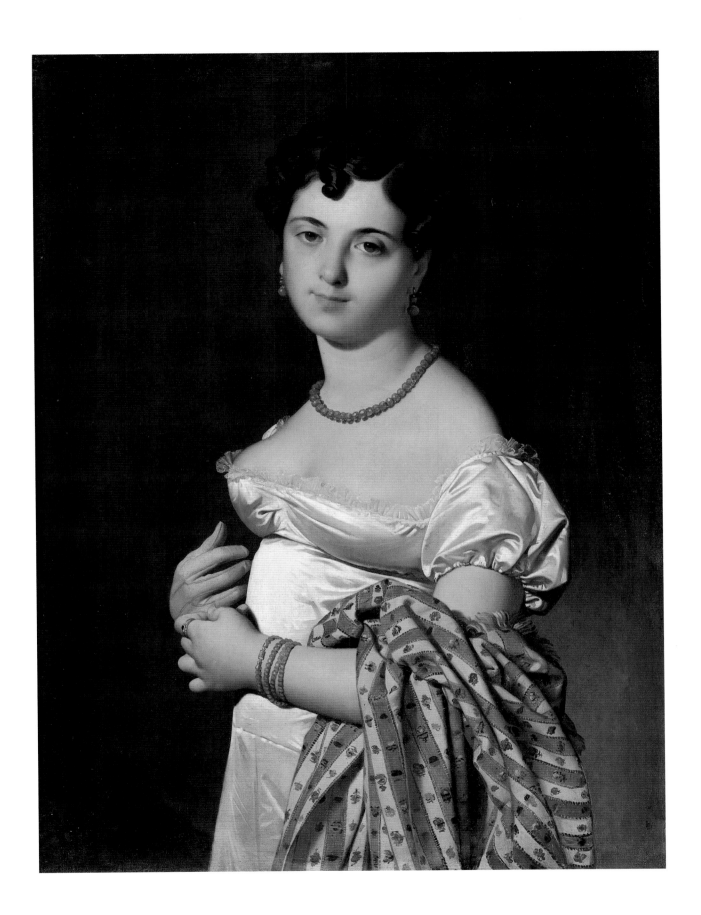

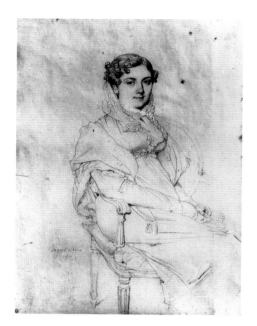

81 Ingres, *Cécile Bochet, Madame Panckoucke*, 1811. Pencil on paper. Musée Bonnat, Bayonne.

By this time in his career, Ingres had begun to make a number of drawings relating to the painted portraits (none has survived for Madame or Mademoiselle Rivière); as his career progresses there are greater numbers of preparatory drawings in existence. This may be due to the accidents of history (in that more such drawings survive as his fame grew), or because Ingres in his later years found painting portraits more demanding than in his youth, and took more trouble in getting pose and costume right. It is not always clear how far some of the portrait drawings relate specifically to a painted portrait of the same sitter or were to be considered as an end in themselves; in the latter case Ingres usually signs them. Thus, his portrait drawing of Madame Panckoucke (pl. 81), although dated the same year as the painting, may be unconnected to that work. But some elements are common to both images, such as the fringed shawl, and the curls arranged *à l'enfant*, part of the cult of youth that informs fashion in this period; such a hairstyle looks not unlike the home perms of the 1950s. In the drawing Madame Panckoucke wears a long-sleeved day dress, probably of white cotton; it might very well have been the kind of costume she would have worn for her first sitting to the artist, after which – as was usually the case – Ingres then decided that a more formal dress was suited to the finished painting.

There are no more painted portraits of women in white by Ingres from then onwards. Perhaps he felt he had proved his skills in this respect with the ethereal perfection of the Rivières' *toilettes*, and the substantial tactility of Madame Panckoucke's costume. White was, however, a colour associated with the neo-classical styles of the First Empire, and to some extent it lost its position at the cutting edge of high fashion in the years following the Restoration,[11] although of course it was retained for weddings, for young girls and for the kind of informal cotton dresses that Ingres depicts in his portrait drawings of the 1820s and 1830s. In the 1850s white returned to favour for formal wear, under the aegis of Worth. Worth had begun his career in the late 1840s by making plain white muslin dresses as 'backgrounds' for the mantles and the shawls which his employers, the firm of Gagelin, sold in their mercer's shop, and these gowns became popular in their own right, ordered by Gagelin's fashionable female customers. Setting up on his own some years later, Worth made a name for himself with white evening gowns, most spectacularly of tulle, of the kind to be seen in the canvases of such society artists as Winterhalter. Moreover, the court of the Second Empire required women to wear white at formal presentations, and court designers were kept busy with variations on a theme – white silks – tulle, satin, velvet and so on. Ingres did not need commissions from society women wearing Worth *toilettes*; indeed, once he was established in France in the mid-1820s he seems never actively to have sought clients. His interest was to create portraits where the dress was not a particular type (such as court costume) denoting the aristocracy, although a number of his sitters came from that milieu, but where it underscored character and had its own individual appeal.

82 Detail of pl. 80.

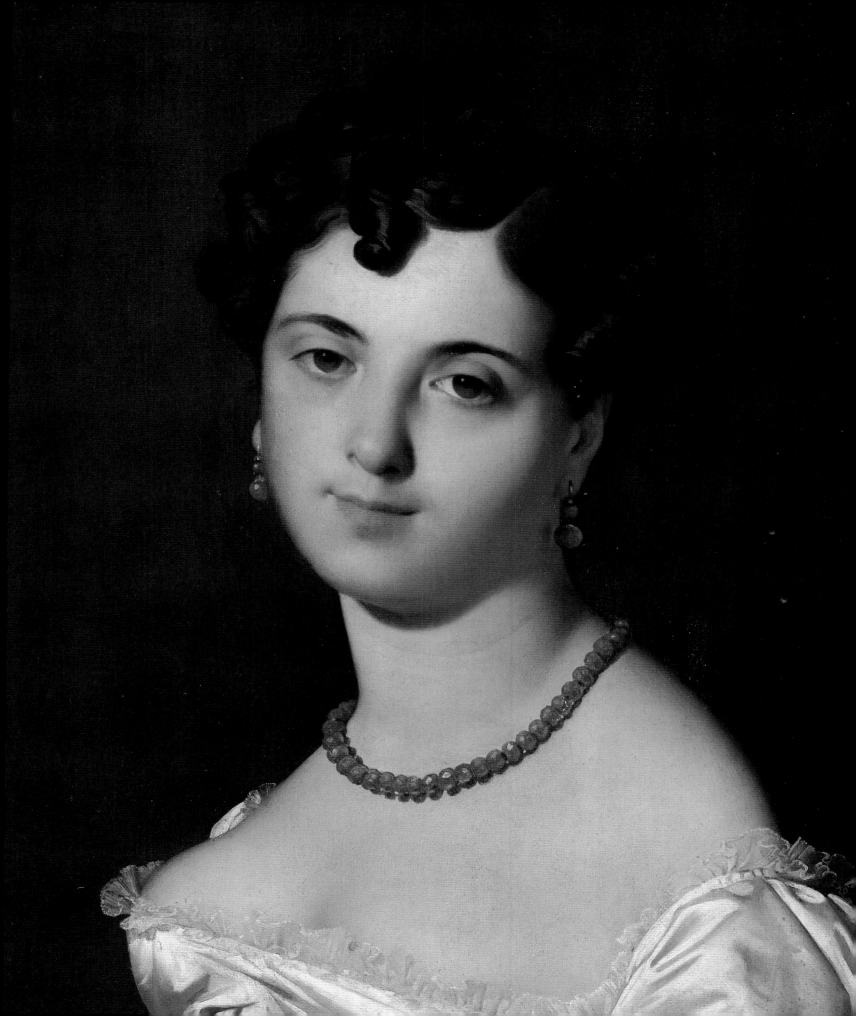

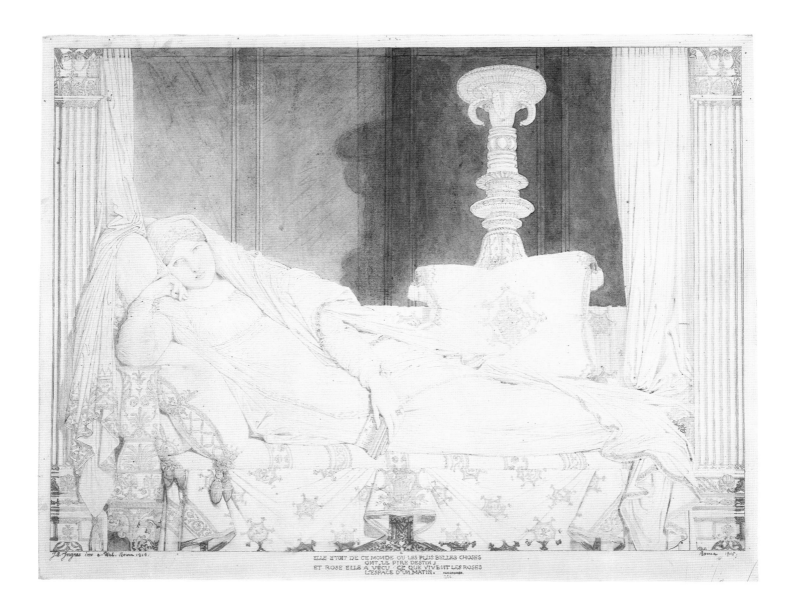

ELLE ETOIT DE CE MONDE OU LES PLUS BELLES CHOSES
ONT LE PIRE DESTIN ;
ET ROSE ELLE A VECU · CE QUE VIVENT LES ROSES
L'ESPACE D'UN MATIN ·

83 Ingres, study for 'The tomb of the Lady Jane Montagu', 1816. Pencil with ochre wash, pen and brown ink on paper. National Gallery of Victoria, Melbourne, Felton Bequest.

As a kind of coda to Ingres's women in white, his beautiful and melancholy drawing of Lady Jane Montagu (pl. 83) should be briefly mentioned, for it encompasses some of the artist's favourite themes – a beautiful young woman lying like an odalisque in a pose that was also reminiscent of classical antiquity. Ingres's design for a monument to Lady Jane, who died in Rome in 1815, recalls the full-length recumbent figures 'asleep' on their tombs of the classical past; it was also based on a sight of Lady Jane reclining in this way, and possibly also inspired by the portrait of Madame Récamier. White was by long tradition a colour of mourning as well as of youth and marriage. White denoted youth before the transition to the adult world of colours; in a similar way it was worn as mourning to signify a life bleached of colour and bereft, at least temporarily, of meaning.[12] Ingres depicts Lady Jane in a dress that incorporates the fine

white draped muslins of contemporary fashion, and also the pleated tunic or *chiton* of ancient Greece. Enveloping her from top to toe is a long mantle with embroidered edges; this serves as a mourning veil, and points the way towards the shroud of death.

It is a portrait that both contemplates the sadness of early death (the sitter was only twenty) and yet celebrates the beauty of a young woman never to achieve the sexuality of adulthood, although she reclines like an odalisque. To Ingres – as to so many artists – white as a colour was both virginal and seductive. It stood for childhood, for innocence, for the sanctity of marriage, for degrees of mourning. But white is also the colour of the garments closest to a woman's body: white shifts slide off the bodies of Ingres's odalisques and reveal the nakedness of his bathers. Black, on the other hand, is a more worldly colour; unlike white, it features throughout Ingres's career as an artist of fashion.

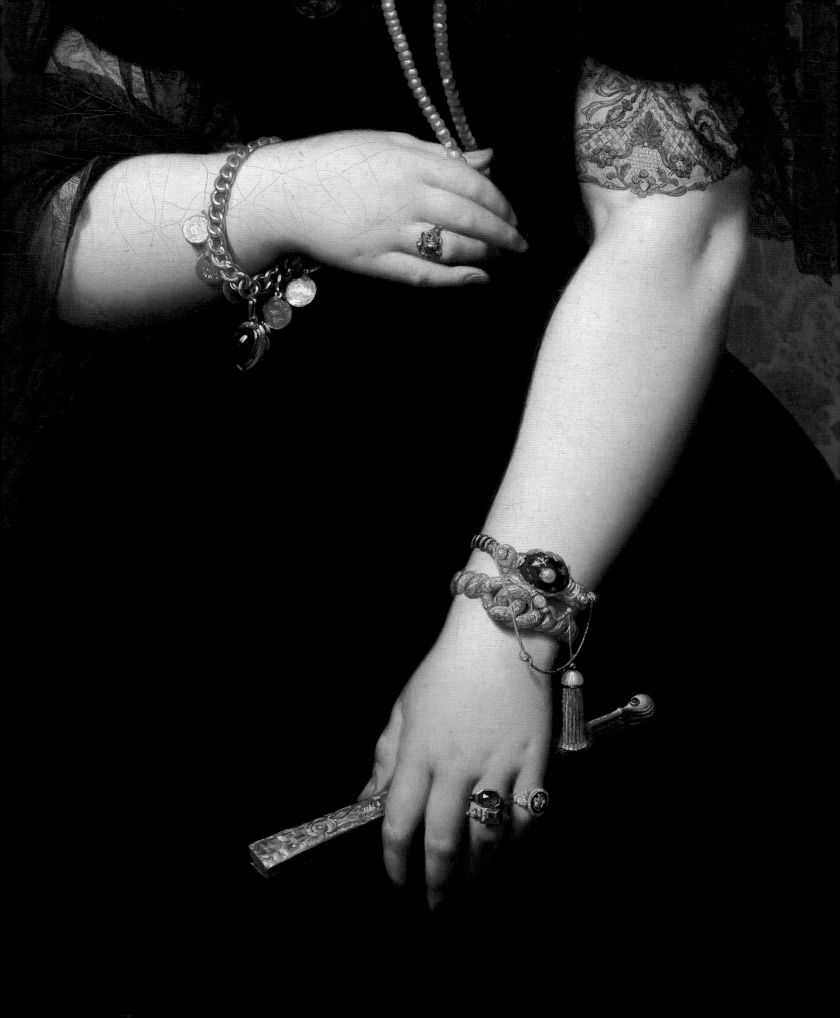

6 Women in Black

Parisian women, by what means no one knows, manage to possess lovely
contours . . . Her dress, of black velvet, seemed about at any moment to
slip from her shoulders . . . She was like those luscious fruits, arranged
enticingly on a fine plate, which make the very metal of the knife-blade
ache to bite into them.

Honoré de Balzac, *Cousin Bette* (1847)

BLACK HAS ALWAYS BEEN A COLOUR of immense significance in the history
of dress. Black clothes were expensive, for the dyes used were costly; a poor-
quality dye produced cloth of uneven colour which quickly faded, but a good
dye enhanced the lustre of fine cloth, whether of silk or wool.[1] Throughout
history, black clothes usually indicated rich but unostentatious consumption,
whether one looks at the sober but costly silk damasks, velvets or woollen stuffs
seen in portraits of seventeenth-century Dutch burghers, or at images of
nineteenth-century English gentlemen in suits of fine black cloth. Black
created an impression of gravitas; it was the colour of officials and dignitaries;
it was the colour of ruling castes such as the élite of the city-state of Venice and
the merchant oligarchy of The Netherlands. Black was the colour worn by
clerics, by lawyers and academics as part of a collective wish by society that
sobriety should mark its formal dealings. Whereas bright colours denoted too
great a concern with the mutability of fashion, black came to signify the *status
quo* of officialdom, the familiarity of the unchanging.

Professional occupations were, in most European societies, a male preserve,
outside the experience of women. This is not to say that women were excluded
from wearing black; from the late medieval period onwards, many women
from all classes in both city states and nations, wore black for a variety of reasons
– because of sumptuary legislation, or religious custom, or conventions that
dictated the appearance, for example, of older women, and so on. At a more
basic level, black was a practical colour which did not show the dirt as much as
lighter colours; this was a necessary consideration in a period when personal
hygiene was not a simple matter, and laundry facilities were limited.

When we think of black for women in the nineteenth century, we think
mainly of mourning. Black had assumed this connotation from the late Middle
Ages; in earlier periods it was too expensive a dye, and as a sign of grief and
indifference to the world, shades of brown or grey – the colours of humble,

84 Detail of pl. 98.

woollen stuffs as they came directly, undyed, off the loom – were often worn. As funerals became more elaborate by the early modern period, a hierarchy of mourning appeared, and by the nineteenth century mourning was as restrictive as the sumptuary laws of earlier times. The general principle of mourning was to begin with the wearing of such dull, matte fabrics as wool in the darkest of black dyes, then to move to lighter fabrics, such as some types of silk or silk-and-wool mixed cloth but still in black, and finally to a wider range of materials where black could mingle with white or grey, or where shades of lavender or purple could be worn. There were varying periods of time for mourning, depending on the closeness of the deceased; etiquette manuals provided information of this kind. In addition, one of the functions of the more 'establishment' fashion magazines was to outline what people were expected to wear in the way of court mourning,[2] and which tailors, dressmakers and shops made this a part of their business. Women, as guardians of hearth and home, were expected to spend more time in mourning than men; the period of mourning was considerably longer for a widow than for a widower, and many widows (Queen Victoria being the most famous example) spent the rest of their lives dressed mainly in black. It was the task of women to arrange mourning for the whole household, including servants; Alphonse Karr in his widely read work *Les Femmes* (1853) was not necessarily being sarcastic at the expense of women when he described how they could find comfort in alleviating the misery of death by attention to the details of the various stages of mourning, and by ordering the different materials that specialist shops supplied.[3]

Black has never been out of fashion as a colour that women like to wear as fashion; apart from its traditional connotations of dignity and formality, black flatters the majority of women by making them appear slimmer than they are, by acting as a foil to the whiteness of the skin and by setting off accessories and jewellery. It was for such reasons, whether stated or implied, that many of Ingres's sitters chose to wear black for their portraits, or else agreed with the artist's suggestion that they should do so.

Ingres's earliest portrait in black is *Madame Devauçay* of 1807 (pl. 86), the Neapolitan mistress of Charles Alquier, a French diplomat in Rome. Painted shortly after Ingres's arrival in Rome, the portrait marks a dramatic departure from the neo-classical Rivières towards the influence of the Italian Renaissance. It is clear that Ingres had already looked long and hard at portraits by the Old Masters; it was the beginning of his love-affair with artists of the early sixteenth century, and not just Raphael. Madame Devauçay's square-necked dress of black velvet and her long necklace of hair set in gold links reminds one of an earlier drawing made by Ingres, a copy of the so-called Leonardo, '*La Belle Ferronnière*' (pl. 85). The drawing was inscribed to David, and was probably done while Ingres was his pupil, or shortly afterwards. While the structure of the original dress has not been perfectly understood (it is not

85 Ingres, '*La Belle Ferronnière*'. Black chalk, stump and wash. The Barber Institute of Fine Arts, University of Birmingham.

86 (*facing page*) Ingres, *Madame Antonia Devauçay de Nittis*, 1807. Oil on canvas. Musée Condé, Chantilly.

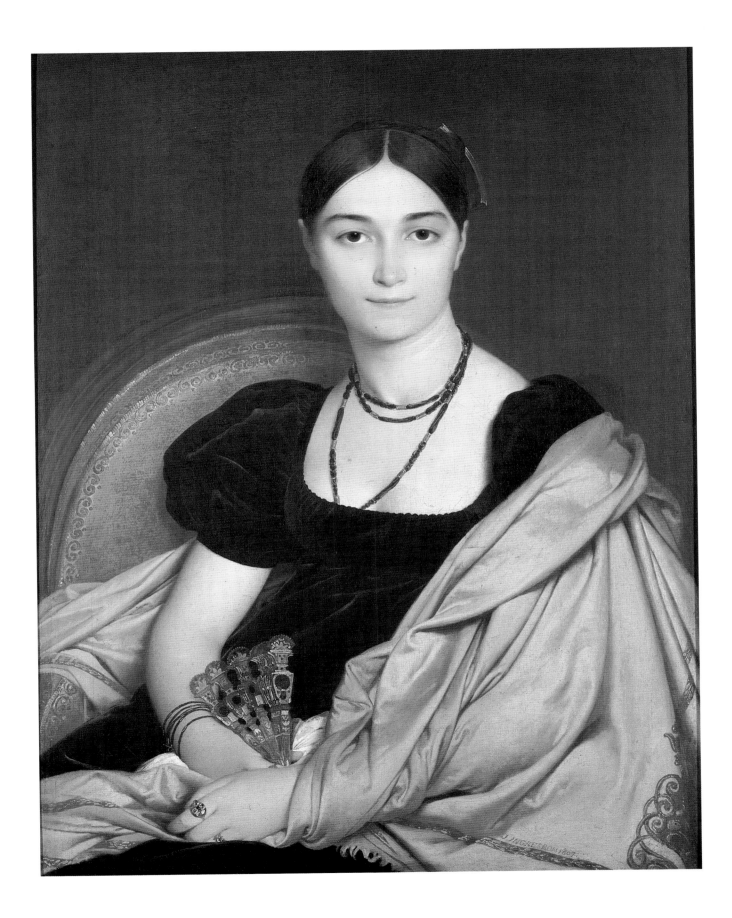

clear, for example, what Ingres is depicting to the right of the sleeve), the feel of the early sixteenth century is clearly expressed. The tied-in sleeves with puffs of extra material (i.e. the linen shift under the dress, which is revealed at the top of the arm) serve to create a break in the shoulder area, and inspired such 'Renaissance' features in Ingres's portraits as the small 'epaulette' or upper sleeve in the drawing of Countess Apponyi (pl. 48) or that of Madame Leblanc (pl. 95); the sleeves of Madame de Senonnes's dress (pl. 107) are decorated with silk puffs in imitation of the style seen in 'La Belle Ferronnière' and other contemporary works.

It is probably fair to assume that the self-confident young artist created the pose and the dress (as he did with the Rivières) right from the start; the finished painting shows hardly any alteration from the related drawings.[4] While some critics complained of faults in Madame Devauçay's anatomy – the bonelessness of her right arm and the inordinate length of her left arm, which is hidden beneath the shawl – the general consensus was that Ingres's portrait was a *tour de force*. Delécluze, seeing the portrait in the Salon of 1833 thought of Dante's Beatrice, and Gautier declared that Leonardo himself could have painted it. Lapauze remarked that Madame Devauçay was the sister of the Mona Lisa, and with her intense and enigmatic gaze one can see the connection, heightened, as suggested above, by Ingres's choice of Renaissance-style costume, and the sitter's hair parted in the centre *à la madone*.

Gautier was particularly impressed by the almost frightening intensity of the portrait, with its penetrating black eyes, the faint smile on the lips and the perfect insouciance of the gesture with which she holds the tortoiseshell fan.[5] At the same time as Gautier describes the portrait, in 1855, the critic About also went into raptures about it; he found it one of Ingres's most admirable works:

> Never has M. Ingres drawn anything so pure; never has he succeeded so well in depicting the inner flame which is called life. All the sun of Italy glows on the satin skin of Mme D . . . Her black eyes shine like Alençon diamonds, and her red lips have a strange fascination . . . Her breast, enclosed in one of those frightful Empire bodices, struggles energetically against its prison. It cries, like Sterne's starling: *I cannot go out*! [sic] But even with its awkwardness, the costume has a divine grace . . . This is not just a portrait which gives pleasure, it's a portrait which makes one dream . . .[6]

Despite the 'frightful' costume, then, About declared that Ingres's early portraits were better than those of his later years. This is a judgement with which many subsequent commentators, and perhaps even more today, would agree. This preference may have to do with Ingres's immediacy of perception; the relative speed at which he assessed the pose and the dress gives these portraits an almost spontaneous appearance, deceptive though this is in terms of the work involved in the execution of the paintings. It may also have something to do with the style of costume, the simple high-waisted lines of the

87 Detail of pl. 86.

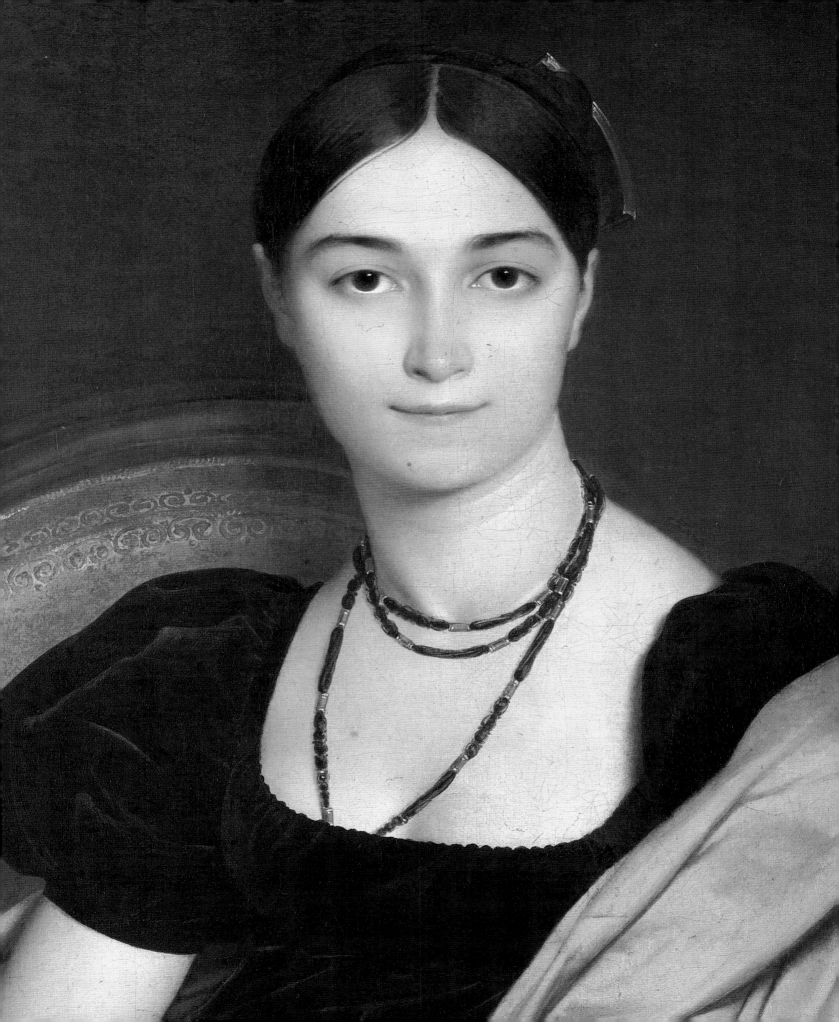

88 Detail of a fashion plate from the *Journal des dames et des modes*, 1813. British Museum, London. The tall-crowned black velvet hat trimmed with ribbon and ostrich plumes is similar to that seen in Ingres's portrait of the Queen of Naples, 1814 (pl. 90).

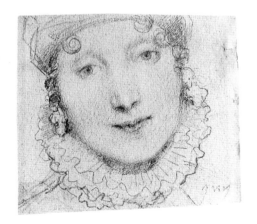

89 Ingres, study for the head of Caroline Murat, Queen of Naples. Pencil on paper. Musée Ingres, Montauban.

90 (*facing page*) Ingres, *Caroline Murat, Queen of Naples*, 1814. Oil on canvas. Private collection.

dress, against which a few carefully chosen accessories can make maximum impact. This is certainly the case with *Madame Devauçay*, where the rich black velvet of her dress is a perfect complement to the superb yellow embroidered cashmere shawl that the sitter wraps round her arm in a similar way to Madame Rivière.

Velvet reminded contemporaries of Renaissance luxury, as it still does today, and it was a fabric that Ingres loved to paint, not just for its historical resonance, but because of its tactility; he was particularly deft at catching its slight shine and the furry pile of the silk. It seems quite likely that Ingres, even as a young artist, could dictate the choice of dress his sitters wore, and in these early years it was often velvet that he decided upon, as can be seen in his portraits of the comtesse de Tournon and the vicomtesse de Senonnes. However, with the portrait of Ingres's grandest client, Caroline Murat, Queen of Naples, of 1814 (pl. 90), it would have been the sitter who selected her own costume. Napoleon's youngest sister (wife to Joachim Murat who was made King of Naples in 1808) is shown in sweeping black velvet trimmed with lace, a ruff of black tulle and a feathered satin hat or *casque à la Minerve*. Queen Caroline was famed for her lavish expenditure on dress and for her elegant style – the Empress Josephine's daughter Hortense de Beauharnais remarked that she had the seductive grace of an odalisque; this is evident even within the confines of a rather stiff and formal portrait and despite the faintly ridiculous hat, supposedly akin to an antique helmet and part of the vogue for the neo-classical in dress. A more flattering headdress, possibly a turban, can just be seen in Ingres's drawing of the queen's head (pl. 89), one of a number of drawings of the sitter that possibly relate to the finished portrait.[7] In this drawing Ingres has indicated the same style of earrings (*à la girandole*, like a chandelier) as well as the ruff that she wears in the painting; her slightly imperious appeal is also well conveyed.

It seems likely that the queen wears black as mourning for the ex-Empress Josephine, who died in May 1814; the complete black of the ensemble, and the diamond jewellery (no coloured stones were permitted for mourning) would support this suggestion. Although Napoleon's sisters were noted for their dislike of Josephine (they were, however, prepared to accept her cast-off clothes, as Caroline Murat did, for the empress was renowned for her elegant *toilettes*), strict court protocol demanded that all the imperial courts adopt mourning at the express wish of the emperor, who remained fond of his ex-wife. Black, even for mourning, could be stylish; Ingres has captured the costume (possibly created by Leroy) with some panache. The portrait was finished by the artist when he returned to Rome; it then disappeared during the chaos that attended the collapse of the empire, the end of Murat's rule (he was court-martialled and shot in 1815) and the exile of Caroline, no longer Queen of Naples, but self-styled Countess of Lipona (an anagram for Napoli).

In Ingres's work, black demonstrates its versatility in portraits ranging from

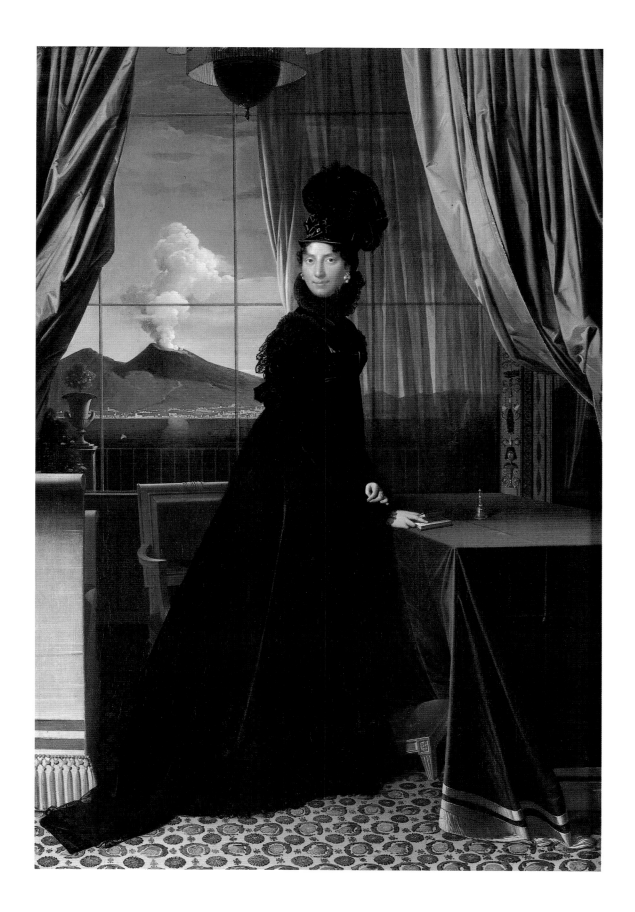

the grandeur of court mourning in his *Queen of Naples*, to the relative simplicity of the afternoon dress worn by Mademoiselle Jeanne Gonin (1821; pl. 91). Painted during Ingres's stay in Florence, the portrait was probably commissioned by the sitter's fiancé Pyrame Thomegeux, who had a factory making straw hats; very finely woven straw was a long-established Tuscan industry, and made the elegant hats, often trimmed with ribbons, feathers or flowers, which feature so prominently in Ingres's drawings. Mademoiselle Gonin's dress consists of a front-buttoning bodice and a skirt of black satin; it is a modest interpretation of the Renaissance mood in women's costume, incorporating 'epaulettes' (often called 'Vandykes' in England) at the shoulders, and a small neck ruff edged with embroidery or lace and tied with checked ribbon.

Jeanne Gonin's family introduced Ingres to the Leblancs, whom Ingres painted in 1823; Jacques-Louis Leblanc married Françoise Poncelle in 1811 at Florence where they both worked for Napoleon's sister Elisa Bonaparte, Grand Duchess of Tuscany — he as her secretary and she as a lady-in-waiting — and they stayed on after the end of the empire. It is possible that the fine French woollen shawl that is draped on Madame Leblanc's chair is a gift from Elisa Bonaparte, for the design incorporates a capital E.

The portrait of Madame Leblanc (pl. 94), which was once owned by Degas, who revered Ingres,[8] is a perfect demonstration of the harmony between character and costume which critics sought in such images. Ingres shows Madame Leblanc as sensible and worldly in a formal evening dress of black satin and a striped shawl in shades of black, white, yellow and coral, decorated with a stylized floral design. In the eyes of Kenneth Clark, it was the stunning shawl that 'made' the portrait, for he claimed to find the dress 'a dreary black with a form-obliterating cut'.[9] This is a curious comment, for the dress in fact emphasizes the shape of the body, especially the bust and the arms. The bodice, with the horizontal pleating so characteristic of the 1820s, has transparent silk gauze over-sleeves known as *aerophanes*, a word that well describes the airy, floating garment that both reveals the arms and yet hides them (pl. 6); it is a style that was particularly flattering to the heavier physique of the middle-aged woman. Here the sleeves tie at the wrist with bows of black satin ribbon, matching that threaded through Madame Leblanc's glossy dark brown hair. The eye is drawn to her well-preserved neck and firmly corseted bust by the heavy gold chain that holds the turquoise-decorated watch which is pinned to the belt of her dress. For evening wear, women carried small bags which often matched the fabric of their dress; Madame Leblanc's bag which she clutches on her knee, is of black velvet and bugle (glass) beads. It is more luxurious and more structured than the simple drawstring reticule in Ingres's drawing of the same sitter (pl. 92); here she wears (if it is this sitter, and some doubts have been expressed) a bodice and skirt costume, rather like that worn by Jeanne Gonin, and the portrait must date from around the same time.

91 Ingres, *Mademoiselle Jeanne Gonin*, 1821. Oil on canvas. The Taft Museum, Cincinnati, Ohio, Bequest of Charles Phelps and Anna Sinton Taft.

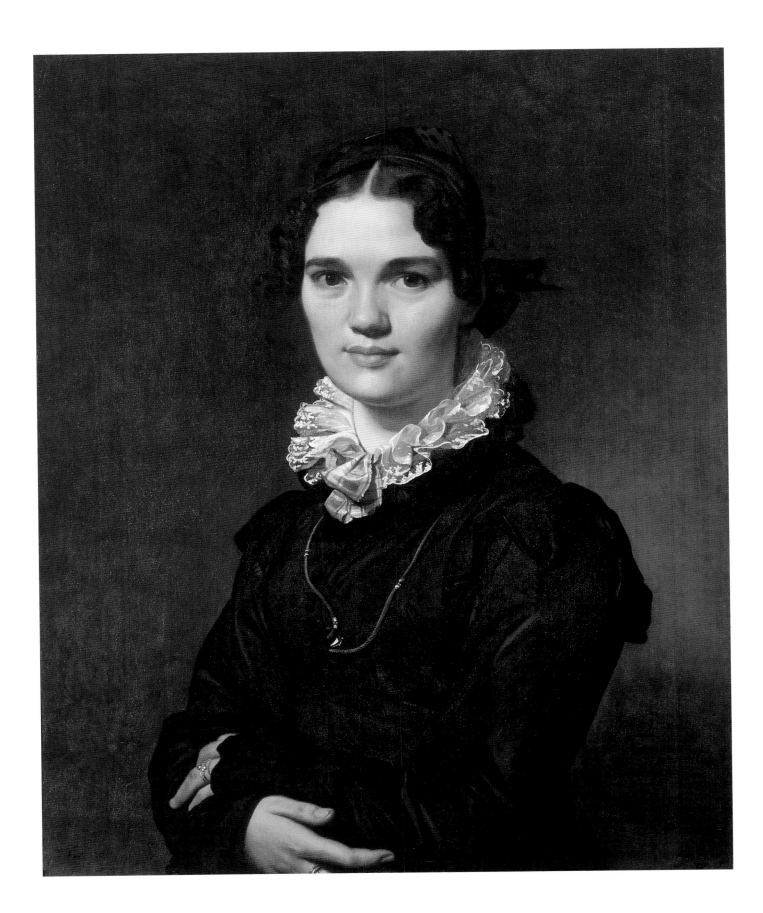

92 Ingres, *Françoise Poncelle, Madame Leblanc (?)*, c.1822. Pencil on paper. Ecole des Beaux-Arts, Paris.

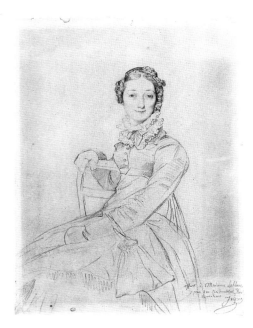

93 Ingres, study for the portrait of Madame Leblanc. Pencil on paper. Musée Ingres, Montauban.

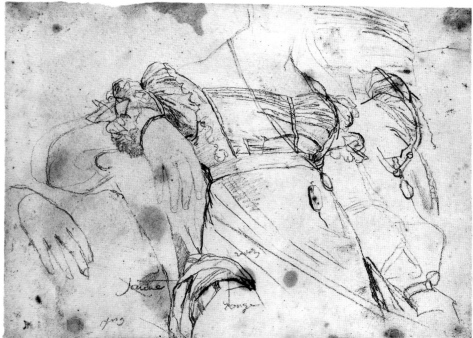

94 Ingres, *Françoise Poncelle, Madame Leblanc*, 1823. Oil on canvas. The Metropolitan Museum of Art, New York, Catharine Lorillard Wolfe Collection, Wolfe Fund, 1918.

In connection with the painted portrait of Madame Leblanc, a number of preparatory studies exist, which show how Ingres worked out the final composition, taking particular trouble with the sitter's right arm; what is presumably the final drawing in the sequence at the Musée Ingres is reproduced here (pl. 93). The artist made a number of drawings of her hands, a feature of the portrait that Lapauze particularly admired, describing them as 'les plus belles

du monde'; to the late twentieth-century eye, accustomed to the beauty of bone structure, they may look somewhat limp and formless, the sign of a pampered woman, but it was precisely the effect that Ingres and his contemporaries found attractive.

The painting of Madame Leblanc is worth considering in connection with a drawing of the same sitter made in the previous year (pl. 95); it is one of Ingres's most beautiful works. Although in the drawing Madame Leblanc wears a day dress, some of the features of her appearance here may have suggested Ingres's approach in the painting. We see, for example, the same hairstyle with a ribbon bow at the side and the hair parted slightly off-centre; the drawing shows two small combs on either side of the parting, which helped to keep the curls from falling over the forehead, and these were removed for the painting, having served to 'fix' the hairstyle. In the drawing the watch is pinned to her waist as it is in the painting, and there is the same effect, in both images, of something fluttering at the wrist; at the bodice, horizontal bands of applied braid anticipate the gathered folds of the painted corsage. With his by now practised skill in describing fabrics, Ingres indicates the shine of silk on the dress, and with a few hazy lines he sketches out the fine starched muslin ruff at the neck. What makes Ingres's drawings works of art and not just images of costume, is the way the artist brings dress alive; note, for example, how the top flounce of the left sleeve 'epaulette' stands up on her shoulder as though momentarily ruffled by the breeze.

In the painting of Madame Leblanc, Ingres realized that black was the perfect colour for evening dress, particularly for the mature woman; even more sumptuous and formal – the apotheosis of the woman in black – is his portrait of Marie-Clothilde-Inès de Foucauld, Madame Moitessier of 1851 (pl. 98). With her pose of regal disdain and the heavy immobility of her features Madame Moitessier does not speak directly to the late twentieth-century spectator; the wife of a banker much older than she was, she is often characterized as a kind of 'trophy' wife, in love with all the luxury that her husband's money could buy to adorn her. But to dislike the conspicuous consumption that is displayed in this portrait is to fail to understand what earlier critics admired in it. To Edmond About, Madame Moitessier appeared as a queen: 'M. Ingres has surrounded her with majesty and grandeur, without neglecting the flowers, the draperies, and the admirable Chantilly lace.'[10]

The painting of black on black requires virtuoso skills, which Ingres demonstrates in his depiction of lace on velvet; Lapauze rightly claimed that the artist had created a *tour de force* with the spider-like web of lace over the profound black of the velvet dress.[11] Madame de Moitessier wears an evening *toilette* with such a low décolletage ·that the dress threatens to slip from her shoulders, just as Balzac describes almost happening to the ultra-fashionable Valérie Marneffe in *Cousin Bette*, quoted at the beginning of this chapter. Shoulders like sloping champagne bottles were the fashionable ideal, revealed

95 Ingres, *Françoise Poncelle, Madame Leblanc*, 1822. Pencil and watercolour. Cabinet des Dessins, Musée du Louvre, Paris.

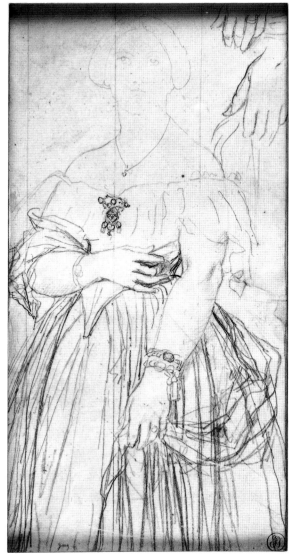

96 (*above left*) Ingres, study for the head of Madame Moitessier. Pencil and white chalk. The J. Paul Getty Museum, Los Angeles.

97 (*above right*) Ingres, study for the costume of Madame Moitessier. Pencil on paper. Sale, Christie's London, 3 July 1990.

98 (*facing page*) Ingres, *Marie-Clothilde-Inès de Foucauld, Madame Moitessier*, 1851. Oil on canvas. National Gallery of Art, Washington, Samuel H. Kress Collection.

where appropriate and certainly for a formal portrait; as Balzac stated, 'the beauty of lovely shoulders is the last to desert a woman'. Dressed in this way, Madame Moitessier looks like a goddess arising from a sea of filmy black draperies. In his *Notes on Paris* Taine describes a similar vision of a woman of fashion, also dressed in black velvet: 'Her round and divinely white shoulders rose luminous from this deep darkness, and the lines of her neck undulated in graceful curves'.[12]

From the late 1840s there are increasing references to the popularity of black for evening wear. *Le Follet* in 1848 remarked on the vogue for black lace, Chantilly in particular; a few years later the *Petit Courrier des dames* (1852) spoke of the continuing fashion for black, and for roses as an evening headdress. The combination of black and pink was thought of as Spanish and thus exotic; Spain

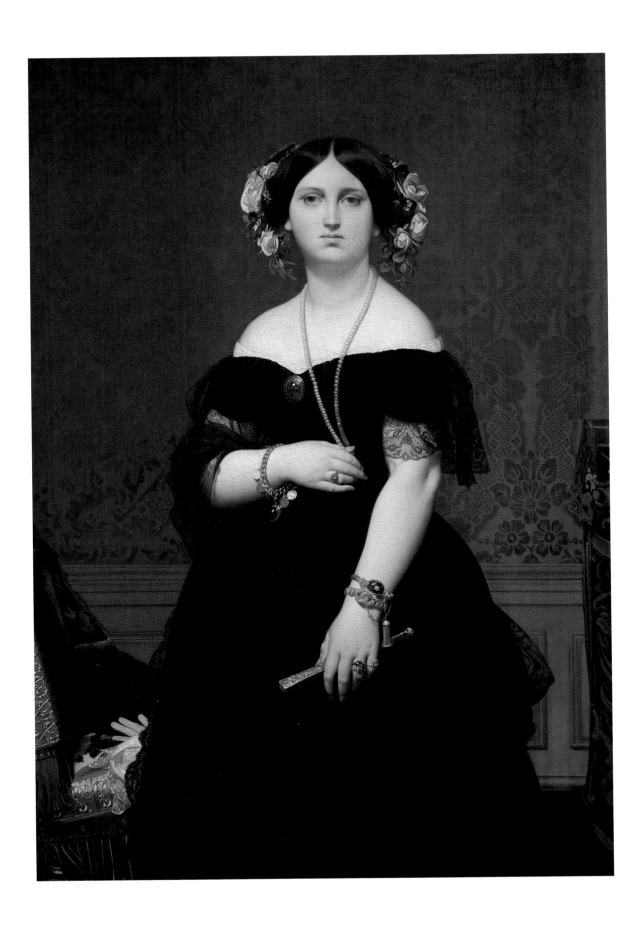

was, in a manner of speaking, Europe's Orient, largely cut off from the rest of the continent for a host of reasons (historical, social and economic), but gradually, during the second quarter of the nineteenth century being 'rediscovered' by travellers and writers and inspiring a wide range of the arts, painting, literature and music. The fashion journals of the 1840s and 1850s perceived a Spanish influence in the popularity of black, of lace (especially the wearing of mantillas), and of flowers in the hair. The 'coiffure Espagnole', stated one such magazine in 1848, has 'recently gained great favour in Paris . . . among the leaders of fashion . . . Many ladies wear merely a small mantilla of black blonde or lace fastened on each side of the head by bouquets of Bengal roses.'[13]

The portrait of Madame Moitessier was in some ways the culmination of Ingres's notion that in a portrait of a woman, the classical ideal should be combined with the temporality of contemporary costume to produce a 'timeless' masterpiece. An early attempt in this genre, according to Gautier, was Ingres's *Madame Devauçay* (pl. 86), whom he likened to 'la Chimère antique, en costume de l'Empire' – the antique chimera (an unreal, hybrid creature of classical mythology) in Empire costume. Critics such as Lapauze likened Madame Moitessier to Minerva or Juno – both goddesses of forceful temperament and not easily crossed – but dressed *à la mode*, 'to the nobility of an antique goddess, she adds the charm of the fashionable Parisienne of her time'.[14]

Ingres underlined the classical element in his portrait of Madame Moitessier by making her pose a distant echo of that of the Medici Venus. Her majestic aloofness reminds one of the image of Marie Arnoux evoked by Flaubert in his great novel *A Sentimental Education*, which begins in the 1840s; the hero Frédéric Moreau sees his sacred muse and true love singing after dinner at her house in Paris, and dressed in black velvet 'with her arms hanging down at her sides and her gaze lost in space'.[15]

Compared with the portrait of Madame Moitessier seated in her floral gown (pl. 135), which Ingres had begun in 1844 and did not complete until 1856, the portrait in black was relatively trouble-free considering his notorious slowness; it was finished within a year, by late 1851. There are a few preparatory studies of the pose and the dress. The differences in pose relate mainly to the position of the arms (always a source of difficulty for Ingres), for he seems to have thought out the choice of dress early on, and apart from minor changes, such as the suggestion of a flounce in the skirt in one drawing, and a scarf arranged over the shoulder in another, there were no real crises.

It was a different story, however, with regard to the headdress and the jewellery. Initially Ingres asked Madame Moitessier to bring with her some yellow-orange silk flowers and velvet ribbons, as he was dissatisfied with the white lace headdress she had initially worn; finally he settled on the pink silk roses with their green foliage which appear in the finished portrait. He also

kept changing his mind about the jewellery; in one of the costume studies (pl. 97) she wears an elaborate brooch and a locket on a short chain around the neck, neither of which appears in the painting. Writing to his sitter in October 1851, Ingres told her the brooch was too old-fashioned; he suggested that she replace it with a cameo, and asked her to bring her jewel box to the next sitting so that he could make a final selection.[16] How interesting it would have been to hear that discussion as artist and sitter debated the merits of what was clearly a treasure-trove of jewels.

When the painting was finished, Madame Moitessier was resplendent in a rose-cut garnet brooch set in silvery gold, a long rope of pearls round her neck and a gold charm bracelet from which hangs a pendant cabochon amethyst on her right wrist; on her left hand are rich coiled bracelets of gold with enamel and pearls, and a selection of rings including one set with a glowing garnet to match her brooch (pl. 100). She seems quite enervated by the amount of her jewellery, with barely enough strength to hold her fan – her fingers do not actually grip it but merely co-exist with it (pl. 14). It is difficult not to dwell on the beautiful objects that testify to Madame Moitessier's taste and life-style, objects that Ingres has painted with reverent care, such as the lace-edged handkerchief and the stiff new pale kid gloves which rest on the chair (pl. 99). When the portrait was almost finished, Ingres's final demand of Madame Moitessier was 'an evening wrap of the kind you wear when leaving the ball, to throw on a corner of the chair'.[17] Such a wrap, known as a *sortie de bal*, is indeed draped over the chair; with a final touch of luxury, it is of black satin lined with sable.

99 Detail of pl. 98.

100 Detail of pl. 98.

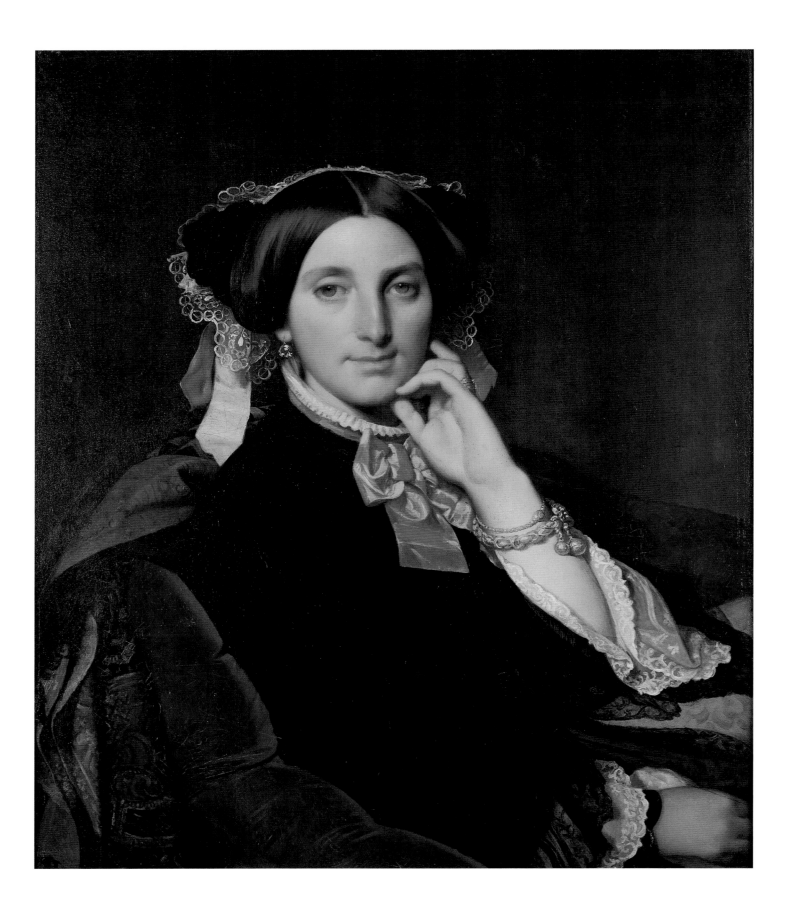

It is almost with a sense of relief that one turns from the rapt intensity that marks Ingres's portrait of the 'belle et bonne' Madame Moitessier, to the quiet, cool portrait of Caroline Maille, Madame Gonse of 1852 (pl. 101). Like many of Ingres's sitters, Madame Gonse was remarkably patient, for her portrait was begun in 1845 and – interrupted by the artist's despair after the death of his wife in 1849 – was not completed until seven years later. The sitter had been a pupil of Ingres and had married a lawyer in Rouen. The sober and understated elegance of her costume is enlivened by such unexpected touches of colour as the pink ribbons in her cap and the pink bow tied under her crisply pleated ruff. In contrast to the glamour of Madame Moitessier's evening dress, Madame Gonse's costume is a modest day dress; it is, in fact, a relatively new garment called a *visite*, a fitted three-quarter-length jacket which was worn, as the name implies, for formal visits, which usually took place in the afternoon. Madame Gonse's *visite*, which dominates her ensemble (only a glimpse of her blue dress can be seen), is of black velvet trimmed with satin and Chantilly lace; delicate touches of white and pink in the outfit alleviate the darkness of the jacket and complement the complexion. The artist has singled out for attention the delicate Caen silk lace of the sitter's cap and the undersleeves of embroidered net which have an echo, as does the pose, of Liotard's portrait of Madame d'Epinay of 1759 (pl. 123), which Ingres much admired. As for the pink accessories, they harmonize with the glowing jewel-like colours of the shawl, and the rich velvet of the sofa. There is a true concordance between costume and character in this portrait, between the muted elegance of the dress and the firm repose of the personality; the critic Charles Blanc admired the skill with which the dress underlined the nature of the sitter, as distinct from Ingres's 1856 portrait of Madame Moitessier in which he found the patterned dress to be a distraction.[18]

It is appropriate to end with Madame Gonse, for, in a sense she is the most 'colourful' of Ingres's studies in black; her black *visite* and her dark shining hair are encircled by colour. It is colour of the kind that glows and vibrates in Ingres's portraits of women of the world.

101 Ingres, *Caroline Maille, Madame Gonse,* 1852. Oil on canvas. Musée Ingres, Montauban.

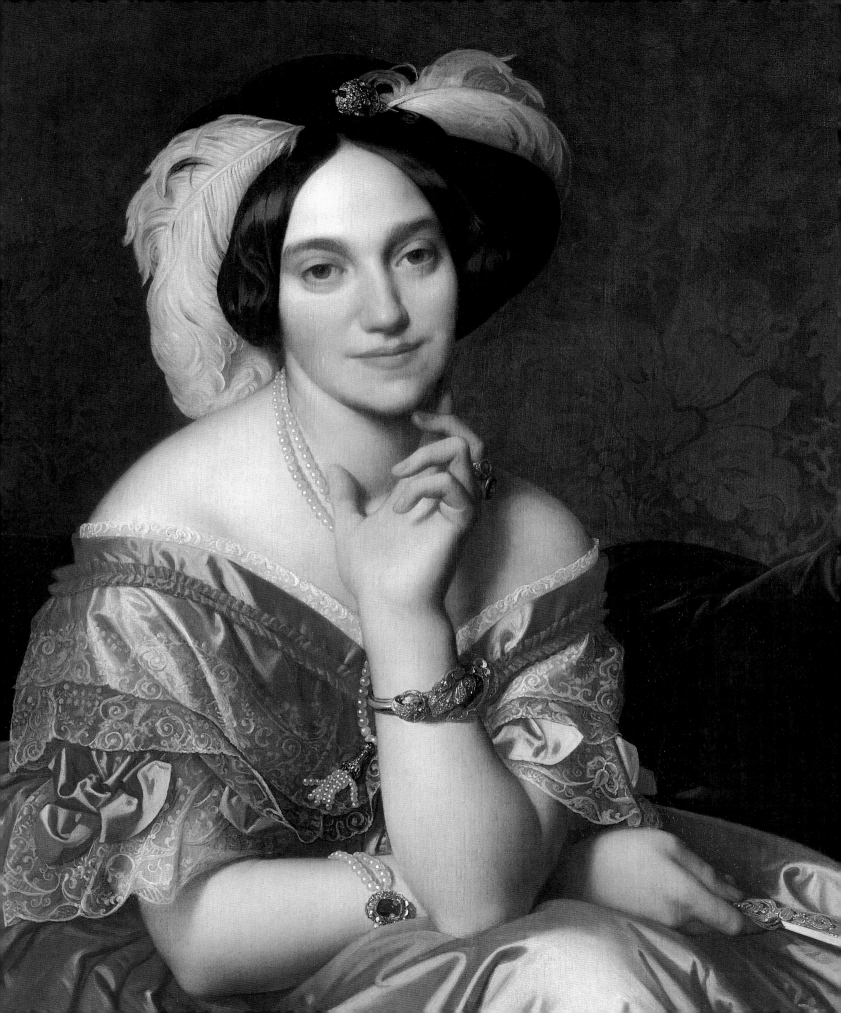

7 Women of the World

France will always be the country in which there are the greater number
of passable women, who, without being handsome, cannot fail to please.
They are seductive from their manner of dressing themselves, which
uniformly seems to promise delicate pleasure, and these pleasures can be
appreciated even by souls the least subjected to the passions.

Stendhal, *Rome, Naples and Florence* (1817)

STENDHAL UNDERSTOOD AND DESCRIBED the notion of chic before the
word was coined. To be chic a woman needs to have an expert knowledge of
dress, and the confidence to know what suits her personality. As the *Journal de
Paris* notes in 1805: 'Dress is like a musical accompaniment and must be suited
to the person it adorns.' This analogy would be as much appreciated by that
great lover of music Stendhal, as by Ingres, no less a devotee of music, albeit of
a more conservative kind.

A sense of chic is evident in most of Ingres's portraits of women; they reflect
the luxury and sophistication that is so marked a feature of female costume in
the period. No matter what the age of the sitter, Ingres enhances her
appearance and her appeal with subtle flattery. As has already been said,
Baudelaire claimed that Ingres deliberately chose women of 'rich and generous
natures, embodiments of calm and flourishing health' for the subjects of his
portraits, which were then created in the artist's notion of ideal femininity.[1]
But if we examine Ingres's portraits, there is no particular 'Ingres look' other
than the personal vision that every great portraitist has, and that he extends
alike to the slim and the plump, to the young and the middle-aged. It is the fact
of being perceived through the artist's eye that unites the women that Ingres
paints; the costume and the pose (and the poses are always natural and
unforced, even for the grandest of *grandes dames*) are always conceived as part
of the whole composition. Only in that way can Ingres's portraits be said to
look alike, which is a similar philosophy to Balzac's, that all beautiful women
resemble each other, not through their physical features, but because of their
'distinction, dignity, grace, refinement, elegance, and incomparable
complexion'.[2]

It is costume which fills the space in a portrait by Ingres; the background takes
second place, charming though it might be, as is the elegant boudoir of Madame
d'Haussonville. Most of Ingres's painted portraits of women are set indoors, a

102 Detail of pl. 125.

natural state of affairs when one considers the type of dress, usually formal, which his sitters wear. Where furniture is shown it either supports the sitter or the costume's accessories; Ingres's choice of furniture highlights the textile element, the rich velvets of sofas, the gleaming damasks of upholstered armchairs; he paints fabrics, as Lapauze points out, with a feel for their intrinsic qualities – silky, matte, muted or vibrant.[3] On the whole, however, the presence of luxurious interiors is implied rather than described; only in two portraits, *Madame d'Haussonville* (pls 103 and 117) and *Madame Moitessier* (1856; pl. 135), does Ingres give a glimpse of an interior that is more than just a wall or a chair. No doubt he found the demands placed on him apropos the costume in portraits sufficient in themselves; in any case it was dress, so individual and intimate to the sitter, that best expressed her personality.

Apart from the portrait of Mademoiselle Rivière, there is only one other portrait by Ingres that is set outdoors: the contemporaneous image of Madame Aymon (pl. 104), sometimes subtitled, from the words of a popular song, '*La Belle Zélie*'. Little is known about this sitter except what Ingres reveals through her dress and appearance; she is certainly – in Baudelaire's words – a woman of 'calm and flourishing health', and with her 'sticky' curls and sultry glance she looks not unlike a glossy film star of the 1920s. The colours of her costume, which comprises a rich brown silk high-waisted dress and a brilliant red shawl, underline the warmth of her skin and the tints of her complexion. It

is completely an image of a bouncing young woman dressed in the height of fashion, and far removed in spirit (although close in time) from the refinement and fragile elegance of Madame Devauçay.

Although Ingres succeeds best, if Baudelaire is to be believed, at portraying young women, one of his most accomplished portraits is that of the elderly comtesse de Tournon (1812; pl. 105); at sixty she is the oldest female sitter painted by the artist. The portrait was commissioned by her son, baron Camille de Tournon, the Prefect of Rome, and Ingres responded with a display of the sitter's wisdom and intelligence as well as her taste for luxury in dress. She sits upright in a straight-backed chair, against a cushion of green satin embroidered in gold; green and gold had appropriate Napoleonic significance, for they were not only the colours of the emperor's livery, but also of his coronation costume as King of Italy. No expense has been spared with the comtesse's clothes; a pale cream cashmere shawl rather like Madame Rivière's,[4] falls over the arm of her chair and into her lap, partly covering the skirt of the thick green velvet dress. A ruby and diamond ring glitters on her right hand, and her veil is of the finest and most expensive Brussels bobbin lace.

There is a certain flair in the comtesse de Tournon's self-presentation, which Ingres has seized upon, although in no way has he flattered his sitter; he has not diminished her rather bulbous nose, or plumped out the flesh round the mouth, slightly fallen in with the loss of some teeth. With a sympathetic but penetrating eye Ingres records the toll taken of a woman's face over the years and notes how she attempts to defy time with a wig of dark brown curls. Lapauze comments on the way the choice of costume can help to minimize the ravages of age and present the best features of an older woman:

> The neck – a terrible chronometer – is surrounded by an enormous ruched collar, almost like a ruff of the time of Henri II, which supports the cheeks and the chin. The low neckline of the dress does not reveal the flesh, but a semi-transparent muslin [covering]. In contrast, the arms – the last beauty left to a woman – are left uncovered.[5]

Compared with Madame de Tournon's quasi-regal pose, that of the vicomtesse de Senonnes (pl. 107) is positively relaxed, even indolent, as she leans forward on the luscious yellow satin cushions of her sofa, a large mirror behind her. This is Ingres's first use of the mirror, which serves a number of purposes, both artistic and practical. Artists from Leonardo onwards suggested that the incorporation of a mirror into a painting would 'enhance the plasticity of the direct vision';[6] there were also the traditional connotations of the naked Venus gazing into a mirror held up by Cupid, and the figure of Vanitas admiring her image. The mirror was practical as well, for it enables Ingres to sign the portrait by way of slipping his visiting card into the mirror frame. According to the etiquette manuals it was thought vulgar to place visiting cards in the frame of a mirror, such a practice being 'attributed without doubt to an

103 (facing page) Detail of pl. 117.

104 (following page) Ingres, *Mme Aymon, 'La Belle Zélie'*, 1806. Oil on canvas. Musée des Beaux-Arts, Rouen.

105 (page 131) Ingres, *Alix-Geneviève de Seytres-Caumont, Comtesse de Tournon*, 1812. Oil on canvas. Philadelphia Museum of Art, The Henry P. McIlhenny Collection in memory of Frances P. McIlhenny.

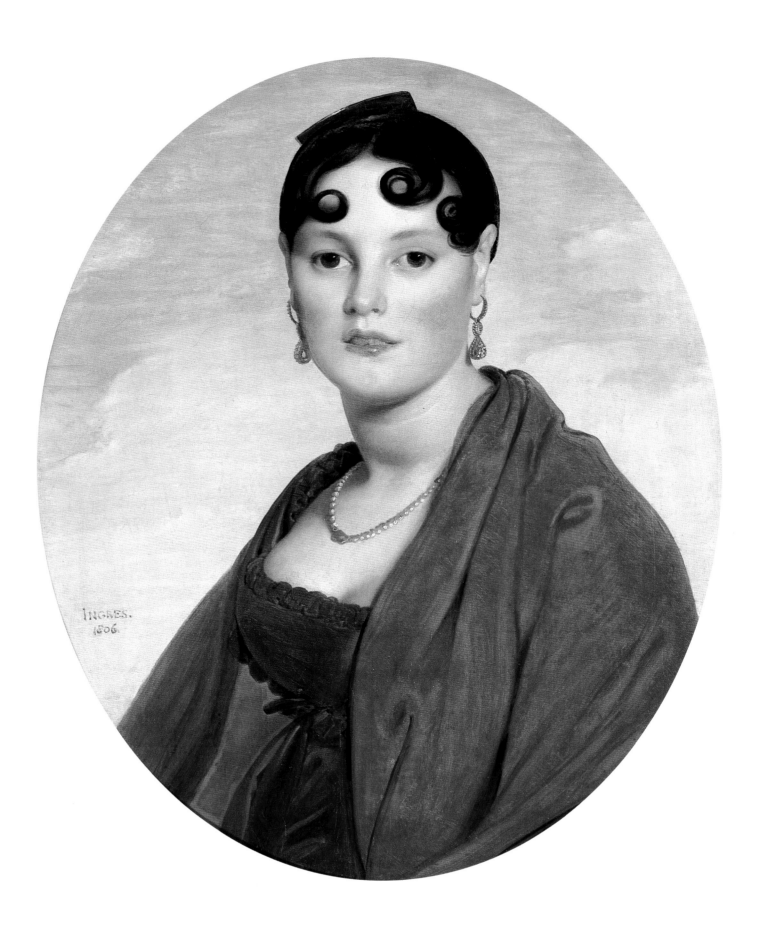

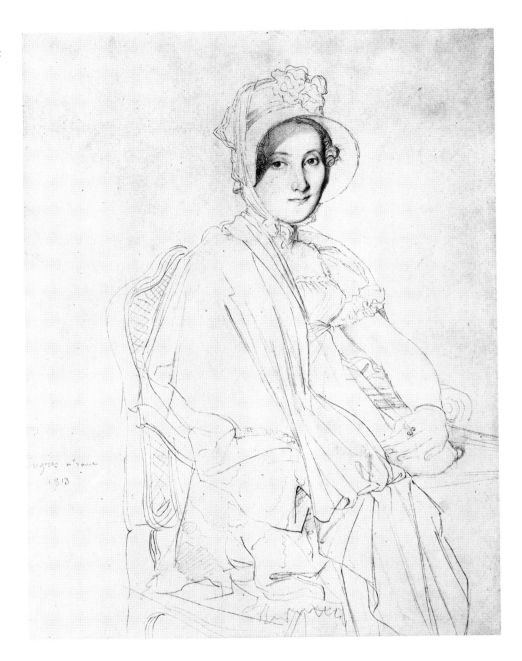

110 Ingres, *Marie Marcoz*, 1813. Pencil on paper. The Detroit Institute of Arts, Bequest of Robert H. Tannahill.

112 (*following page top right*) Ingres, study for the portrait of Madame Marcotte de Sainte-Marie. Pencil on paper. Cabinet des Dessins, Musée du Louvre, Paris.

'dull, prudish', but the stylish black evening gown worn by Madame Leblanc is the height of sophistication, and the beautifully painted dress of Madame Marcotte de Sainte-Marie (1826; pl. 113) has a subtle and sensual appeal.

Ingres's portrait of Madame Marcotte de Sainte-Marie (one of the extended Marcotte clan who feature in so many of the artist's drawings, and into which he married *en secondes noces*) was one of his first commissions after returning to France from Italy; it is also the last painted portrait of a woman for many years, until the 1840s. The sitter was a sickly woman with barely enough strength to sit for her portrait (according to Lapauze, Madame Ingres had to pose for the

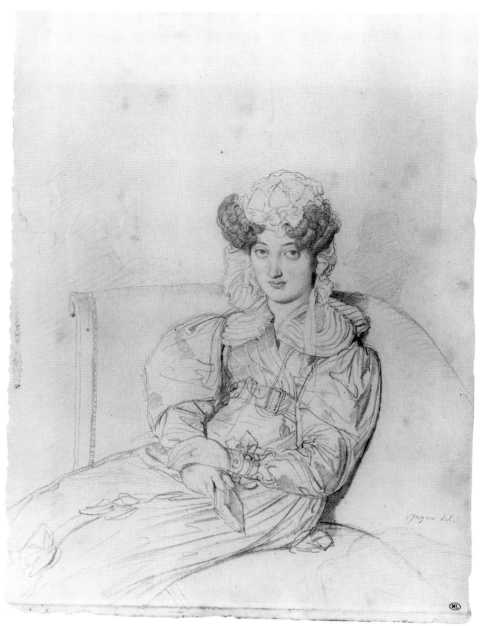

111a and b Two details, the sleeve and the bows on the skirt, from a brown silk pelisse dress of the mid-1820s, which is very close to that worn in Ingres's *Madame Marcotte de Sainte-Marie* (pl. 112). Museum of London.

hands); unlike Madame de Senonnes, who leans forward from her sofa as though to engage the spectator in conversation, Madame Marcotte de Sainte-Marie sinks back rather warily into her yellow satin sofa. Her almost Pre-Raphaelite face with its myopic large eyes, long nose and rather fleshy lips seems overwhelmed by the large curled hairstyle, arranged in the ultra-fashionable Apollo knot. Compared with the succulent beauty of Madame de Senonnes, Madame Marcotte de Sainte-Marie appears rather austere in the style of her dress, a brown silk pelisse gown whose pleated bodice and *gigot* sleeves hide the figure.

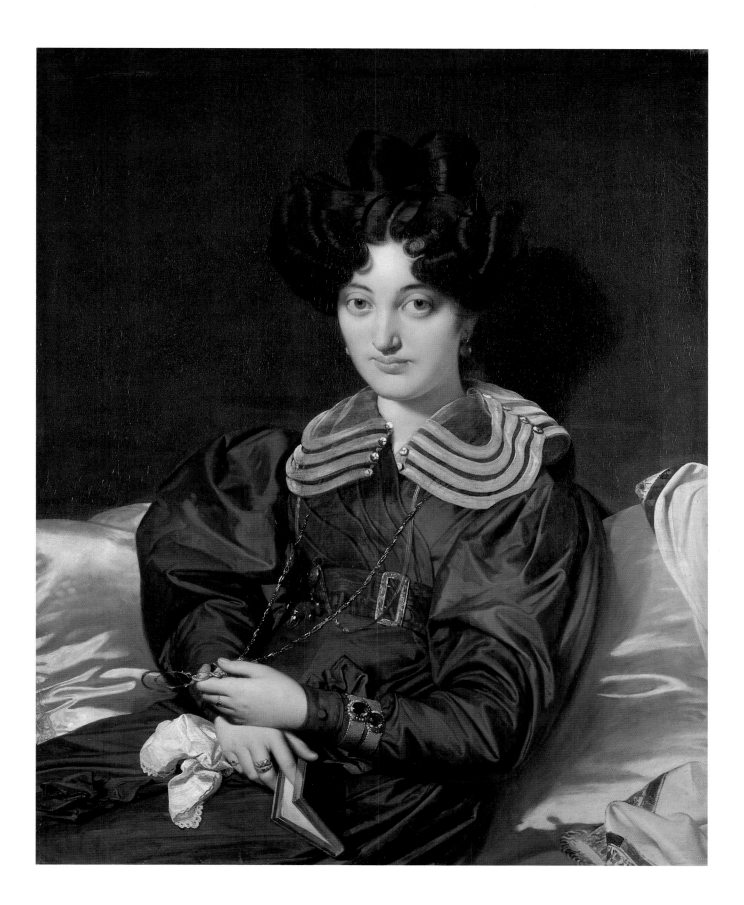

114 Ingres, study for the portrait of Madame Marcotte de Sainte-Marie. Pencil on paper. Musée Ingres, Montauban.

113 (*previous page*) Ingres, *Suzanne Clarisse de Salvaing de Boissieu, Madame Marcotte de Sainte-Marie*, 1826. Oil on canvas. Musée du Louvre, Paris.

With little flesh on display, the eye is drawn towards the details of the dress – the shining chestnut brown of the silk, the side-fastening ribbon rosettes and the belt of watered silk with its large gold buckle. Tucked into the belt, and hanging from a long gold chain round her neck, is a chateleine, which includes (among the other small, personal utensils) a tiny bottle either for scent or for smelling salts; another long chain, this time of silver, holds her eye-glass. A typical Ingres touch is the way in which he emphasizes the individuality of clothing; here he has noted (perhaps he suggested the slight alteration himself) the way in which one side of the stiffened gauze collar curves into the neck at

the front so that only two of the satin-covered buttons are visible, against the four on the other side.

Almost certainly it would have been Ingres's decision to paint Madame Marcotte de Sainte-Marie's thick, lustrous hair unadorned by any headdress; there are only two small combs on either side of the central parting. In some of the preliminary studies for the portrait, the sitter appears in the frilled day-cap with pendant ribbons popular in the 1820s; a drawing at Montauban (pl. 114) shows such a cap on the fuzzy aureole of the sitter's curls. In this drawing she wears a different dress from the finished portrait, the informal *blouse* which has a softly gathered front, smocking on the shoulders and sleeves of modest dimensions; the soft, turned-down collar is probably of whitework, white embroidery on white cotton or linen, and over her shoulders is a shawl which then drapes over her lap, held in place by her hands, the right one holding an eye-glass. A more advanced study (pl. 112) still shows the cap, but the dress has become that seen in the painting; the bracelets and the chateleine appear, but not the eye-glass, and a watch has been sketched in at the belt.

Slightly out of the chronological sequence of Ingres's portraits of women, but related to his Madame Marcotte de Sainte-Marie in terms of the quiet simplicity of the dress, is the image of Madame Hortense Reiset of 1846 (pl. 115). The immediacy and intimacy of this portrait may be because it was not painted in the studio, but in the home of the sitter at Enghien, a favourite summer retreat of the artist, where he found particular consolation after the death of his first wife in 1849. Frédéric Reiset was a friend of Ingres and one of the main collectors of his work; shortly after the portrait of his wife was completed, he acquired the artist's painting of Madame Devauçay.[18] Madame Reiset wears a simple but elegant afternoon dress of dark violet and black silk decorated with a small whitework collar and a satin bow; the creamy white cashmere shawl draped over the back of the chair relieves the sobriety of the gown. The effect created by the limited colour palette is akin to a daguerrotype, or possibly to an engraving in a contemporary keepsake album; it is a deceptively simple portrait which caused Ingres much anguish as he sought to combine truth and style. He has avoided sentimentality and over-prettiness by the honest depiction of her long nose and by the directness of her gaze. To the English viewer, the glossy ringlets recall images of dainty, perhaps rather childish-looking, mid-Victorian young women, but it was a style of hair-dressing popular among all ages of women. In France this kind of hairstyle was thought of as English and regarded as both virginal and seductive; when, in Balzac's novel *Cousin Bette* (1847), the beautiful and virtuous Adeline Hulot has a favour to ask, she dresses her hair in ringlets 'designed to captivate'. To Frédéric Moreau in Flaubert's *A Sentimental Education* the ringlets worn by Madame Dambreuse (the ambitious and elegant wife of a politican and later the hero's mistress) 'hinted at a sort of wistful, dreamy passion'. Flaubert's description of Madame Dambreuse, set in 1846, is not unlike Ingres's portrait

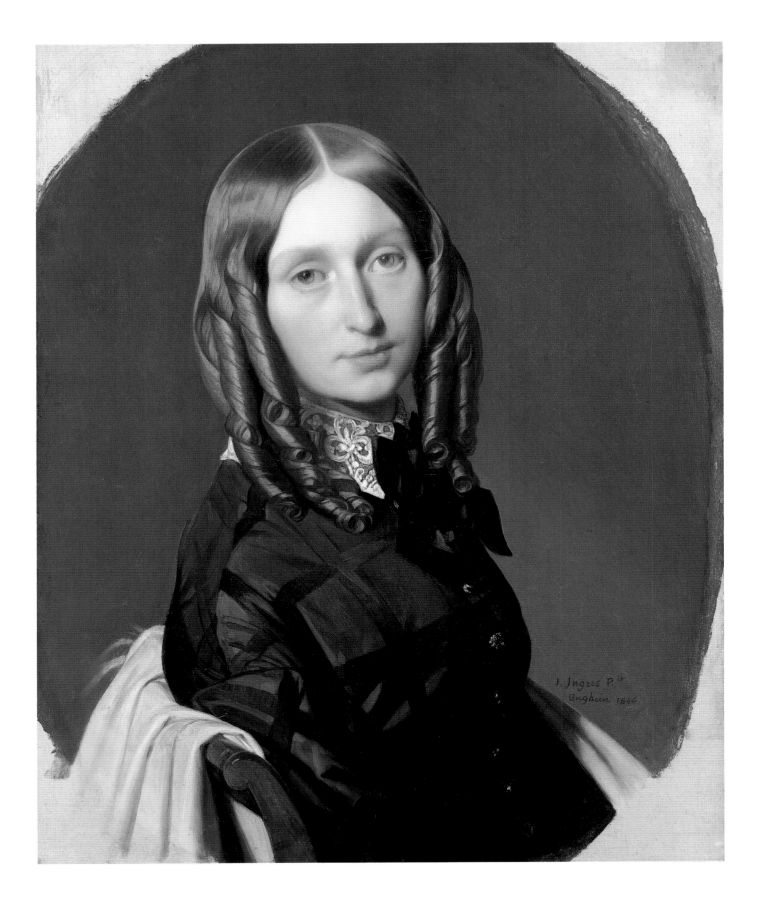

of Madame Reiset: 'The waxy skin of her face seemed taut, youthful but lifeless, like glacé fruit, but her hair, hanging in ringlets in the English style, was finer than silk'.[19]

Because the portrait of Madame Reiset was painted for an intimate friend, and in the sitter's home, Ingres did not use a model for the pose, and any preparatory drawings he might have made have not survived.[20] The artist's 1844 drawings of Madame Reiset (pls 63 and 64) are unrelated to the painting (although ringlets appear in one of them), but the grace and modesty of these earlier images must have been a source of inspiration for the portrait of two years later.

By the mid-1840s, after his second stay in Italy, and a series of religious, mythological and allegorical paintings, Ingres seems to have rediscovered his taste for portraits of women. By now moving in the highest social circles, Ingres tackled the elaborate *toilettes* of the comtesse d'Haussonville, her sister-in-law, the princesse de Broglie, and the baronne de Rothschild. These were grand women of very different characters, which the artist wished to emphasize by a perceptive choice of dress: it had to demonstrate the quiet intelligence and taste of Madame d'Haussonville, the shy reserve and dignity of Madame de Broglie, the vivacity and charm of Madame de Rothschild.

Louise de Broglie (pl. 117) was the grand-daughter of Madame de Staël, and a writer herself (of novels, essays and memoirs). In 1836 she married the vicomte Othenin d'Haussonville (he succeeded to the title in 1846), a liberal peer, historian and member of the Académie Française. After their marriage the couple travelled abroad, and met Ingres in Italy; on a visit to the artist's studio in Rome, the comtesse particularly admired his *Antiochus and Stratonice* (1840; Musée Condé Chantilly), and the figure of Stratonice may have inspired the pose of Madame d'Haussonville in her portrait by Ingres, as well as serving as an allusion to her artistic interests.[21] While in Italy Monsieur d'Haussonville had asked Winterhalter if he would paint his wife, but the artist refused – it would have been interesting to see how he would have depicted the comtesse – and so Ingres was approached in 1842; by this time the d'Haussonvilles were back in Paris where the comtesse established a literary and musical salon.

A drawing dated 1842 in the Musée Bonnat at Bayonne (pl. 116) shows the comtesse in a long-sleeved, white-collared dress, decorated with braid or embroidery down the centre front; it is a winsome image, the tilt of the head very close to that in the final portrait. The fact that this drawing is signed may indicate that it was intended as a portrait in its own right, or that it may be the first in a sequence of some fifteen or so studies related to the painting, which have been identified by Edgar Munhall.[22] Work on the portrait was delayed for some months while Madame d'Haussonville gave birth to a son in the autumn of 1843, followed by lengthy travels with her husband to Greece and the Near East, and the sittings were not resumed until late in 1844. Ingres busied himself with different poses, turning the sitter first to the right, and then deciding she

115 (*facing page*) Ingres, *Hortense Reiset, Madame Reiset*, 1846, Oil on canvas. Courtesy of the Fogg Art Museum, Harvard University Art Museums, Bequest of Grenville L. Winthrop, 1943.

116 (*following page*) Ingres, *Louise de Broglie, Comtesse d'Haussonville*, 1842, Pencil with touches of white. Musée Bonnat, Bayonne.

123 J.-E. Liotard, *Louise-Florence d'Esclavelles, Madame La Live d'Epinay*, 1759. Pastel on parchment. Musée d'art et d'histoire, Geneva.

124 (*above*) Detail of a fashion plate from the *Petit Courrier des dames*, 1848. British Museum, London. The evening dress has rows of gauze ruching trimmed with satin bows, reminiscent of the *robe de bal* worn in Ingres's *Madame de Rothschild* (pl. 125).

125 (*facing page*) Ingres, *Betty de Rothschild, Baronne de Rothschild*, 1848. Oil on canvas. Private collection.

de Rothschild (pl. 125), completed in 1848; when Gautier saw the portrait in the artist's studio he was taken aback by the vivacity of the image, by the way in which the sitter looked as though she were continuing a conversation with the spectator which had begun in the ballroom or at supper.

Betty de Rothschild came from the Vienna branch of the famous banking family and married her uncle James from the Paris branch in 1824; her letters reveal a lively hostess (the word 'blooming' is often used to describe her in the Rothschild correspondence), and at her convivial salon she entertained such guests as Balzac, Rossini, George Sand and the Moitessiers. The French Revolution had created greater political, social and cultural opportunities for the Jewish community; families such as the Rothschilds, often ennobled,

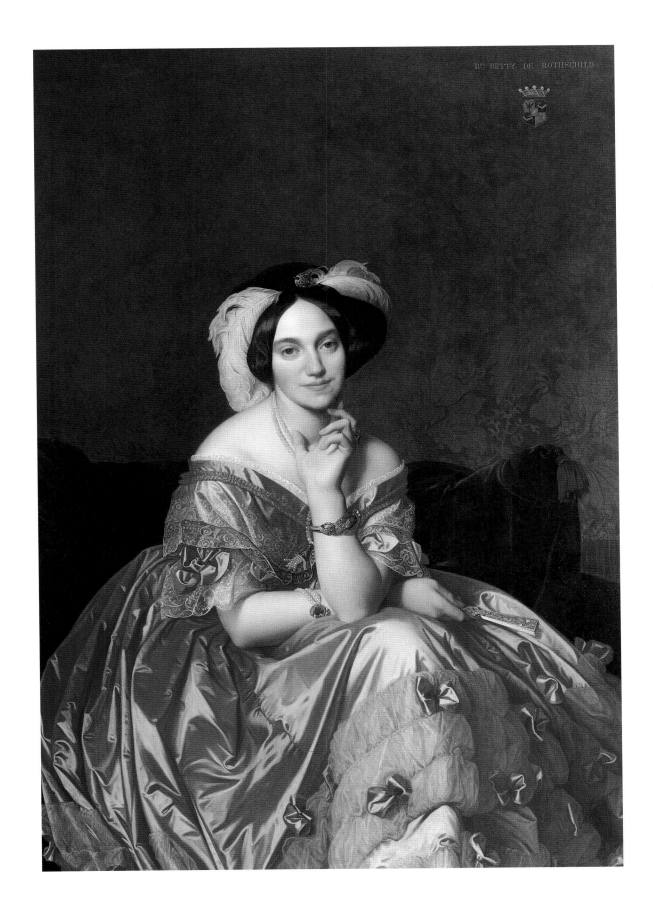

became an international force. Assimilated into French society, they represented qualities highly prized in nineteenth-century France – they were literate and artistic, and their tastes were urban and sophisticated. Patrons of the arts, their houses in city and country were places to display fine paintings and sculpture; in Madame de Rothschild's salon in the rue Laffitte, her portrait by Ingres was the focus of attention. The vicomte de Beaumont-Vassy, recording the *Salons de Paris et la société parisienne sous Louis-Philippe*, declared that this portrait was more natural than any other portrait of a woman by Ingres:

> Mme de Rothschild is represented seated, one arm on her knee with her fingers lightly touching her chin, and the other hand holding a fan. On her head is a toque of black velvet to which two feathers [*aigrettes*] are attached; she wears a dress of cherry-coloured [*cerise*] satin, and there is something bizarre in the choice of this colour next to that of the sofa on which she sits. This couch is, as a matter of fact, covered in garnet-red velvet. The accessories, such as the necklaces and bracelets of pearls and diamonds are marvellously handled without distracting attention from the whole.[35]

As Beaumont-Vassy suggests, the portrait is carefully created so that the component parts form one harmonious whole and there is never any danger of the sitter being overwhelmed by her costume. To some extent, Madame de Rothschild's pose was inspired by Liotard's portrait of Madame d'Epinay of 1759 (pl. 123); Ingres particularly admired this fine portrait of the famous salon hostess and writer, which he saw on his way back to France from his second stay in Italy. Madame d'Epinay engages the spectator with her direct, interrogatory glance, head slightly to one side, and the index finger of her right hand on her chin. As one connoisseur of female dress to another, Ingres would certainly appreciate the Swiss artist's clever use of movement in costume, the small black lace-trimmed shawl which twists restlessly through the horizontal bands of the bodice, and the graceful fall of the embroidered linen sleeve-ruffles. A similar sense of an almost speaking likeness can be seen in Ingres's portrait of the baronne de Rothschild.

The critic of the *Revue des deux mondes* for 1848 (who had the unnerving experience of seeing Ingres's bland and simpering *Venus Anadyomène* (Musée Condé, Chantilly) just a few paces away from the vigorous and lifelike image of Madame de Rothschild in the artist's studio) compared the baronne's portrait to that of *Louis-François Bertin* for its intense reality and physical presence. The colour reminded him of Venetian painting, and he declared that the portrait of Madame de Rothschild was fit to be placed side by side with Tintoretto and Moroni; moreover, the velvet of the cushions would honour the shoulders of a doge.[36]

Critics of Ingres's portraits often comment on his choice of colours; Thoré, as we have seen, complained at the range of blues in the portrait of Madame d'Haussonville, and Beaumont-Vassy expressed surprise at the *bizarrerie* of setting the pink of Madame de Rothschild's dress against the red of the sofa.

'C'est tout une histoire que celle de cette robe', we are told, and indeed it was – as is the case with many of Ingres's late portraits of women – something of a saga. Originally, the dress chosen by Madame de Rothschild was blue, but Ingres changed the colour without any consultation; when she protested, the artist said bluntly that he painted for himself, and not for her – 'C'est pour moi que je peins et non pour vous'.[37] Any lesser mortal (and particularly a society woman) might have been offended by such rudeness and lack of social grace, and given up the idea of a portrait; but the baronne had waited many years for her portrait since she had first met Ingres in Rome in 1841, and she was determined that it should be completed. Looking at the portrait, one can see a bluish tinge to the dress, particularly under the net trimming of the bodice and the bands of gauze on the skirt.

What Madame de Rothschild wears is a *toilette de soirée* of pink satin, the bodice decorated with embroidered silk net, and the skirt with bands (*bouillonnées*) of silk gauze trimmed with ribbon bows to match the dress. Whatever the genesis of the dress in the portrait, it was a popular colour in the fashionable world; the *Lady's Newspaper* for January 1848 notes the vogue for a 'very vivid shade of rose called African pink'.[38] Gautier's poem 'A une robe rose' (first published in *L'Artiste* in 1850) might be a half-remembered recollection of the portrait seen in Ingres's studio in 1848:

> Frêle comme une aile d'abeille
> Frais comme un coeur de rose-thé,
> Son tissu, caresse vermeille,
> Voltige autour de ta beauté

(Frail as a bee's wing/fresh as the heart of a tea-rose/your dress like a crimson caress/flutters around your body).

Madame de Rothschild's dress is more substantial than a bee's wing, but the huge, soft, light silk floats around her like an overblown rose.

Ingres produced a number of studies for costume and pose. These include the startling drawing of the corsage of the dress on a naked body with heavy, lumpy buttocks (pl. 126), and a sketch of the finished pose (pl. 127). There is a particularly beautiful drawing of the skirt of the dress (pl. 128) where the light on the satin is indicated by white chalk, and with a note by the artist suggesting that one of the *bouillonnées* should be placed lower down. The *Revue des deux mondes*, remarking how difficult it was to paint female fashion because it did not easily fall into 'artistic' draperies, concluded that Ingres had solved this problem in a masterly way by 'rumpling the knots of satin and the gauze'; the dress is depicted 'with such freedom and breadth' that there is no cause to regret the absence of 'the majestic folds of the stola' (Roman tunic).[39]

Ingres may have changed the colour of Madame de Rothschild's dress in conformity with the notion that the artist's aesthetic judgement was paramount and overrode that of the sitter, but he would not alter the jewellery, although

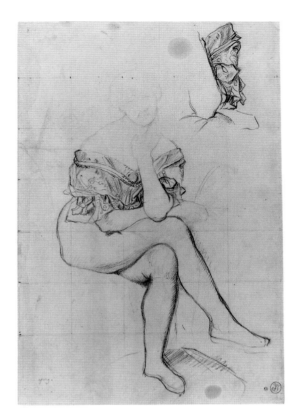

126 (*above left*) Ingres, study for the portrait of Madame de Rothschild. Pencil on paper. Musée Bonnat, Bayonne.

127 (*above right*) Ingres, study for the portrait of Madame de Rothschild. Pencil on paper. Musée Ingres, Montauban.

128 Ingres, costume study for the portrait of Madame de Rothschild. Pencil on paper with touches of white. Musée Ingres, Montauban.

– as with Madame Moitessier – he might have selected it. Betty de Rothschild was known for her love of jewellery[40] and some choice items from her collection are portrayed here; a pearl necklace ending in a tassel, a pearl bracelet with a large ruby clasp surrounded by brilliants, and another bracelet set with gold and precious stones in a complex winding design reminiscent of the popular serpent motif of mid-nineteenth century jewellery. The jewellery must have been selected last, for it does not feature in any of the preliminary drawings. Perhaps this was because of the artist's concentration on the dress and on the unusual pose; unlike the portraits of Madame d'Haussonville and Madame de Broglie, where grand furnishings and possessions serve to create a barrier between sitter and spectator, Madame de Rothschild's encompassing spreading skirt almost draws the spectator into the canvas.

In fact Madame de Rothschild's pose – the way she crosses her legs so that the shape of her knee can clearly be seen – might have been regarded as rather risqué, if we are to believe the etiquette books:

When seated, [a woman] ought neither to cross her legs nor take a vulgar attitude . . . It is altogether out of place for her to throw her drapery around her in sitting down, or to spread out her dress for display, as upstarts do, to avoid the least rumple.[41]

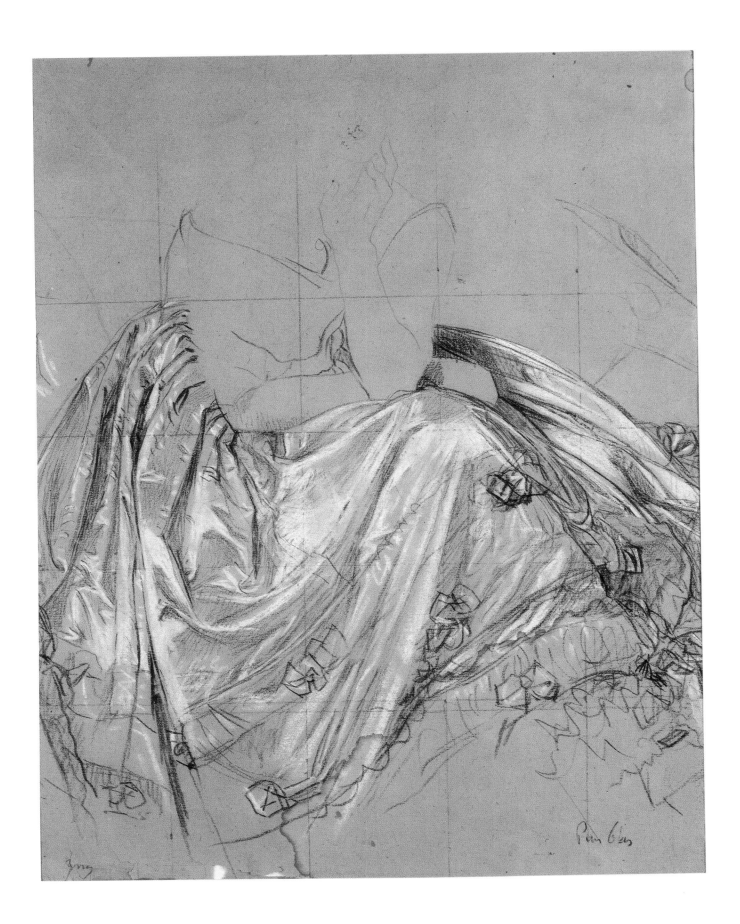

What are we to read into Ingres's unusual freedom of pose and the general sensuality of the image? Marie Simon has recently wondered, 'Is Ingres telling us . . . of the sometimes overdone luxury and coquetry of a social class?'[42] Simon compares the delicacy of the portrait of the princesse de Broglie (pl. 130) with its 'distance and respect', to the 'superflous ornamentation' of the dress worn by Madame de Rothschild in her portrait. This seems to me to be a judgement based on the author's preference for one style of dress over another (and Madame de Broglie wears as much rich jewellery as does Madame de Rothschild). There may be some mileage, however, in Ingres's choice, however unconscious, of shades of red and pink for women such as Madame de Senonnes and Madame de Rothschild, who were outside the mainstream of faultlessly aristocratic French society; both these sitters in their portraits demonstrate an open sexuality far removed from the cool dignity of the comtesse d'Haussonville and the princesse de Broglie.

Carol Ockman's exploration of the sensual in Ingres's work, discusses — apropos the portrait of Madame de Rothschild — the notion of the 'exotic' Jewess who was perceived to be both sexually available and, at the same time, deeply spiritual; this was a well-established literary and artistic convention in Restoration France: 'The baronne's Jewishness, with all that it implied in contemporary consciousness, enabled Ingres to push sensuality further than he could in any other society portrait.'[43] The Jewishness of Ingres's *Madame de Rothschild* does not consist — *pace* Simon — in her dress as such. It is possible that her substantial headdress, a black velvet toque trimmed with ostrich feathers and a Moorish pin, may relate to the Jewish tradition for married women to cover their hair; in the context of a formal evening *toilette*, it would be unusual to see a Christian woman wearing anything on her head other than the lightest decoration — such as the marabou ornaments worn by Madame de Broglie. On the other hand Madame de Rothschild's choice of headdress may have been selected as a stylish foil to set off what we can see of her shining black hair. Dark hair and eyes, and a complexion of ivory — this is the kind of beauty that Balzac celebrates in his descriptions of the Jewish actresses and courtesans who feature prominently in his novels. Such women are often described as having the appearance and sensual charms of the Orient; the courtesan Esther Gobseck (heroine of the sequence of novels published under the title of *Splendeurs et misères des courtisanes*, 1838–47), is set forth as 'le type sublime des beautés asiatiques'. 'L'Orient brillait dans les yeux et dans la figure d'Esther', says Balzac; at the same time she reminded him of a portrait by Raphael, 'car Raphael est le peintre qui a le plus etudié, le mieux rendu la beauté juive'.[44]

The combination of the famed sensuality of the Orient and the famous beauties of the Renaissance as painted by Raphael would certainly appeal not just to Ingres but to a wide range of his contemporaries as well; such women incorporated the refinement of the historic past ('la femme spirituelle') with the exotic other. In Balzac's novel *Lost Illusions*, the novelist speaks through the

129 Detail of pl. 125.

character of Lucien de Rubempré, as he describes the perfect Jewish face (the actress Coralie, later his hero's mistress):

> Her face was of the perfect Jewish type: long, oval and of a light ivory tint, with a garnet-red mouth and a chin as delicately turned as the brim of a cup. Eyelids and curving lashes masked the gleam of jet-black pupils, and beneath them one divined a languorous gaze, aglint on occasion with the fire of oriental passion.[45]

This is a fair description, perhaps, of Madame de Rothschild, although she was considerably older than Coralie in the novel; it is with all the connotations implicit in images of beautiful Jewesses that Madame de Rothschild, in her portrait by Ingres, is noted by the *Revue des deux mondes* as having 'sourcils à l'orientale' (oriental-style eyebrows, i.e. almost joining) which arch over her eyes sparkling with life and brilliance.[46]

Lapauze sounds a Balzac-like note in his comment on the portrait:

> What a captivating sweetness there is in this sumptuous portrait! This woman with a caressing entreaty in her eyes, with an almost imploring smile, this elegant woman so sumptuously dressed, and whose very name signifies wealth, seems to say: 'Forget everything, only see my tender dream, like all the tender dreams of those who love. Only think of my heart which can be touched by grief even beneath so many pearls, so much lace and so much silk'.[47]

It is a far cry from the quasi-orientalist imagery and the throbbing prose of many writers on Ingres's *Madame de Rothschild*, to the aristocratic hauteur of the portrait of the princesse de Broglie (pl. 130) in her cool acid-blue satin evening dress. The deeply religious and painfully shy and reserved Joséphine-Eléonore-Marie-Pauline de Galard de Brassac de Béarn married Jacques-Victor-Albert de Broglie, the younger brother of Madame d'Haussonville in 1845; she bore him five sons before dying of consumption in 1860, aged thirty-five. To her husband she was as he recalled in his memoirs 'la lumière de ma vie'; he was inconsolable when she died, and kept the portrait hidden behind a curtain. 'Her great beauty', he claimed, 'made her the admiration of all, and one could read all the perfection of her moral character in the purity of her features and in the loftiness of her gaze.'[48]

In spite of this marital encomium (perhaps because of it?), Ingres's portrait of Madame de Broglie exudes a chilly reserve, which can be difficult for the modern eye to appreciate. Yet contemporary critics were full of praise; Gautier loved 'the delicious harmony between the blue satin of her dress and the pearly lustre of her arms and hands'.[49] And what may appear to the late twentieth-century viewer to be an image of aristocratic disdain, was precisely the element held up for admiration, as Edmond About declares in his review of Ingres's paintings at the Universal Exhibition in 1855:

130 Ingres, *Joséphine-Eléonore-Marie-Pauline de Galard de Brassac de Béarn, Princesse de Broglie*, 1853. Oil on canvas. The Metropolitan Museum of Art, New York, Robert Lehman Collection, 1975.

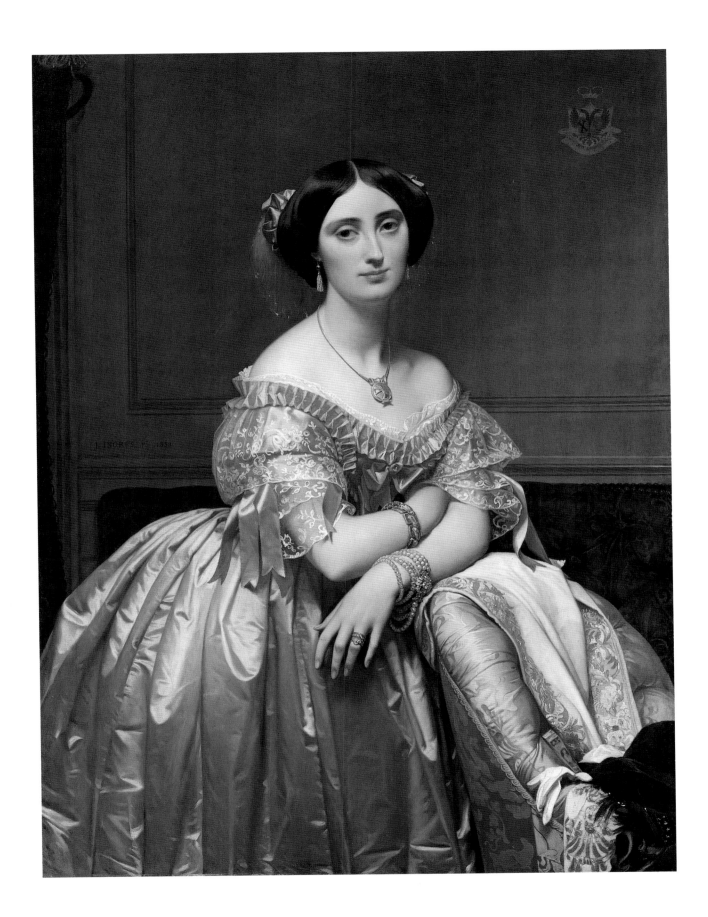

131 Hair ornaments of white marabou feathers tipped with silk, *c.*1850. The Costume Institute, The Metropolitan Museum of Art, New York.

132 Detail of pl. 130.

Mme la princesse de Broglie is fine, delicate, elegant to her finger-tips . . . a marvellous incarnation of nobility. Her pose alone would betray her race, even if the delicacy of her features did not alert us. Around this exquisite beauty, the painter has spared nothing that can reflect its shine. He has given equal attention to the costume, and to the furnishings or exterior decoration. The satin of the gown, the jewellery, the lace and the marabou coiffure are of a Chinese precision and an English elegance. M. Muller has received much praise for his skill in painting silks. But when we see the dress worn by the princesse de Broglie, all Muller's silks look as though they have been bought in the Temple [i.e. second-hand or cheap ready-made clothes].[50]

Ingres's painting of the sitter's costume and jewellery is a triumph of technical skill; the shine on the satin is almost dazzling, and the trimming on the bodice (probably Brussels bobbin lace on fine English net) has been depicted with great intensity and attention to detail. Madame de Broglie's stylish jewellery, much more sumptuous than that worn by her sister-in-law Madame d'Haussonville, consists of earrings of tasselled pearls, a long pearl necklace with a superb diamond and ruby clasp wrapped round her wrist as a bracelet, a bracelet of gold and diamonds on enamel plaques, and round her neck a gold chain with an Etruscan-style pendant. This gold necklace serves to draw attention to the beautiful and delicate slope of the shoulders, and the artist has allowed himself a slight touch of sensuality in the way that the neckline of the dress has begun to slip down on one side, hinting at the curve of the bosom. The most beautiful of Ingres's headdresses decorates her hair; it consists of blue satin ribbons and quivering white marabou feathers tipped with silk (pl. 132). A few years earlier, in 1848, a fashion journal noted:

By ladies of more mature years, feathers are much worn in the hair in full dress. Marabouts, either white or coloured, have a very pretty effect when disposed in the style called *à l'Italienne*, that is to say, fixed on each side of the head so as to droop and curl round . . .[51]

The portrait of the princesse de Broglie, begun in 1851, was completed in the year when an imperial court was established with the marriage of Napoleon III to Eugénie de Montijo. Already a growing opulence in fashion – which the Second Empire encouraged – can be seen in Ingres's portrait of his aristocratic sitter, heightened by the restraint of the setting, a room in the de Broglies' town house in Paris. Luxurious accessories were complementary to the formal evening dress shown, and on a yellow damask chair (or chaise-longue) Ingres has placed a pair of delicate white kid gloves, a fan, a black fringed scarf and – most prominently – a gold-embroidered *sortie de bal*. This evening mantle is probably a white cashmere burnous; this was a tasselled cloak, sometimes hooded, of North African origin popularized by the French conquest of Algeria. The Empress Eugénie was fond of this type of mantle, Princess Metternich recording on one occasion how splendid she looked 'in a sort of

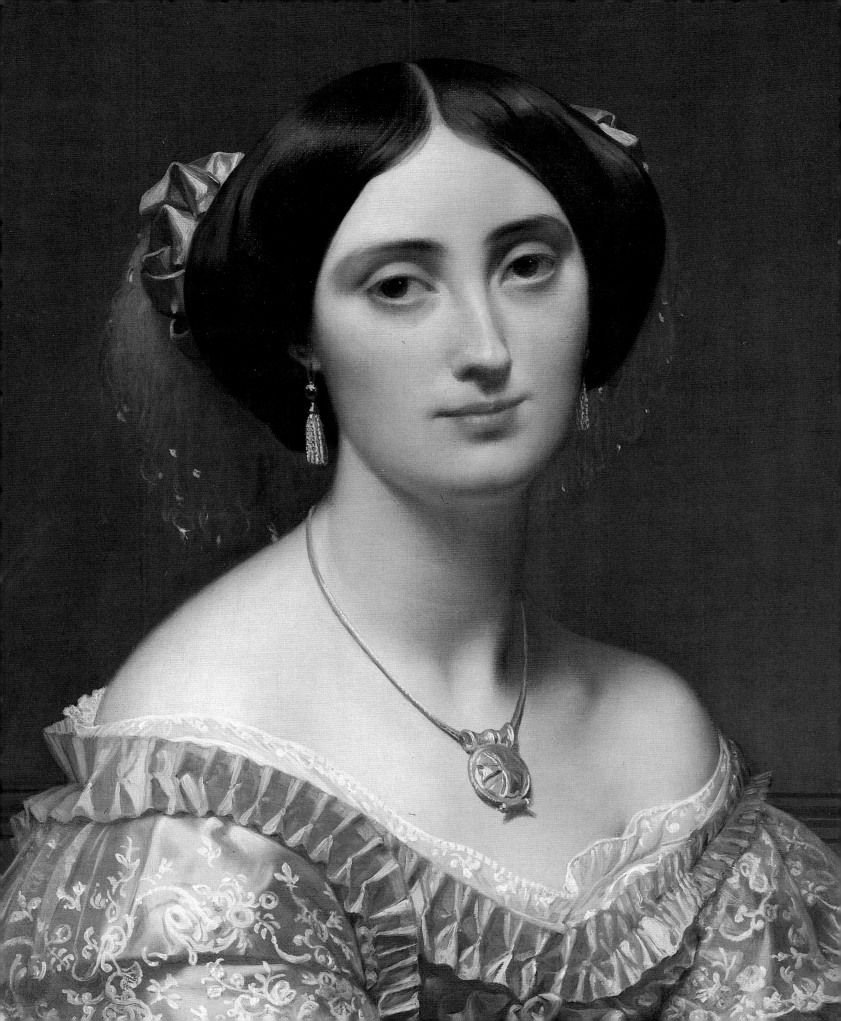

133 Ingres, study for the portrait of
Madame de Broglie. Pencil on paper. Private
collection.

burnous of white embroidered with gold' over a spangled evening dress.[52] The
Petit Courrier des dames (1852) stated in the dictatorial way so typical of fashion
journalism then and now, that the only *sorties de bal* allowed to be in vogue
were of white embroidered cashmere, sometimes trimmed with lace or fringe.

As women's skirts grew wider in the 1850s increasingly capacious evening mantles were needed; some had hoods (to protect the kind of fragile coiffure worn by Madame de Broglie), and some had full 'Venetian' sleeves, which could be pushed back over the shoulders so as not to crush the complicated layers of silk, ribbon and lace which made up the sleeves of the *toilettes de soirée*.

Unusually for Ingres's portraits at this period, relatively few preliminary studies exist for the princesse de Broglie. The Musée Bonnat at Bayonne has a study of the naked body where the pose is more or less the same as in the finished portrait, except for the arms, where slightly different arrangements are sketched out. A drawing of the dressed figure (pl. 133) shows the details of the costume virtually established, minus the ribbons on the sleeve, and the feathered headdress. If there were any problems over the choice of costume and accessories, history has hidden them from our gaze with a polite and discreet veil.

What has been seen so far in Ingres's painted portraits of women is a display of plain silks — notably lustrous satins and rich velvets — which does not truthfully reflect the range of materials that a fashionable woman would have in her wardrobe; these would include patterned fabrics such as damasks, brocades and painted silks. There was, however, a well-established preference by many artists, Ingres included, for the deployment of their skills in the virtuoso depiction of expanses of plain stuffs; they were happier in painting the gleam on satin or the soft pile on velvet, than the complicated details of a woven, painted or embroidered fabric. Figured materials, unless controlled by a masterly artistic hand, could all too easily take over a portrait and unbalance the whole image. Moreover, it could legitimately be argued that patterned fabrics dated more quickly than plain ones; both artist and sitter wished for timelessness, if not immortality, on the canvas.

It is all the more astonishing then, that one of Ingres's most famous portraits, *Madame Moitessier* (National Gallery, London; pl. 135), should depict a dress that is almost ferocious in the intensity of its pattern and ornament. When the portrait was the subject of an exhibition in 1977, the curator stated: 'To allow an article of dress to proclaim itself so loudly, conflicts with all the canons of classical art, and here Ingres betrays his taste for excess . . .'[53] Such a comment is not unique, and many spectators find it difficult to look at this portrait without being overwhelmed by the sense of the material it exudes, an almost stifling emanation of luxury, of *things*. It is hard to separate the character of the sitter from the way Ingres has painted her; this occurs often in his work, because he (and the spectator) is so engaged with his portrayal of his subjects, that they are seen through his eyes, and their personalities are as he understands them. To Martin Davies in the 1930s, Madame Moitessier was 'a stupid, self-centred, well-fed, soulless, beautiful woman', and although Ingres's 'eye remained still passionately objective to discern her quality', the portrait might be regarded as akin to a Winterhalter, 'a nadir of European painting'.[54]

134 Ingres, study for the portrait of Madame Moitessier. Pencil on paper. Musée Ingres, Montauban.

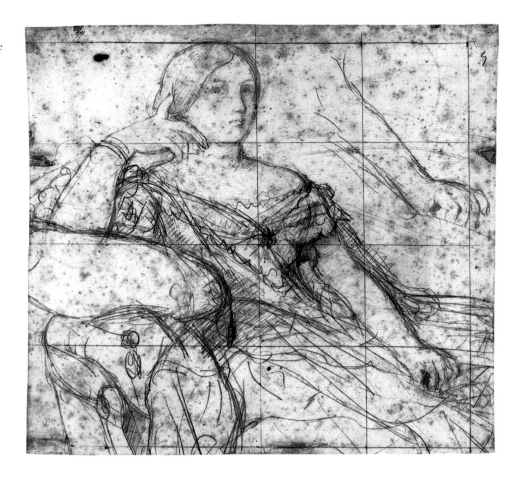

'Impassive in her extravagant finery', Madame Moitessier reminded Kenneth Clark in 1971, of 'some sacred figure carried in a procession'.[55] More recently, the artist Victor Pasmore chose the portrait for an exhibition of his personal selection of paintings from the National Gallery, London, and his general comment, apropos his choice, that 'painting is a language about visual objects expressed in terms of subjective effect – that is to say their beauty' is an apt description of Madame Moitessier.[56] For the portrait does show beauty, both in the painting itself, and in the sturdy Junoesque form of the sitter, a type with particular appeal for Ingres.

Once the artist had selected the pose – based on a figure of Arcadia from a Herculaneum wall painting that he may have seen in Naples in 1814 – it remained constant, especially once it was decided to omit Madame Moitessier's small daughter Catherine, originally intended to be placed at her mother's knee; Ingres could not cope with the impatient child (who later recalled how difficult it was to keep still, and how cold the studio was).[57] In the preliminary drawings there are only slight indecisions regarding Madame Moitessier's attitude, as to whether the skirt of her dress should fall over the arm of the chair or be squashed in at the sides, and if her right arm should be placed on a cushion (pl. 134).

135 Ingres, *Marie-Clothilde-Inès de Foucauld, Madame Moitessier*, 1856. Oil on canvas. National Gallery, London.

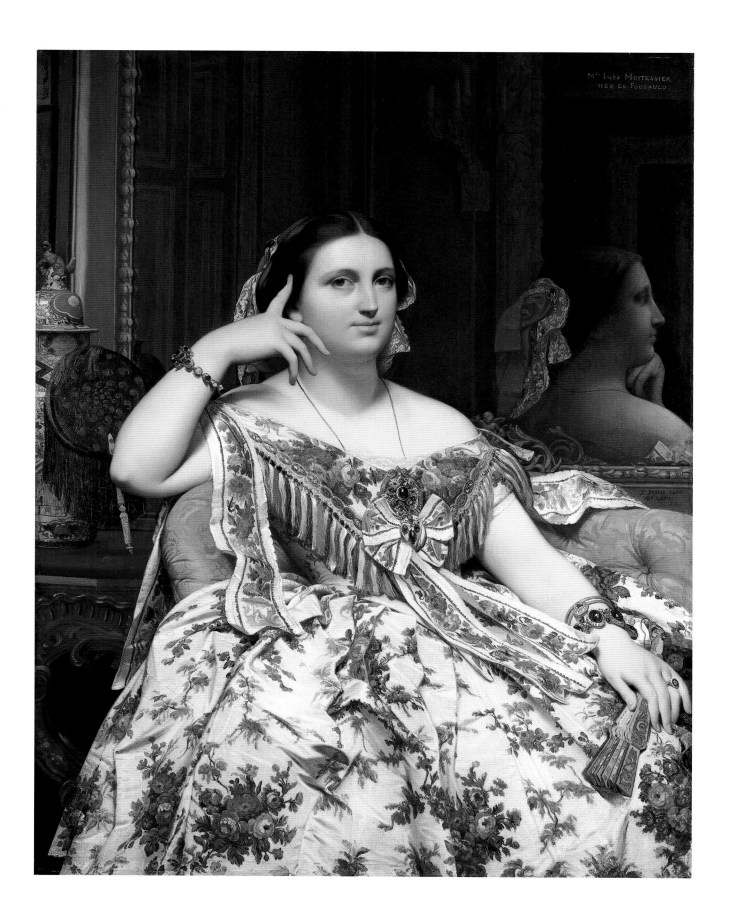

136　Ingres, costume study for the portrait
of Madame Moitessier. Chalk. Musée Ingres.
Montauban.

However, Ingres's ideas on the dress changed considerably, partly because of his personal quest for perfection, and no doubt because fashions themselves changed during the long march of the portrait's progress. It was in 1844 that Sigisbert Moitessier asked Ingres to paint his wife, but the portrait was delayed for a variety of reasons, including the death of Madeleine Ingres in 1849. Although the artist painted another portrait of Madame Moitessier in 1851 (pl. 98), a sense of guilt and some pressure from the sitter's husband, persuaded him to return to the first painting. By then the quiet and discreet styles of the 1840s were no longer fashionable, and so Ingres's thoughts on the dress of the portrait had to be redirected. Originally, his idea was for a plain dress, and a superb drawing at Montauban (pl. 136) shows a kind of blackberry-coloured skirt, created by black crayon on blue paper. Sometime after the completion of the Washington portrait, Ingres seems to have envisaged a yellow dress,

possibly on the advice of his new wife; writing to Madame Moitessier, the artist suggested that at the next day's sitting, she should appear with bare arms, and in yellow: 'Ainsi donc, madame, toujours à demain, bras nus, et s'il se peut, la robe jaune'.[58] We do not know what Madame Moitessier thought about the tediously long-drawn-out process which this portrait involved; what we do know is that she was rather self-conscious about her arms, hoping that Ingres could make them look less heavy. A letter written by Marcotte in 1855 to another of Ingres's closest friends, the engraver Edouard Gatteaux, gives some idea of the tactful approach that was necessary in such matters, for Ingres was notoriously touchy:

> It's the arms, which are found to be a bit too heavy. They already are so in the first portrait. Try to have him reduce them in the second. This has to come only from you, for if our friend suspects that this suggestion comes from the lady in question, he'll take offence. Bring about this change, therefore, very gently. The lady has heavy arms, it's true, but that's only another reason not to exaggerate them. It won't be held against the painter if he renders them a little smaller than reality. It must be remembered, moreover, that when the portrait was begun, Mme Moitessier was eight years younger, and less heavy. I told Mme Moitessier that I had written to you about it, and that no one but you could arrange everything and have her arms slimmed down . . .[59]

It is possible that Ingres may have listened to a diplomatically phrased plea that he reduce the arms of his sitter (for whom he had a certain *tendresse*), for in the finished portrait they do look slightly thinner than the majestic limbs seen in the 1851 portrait. Indeed, in the later portrait, Madame Moitessier's figure has been generally slimmed down, an effect possibly created by a tighter corset and the waist-reducing consequence of the wider skirts of the mid-1850s. It is a tribute to the strong features and the presence of the sitter that she is not overwhelmed by the attention devoted to the dress with its large floral design; it may be a printed silk (the ribbons decorating the bodice are printed) but it is most likely to be a sumptuously brocaded silk from Lyons.

A dress of this kind requires a matching opulence and splendour in the jewellery (pl. 138). Madame Moitessier demonstrates a taste for the neo-medieval, with the large round brooch of diamonds and amethysts set in gold and the bracelet on her right arm of opals and garnets also set in gold. On her left wrist is a fashionable gold snake bracelet with diamond head and emerald eyes, and a bracelet with extravagantly huge cabochon amethysts surrounded by brilliants. Jewelled pins (*épingles de tête*) keep her lace and ribbon headdress in place, as Ingres carefully indicates in the mirror reflection. Madame Moitessier does not need what Alphonse Karr in his book *Les Femmes* (1853) calls the 'témoignage des mirroirs' to convince her of her beauty; Karr's theory was that women were in love with dress and personal adornment as a tribute

to 'the legitimate royalty of their charms'.[60] During the 1850s (a period when mid-nineteenth-century bourgeois materialism was celebrated in vast international exhibitions in London and Paris), conspicuous consumption became almost an art form in the life of an élite woman of fashion. In his book *Les Modes et les parures* of 1857, Auguste Debay remarks:

> Jewellery, dress, flowers and all the immense variety of ornaments that make up a dazzling toilette, have arrived at a state of perfection which characterizes periods of luxury. Diamonds, pearls, gold, silver, polished steel, crystal, feathers, silk, &c, have been transformed into delicious articles of the toilette.[61]

It is these 'délicieux objets de toilette' – the lace, the jewellery, the fan guarded with gold leaf and mother-of-pearl, even the fringed portable fire-screen on the mantelpiece – which Ingres paints with such attention. Almost certainly Ingres would have visited the many pavilions at the Universal Exhibition of 1855 in Paris, which housed the triumphs of the luxury arts of silk-weaving, embroidery, jewellery and so on – even if only out of a professional interest as a painter of fashionable women.

Many of the applied arts on show at the Universal Exhibition demonstrated a revived interest in the styles of the eighteenth century, in tacit acknowledgement of the superiority of the craftsmanship of the earlier period. Eighteenth-century style was seen, by both the aristocracy and the newly enriched bourgeoisie, as the benchmark of gracious living; houses were built new, or remodelled, in a kind of neo-rococo taste, and it followed that furnishings and dress should complement architecture. In the year that Ingres completed the portrait of the comtesse d'Haussonville standing in her boudoir with its eighteenth-century porcelain, the *Moniteur de la mode* noted that people of fashion were copying the fabrics and designs of the period of Louis XV – 'pour les toilettes de bal, le genre Pompadour prédominera . . .'[62] Pompadour dresses, according to the *Journal des demoiselles* (1855) had pretty, fresh, flower designs.[63] Unfortunately, the delicacy of the eighteenth-century silks disappeared when the styles were reintroduced a hundred years or so later, now much heavier in design and lacking the original lightness of touch (see pl. 137). This was bound to happen when the traditional craft skills needed for hand-woven silks were replaced by machine-made fabrics created by the power-driven looms that made fewer demands on weavers' skills. So, Madame Moitessier's dress, made in imitation of an eighteenth-century silk, might easily remind us of a furnishing fabric. It was this kind of brocaded silk that the Empress Eugénie wore on certain official occasions, in order to help the Lyons silk industry (for this reason she called such dresses 'political'), but she did not like them, claiming, with some justification, that they made her look like a curtain; and she was careful never to be painted wearing such costumes.[64] Ingres's portrait of Madame Moitessier demonstrates no such misgivings, being

137 Design for a silk brocade. Engraving from *The Art-Journal Illustrated Catalogue of the Industries of All Nations*, 1851. Courtauld Institute of Art, London. The design is based on an eighteenth-century 'lace-pattern' silk. The silk was manufactured by Le Mire et fils, Lyons, and was exhibited at the 1851 Great Exhibition in London.

138 Detail of pl. 135.

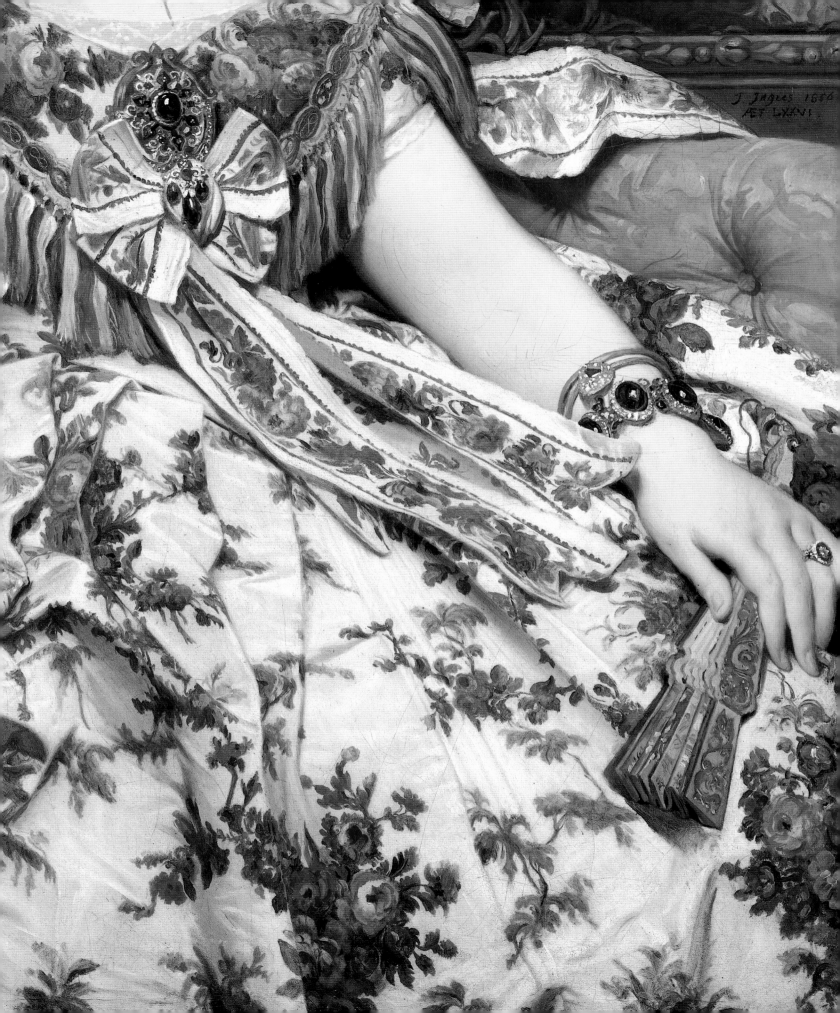

J. Ingres Del.

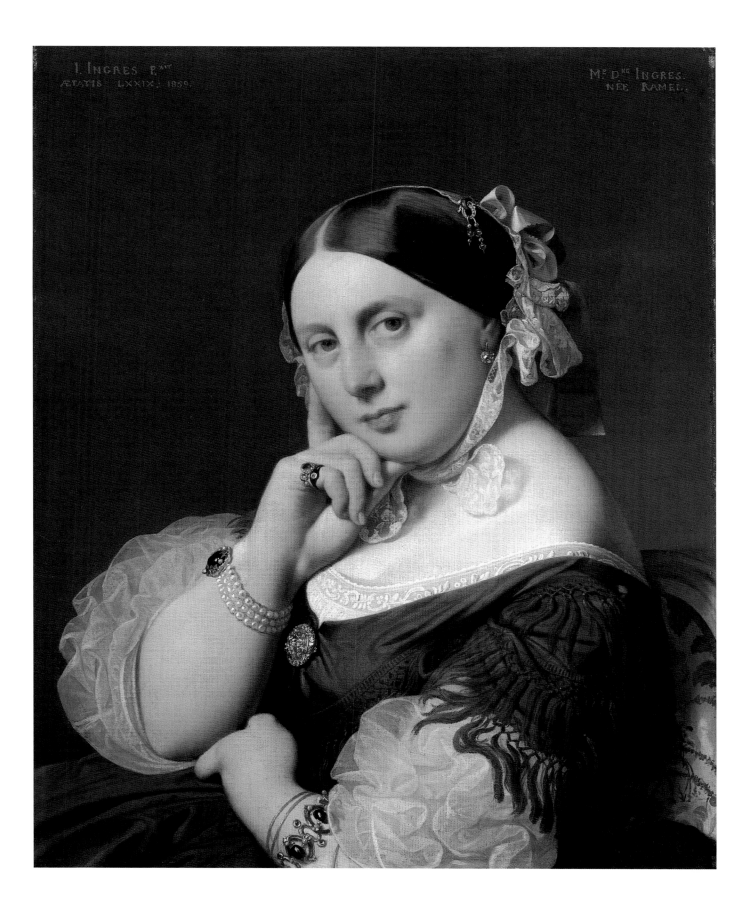

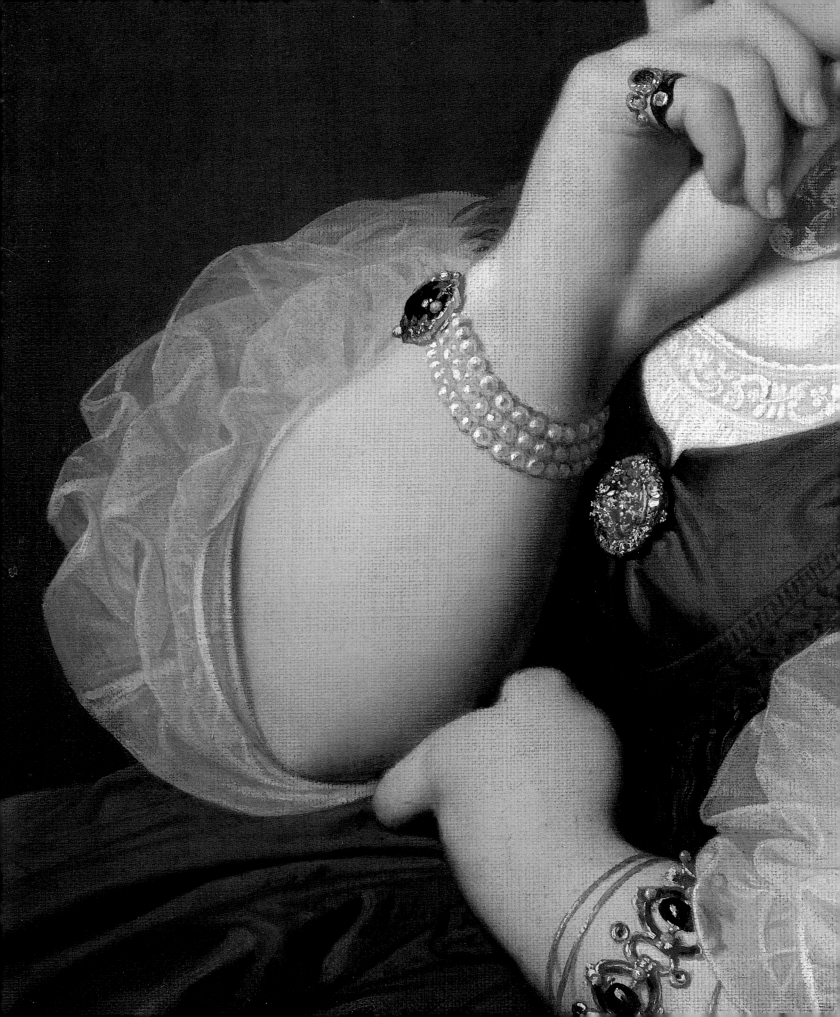

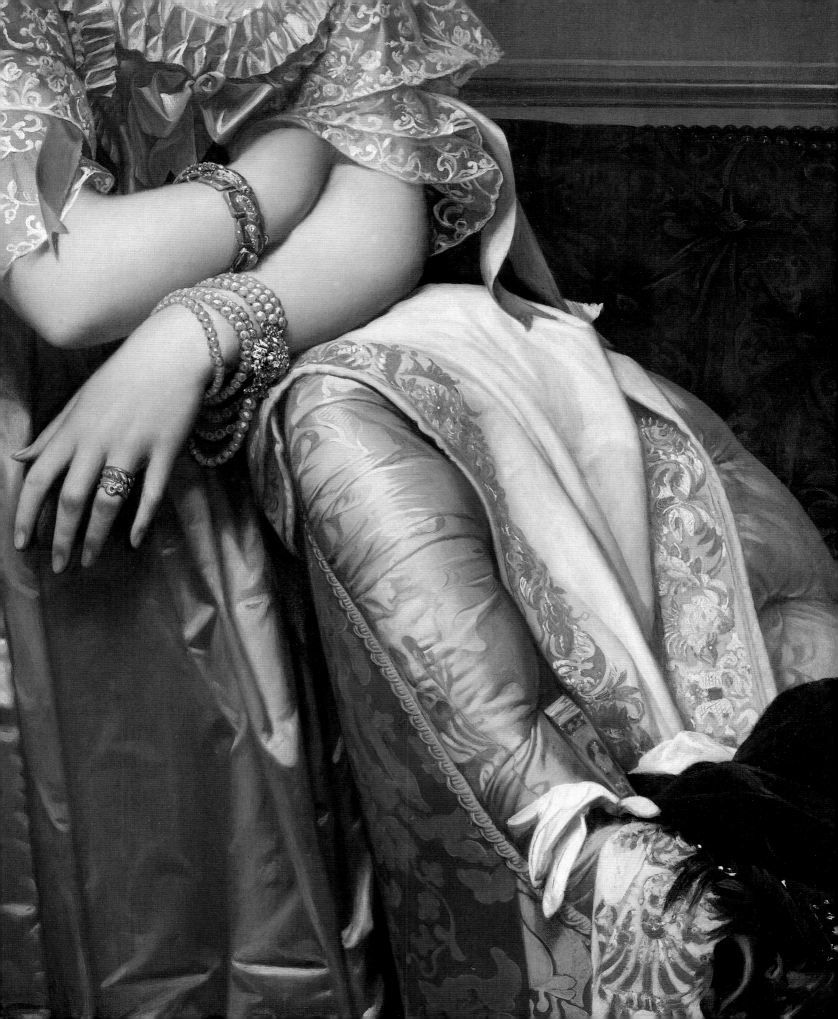

Finery, both in dress and accessories, was particularly necessary when women moved from the domestic sphere into a more public arena, the many social occasions that made up the lives of the fashionable world; these included formal visits, various ceremonial events, dinner parties and grand balls. At times women seemed encased and surrounded by an almost suffocating number of accessories; Flaubert's *Madame Bovary* (1857) describes how the heroine almost faints at the sight of the fashionable women whom she sees at her first ball, with their

> fluttering of painted fans. Smiling faces were half-hidden behind bouquets, gold-stoppered scent bottles twirled in cupped hands whose white gloves showed the outline of finger-nails and pinched the flesh at the wrist. Lace frills, diamond brooches, medallion bracelets, trembled on their bodices, gleamed on their breasts, jingled on their bare arms. On their hair . . . were forget-me-knots, jasmine, pomegranate-blossom, wheatears or cornflowers, in garlands, bunches or sprays.[4]

It is precisely this kind of detail – not just the glamorous accessories such as the glittering jewellery and the flowers – but the ways in which objects relate to the body – how the tight evening gloves describe the shape of the fingernails beneath, how jewellery and lace shivers and moves on the body – that Ingres, too, picks up. His portraits of women show an ever-present awareness of possession, of the things that enwrap them, that dangle from neck and wrist, that cover their heads; things, also that they can play with, such as handkerchiefs, eye-glasses and fans. Some critics have found that what Charles Blanc refers to as the 'vérité frappante des accessoires' (the striking truth of the accessories) can deflect attention from the sitter herself, and almost suck the life from the portraits. Paul de Roux in his recent book on Ingres, claims that such portraits as those of the comtesse d'Haussonville and the princesse de Broglie are depersonalized images; life exists only in the sumptuous exuberance of their costume ('la luxueuese exubérance des toilettes').[5]

Ingres's love of the details of feminine accessories extends throughout his portraits of women, from the formal, public images to the more intimate and engaged figures. The artist delights in accessories for their luxury and tactile appeal; Edmond de Goncourt sarcastically suggested that Ingres aimed to be the 'Memling of the arm of a chair, of a lorgnette or of an embroidery',[6] in other words, to subject such objects to an over-intense and meticulous scrutiny. But it was also Ingres's intention, as Delaborde suggested (in the quotation at the beginning of this chapter) to make the accessories illuminate the individual, the subject of a portrait.

The head was, of course, the focal point of a portrait, whether of a painting or a drawing. With regard to the latter, Ingres often pays more attention to the head than to the rest of the body, as though his interest waned as his eye travelled further down the figure. For example in his portrait of Madame

144 Detail of pl. 28.

Augustin Jordan (pl. 28) the elongated body dressed in checked cotton is of less concern than the hair plaited in a heavy bun and decorated with plaid ribbon tied in a bow at the side of the head. The upper half of the body concerns him more than the lower half, and he concentrates in particular on the lace veil, and on the cashmere shawl where he depicts the pattern on the area by Madame Jordan's right arm, but loses interest when it falls behind her, draped on the chair (pl. 144).

In the nineteenth century only young girls and brides were allowed their hair long; other women could display their unfastened hair only in the intimate surroundings of boudoir or bedroom. Because hair was tied up in a variety of complex ways – plaited, knotted, looped up or arranged in a bun or a chignon – when it was released and allowed to hang free it had a peculiar eroticism to the nineteenth-century (male) eye, which explains the sexual appeal of works such as Ingres's *Odalisque with Slave* (pl. 186), where the abandoned pose of the almost naked figure is complemented by the hair trailing loose.

Ingres seems to have been fascinated by hair and the different ways in which it could be arranged, and then decorated. The different styles of hair that he painstakingly depicts throughout his long career range from the neo-classical curls of Barbara Bansi (pl. 21) in about 1800, to the smooth shining wings of hair in his portrait of Madame Ingres of 1859 (pl. 140); *en route* there are the bizarrely beautiful Apollo-knot coiffures of sitters such as Madame Marcotte de Sainte-Marie (1826; pl. 113) and Madame Raoul-Rochette (1830; pl. 50). Sometimes the hair seems to be an accessory rather than an integral part of the body, and to have a vigorous life of its own; this is particularly so with regard to the curious, segmented hairstyles of the late 1820s and 1830s, where the hair is sometimes plaited, gummed or supported on wires, and energetically curled and ringleted at the sides, as in Ingres's portrait of an unknown woman (1834; pl. 145). It would be interesting to know if Ingres was familiar with Fuseli's feverish depictions of late eighteenth and early nineteenth hairstyles, where the details – large tubular curls and frizzed top-knots – are exaggerated to produce strange and haunting images of fearful female beauty. Like Fuseli, Ingres lived at a time when there was little sense of elaboration or fantasy in men's hair (wigs having been virtually abolished); women, by contrast, took centre stage with regard to their complex and often fantastical hairstyles. In some of Ingres's portrait drawings the head, with its meticulously detailed hair, seems almost to float above the body. In a more practical way, the artist found that the detailed drawing of the hair, shaded in, served to mediate between the pallor of the complexion and the whiteness of lace and linen headdress or cap.

As a classicist, however, Ingres was happiest of all with the simplicity of the style first seen in classical sculpture, the hair parted in the middle and then looped back over the ears; such a hairstyle served to set off the shape of the head and a fine bone structure. This kind of coiffure – variously known as *à la madone* or *à la Raphael*[7] – was in vogue throughout Ingres's career, and can be seen in

145 Ingres, *Unknown Woman* (detail), 1834. Pencil on papter. Sale, Sotheby's, London, 9 April 1970 (111)

146 Detail of pl. 98.

portraits ranging in date from *Madame de Senonnes* (pl. 107) to *Madame Moitessier* (pl. 146). In Gautier's paean to female appearance, *De la mode* (1858), hair is described as a woman's crowning glory, which should be arranged with true artistry – it was equated with the marble of Paros, and the comb likened to the chisel of ancient Greece. Gautier particularly admired the way in which modern women dressed their hair in glossy wings at the side, and gathered it in at the nape of the neck; this style, he says, created beautiful bands of hair which formed pure lines over the brow – here *Madame Moitessier* might be recalled. He was equally enthralled by how wondrously the hair could be made to coil at the back of the head like an ammonite, or like the spirals of an Ionian capital – we might here recall Madame d'Haussonville's hairstyle as reflected in the mirror (pl. 122). Lastly, and with an intensity of poetic rapture, Gautier lists some of the ways in which women could decorate their hair for evening: with jewellery, with ribbons crumpled like the hearts of roses, with nets of velvet, with spangled gold and silver gauzes, with filigree pins, diamond stars, gold fillets, flowers with their foliage, and feathers light as coloured mist.[8] Here

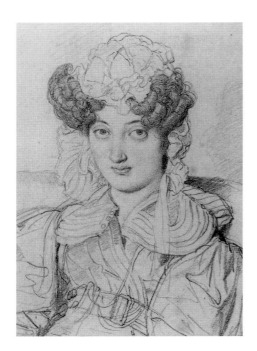

147 Detail of pl. 112.

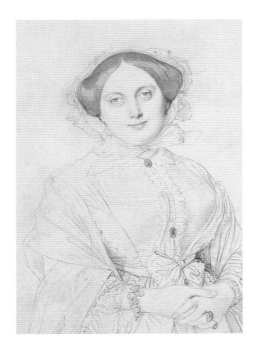

148 Detail of pl. 67.

149 Detail of pl. 140.

Gautier might have evoked Madame Moitessier's pink silk roses, or Madame de Broglie's misty marabou feathers (pl. 132).

In everyday *toilettes*, women wore caps indoors, especially if they were of a certain age. Possibly as a result of his first wife's expertise in matters of millinery, Ingres delights in depicting such forms of headwear; there is a particularly playful touch to his drawings of the frilled caps of the 1820s which appear like cream cakes perched on top of the head – see, for example, the preparatory studies for the portrait of Madame Marcotte de Sainte-Marie (pl. 147). A hierarchy of caps existed for different occasions, growing more elaborate as the century progressed; the terminology, however, is difficult to establish with any precision, for the words and their meanings change over time, and provincial society was usually slower to adopt fashion than the women of the metropolis. According to the fashion journal, the *Petit Courrier des dames* of 1848, a married woman of fashion would wear as an everyday cap a *bonnet* of cotton trimmed with ribbons of lace or silk, and usually tying under the chin; examples in Ingres's drawings include *Madame Hennet* (1842; pl. 60) and *Madame Ingres* (1852; pl. 148). These caps, we are solemnly informed, being quite capacious, could be very useful when the wearer suffered from a cold or a migraine. On more formal occasions a *petit-bonnet* was worn, made of more delicate and luxurious fabrics, and sometimes trimmed with flowers and jewellery; the word 'coquette' is used in this context.[9] By the 1850s these small headdresses had moved towards the back of the head, allowing more of the hair to be seen; one example, in Ingres's portrait of his second wife of 1859 (pl. 149), is indeed coquettish, for Delphine Ingres wears a wholly insubstantial and frivolous confection of ribbons and lace which serves to highlight her large, placid beauty.

Women's caps were on the whole submissive and decorative, signifying their domestic indoors role. Hats, on the other hand, being more structured and assertive, indicated a woman out of doors, in a public place. There was more scope to the creation of a hat, which could signal sexual invitation as well as a demand for distance, it could have topical allusions or it could be classical in form. A truly wonderful hat, claimed the fashion journals, was a work of art and the result of a poetic imagination;[10] it had to be suited to the character of the woman who wore it. Such a woman – and Ingres's *Madame Destouches* (pl. 35) comes to mind – wears her hats with an innate sense of style, which Balzac, in words that sound perilously like a *Vogue* editorial, attempts to define:

> There is an indefinable way of wearing a hat: set it a little too far back and it looks too raffish; set it too far forward and it gives you a crafty appearance; set it to one side and you look too free and easy. Fashion-conscious women wear their hats at the angle that suits them and they always look just right.[11]

Some of the most beautiful still lives in Ingres's paintings of fashionable women occur in the corners of the portraits; they are assemblages of accessories

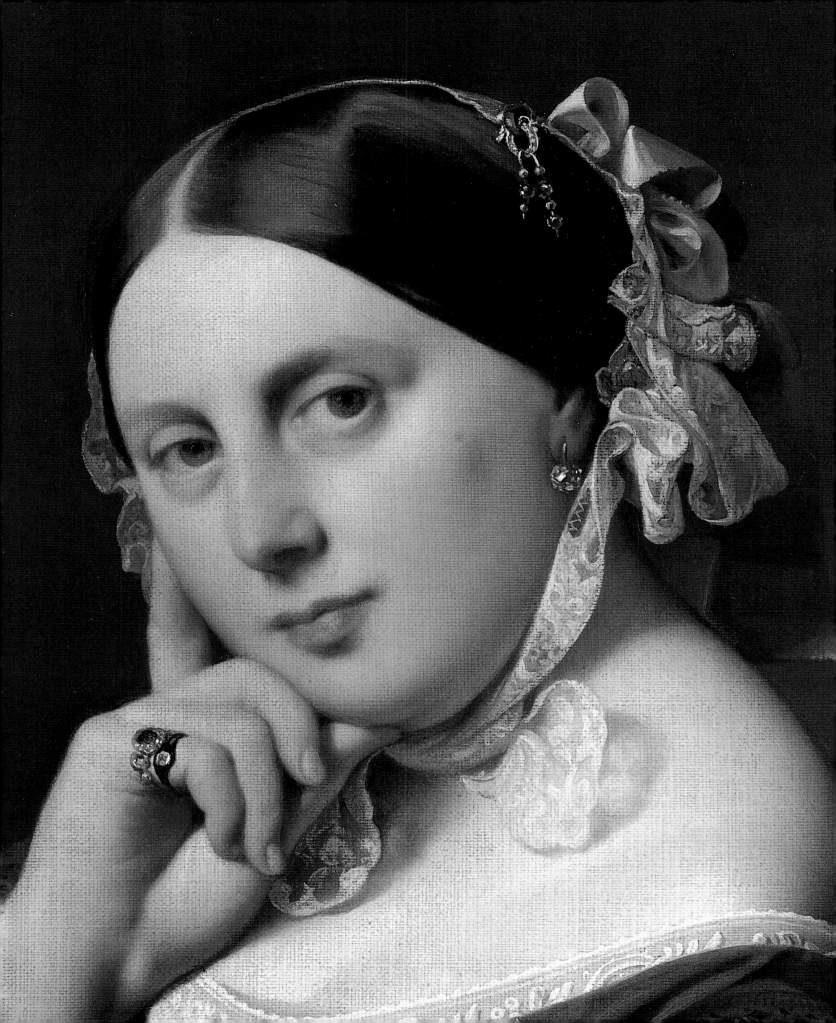

150a and b Madame Devauçay's fan
(pl. 152) is almost identical with this
example, a gilded brisé horn fan of about the
same date, 1808. Courtesy of the Fan
Museum, London, Hélène Alexander
Collection.

151 (*right*) Detail of pl. 188.

152 (*facing page*) Detail of pl. 86.

such as evening mantles, fans and gloves, which are necessary to define the status of the sitter and her taste, but would make the figure too cluttered if worn or carried. On the chair by the side of Madame Moitessier in black (pl. 99), Ingres has painted an evening mantle lined with sable, a lace-trimmed handkerchief, and a pair of kid gloves; the comtesse d'Haussonville (pl. 117) has on her chair a shawl of fringed yellow cashmere with a red paisley border, while the princesse de Broglie's display (pl. 143) includes, along with her embroidered white *sortie de bal*, cream kid gloves and a gold-embossed fan.

Beautiful though these groups of luxury objects are, even more effective is the way in which Ingres makes his sitters act with their accessories, creating a more intimate relationship between the individual and her accessories. It is worth noting, for example, the way that Madame Devauçay (pl. 152) holds her brisé fan half-open on her lap in a gesture of gentle invitation, or the way in which Madame de Rothschild (pl. 125) seems to have just snapped her fan shut before engaging the spectator in an unheard dialogue. In Ingres's *Odalisque with Slave* (pl. 151), the feather fan lies by her side as though flung down in a fit of bad temper or ennui.[12]

153 J. Lewis, *Woman with Sphere*, 1995.
Pastel. Portal Gallery, London.

154 Detail of pl. 80.

Accessories such as fans can be played with by the sitter in a portrait in a way that expresses a state of mind, as well as drawing attention to the luxury of the craftsmanship. Other accessories, those worn on the body, serve a more intimate purpose, to heighten awareness of the body. The most apt example is the glove, the only accessory in use today whose shape has remained virtually unaltered over the centuries. In the past (less so today) gloves indicated status and wealth through their fine leather and choice decoration (usually embroidery, sometimes incorporating semi-precious stones), but they were also erotic – the insertion of the hand into the glove is expressive of the sexual act. Gloves, once the hand has been withdrawn, take on the shape of what they cover; they can symbolize the absent human presence. In the work of Giorgio de Chirico, for example, gloves signify longing and melancholy; they can also take on a life of their own to become a slightly sinister force in his still-lives. In the beautiful and enigmatic pastels of Jane Lewis (pl. 153) gloves draw attention to the rounded forms of the naked female body. This is maybe what Ingres has in mind in his portrait of Madame Panckoucke (pl. 154); she seems to be preoccupied with forcing the fabric of her gloved hand down between the fingers, and still the thumb seems too long.

The most eloquent gloves – mittens in fact – are worn in Ingres's *Mademoiselle Rivière* (pl. 155); their very bulkiness (they look too big for her) forms a startling contrast to the delicacy of her white muslin gown, signifier of her touching fragility. Mademoiselle Rivière is a young girl on the verge of womanhood, and Ingres has gently suggested her incipient sexuality, not just in the slight curve of her breast, but in the insinuating lines of the white swansdown *palatine* looped around her. Fabrics such as swansdown and fur have an erotic and tactile quality, inviting the desire to touch and to stroke.[13] For Ingres the winding shapes of the fashionable stoles created a satisfying and seductive serpentine line; in just the same way that Mademoiselle Rivière is eternally chained by her beautiful *palatine*, so too is *Madame Hittorff* (1829; Louvre, Paris) entwined in a similar garment which snakes round her neck and arms.

Of all the accessories that wrap around the body, the shawl is the one that receives the most devoted attention from Ingres; arrangements of shawls form some of the artist's most beautiful still lives.[14] 'Still' is perhaps the wrong word for the supple, long, rectangular shawls of the early nineteenth century in particular, which have a life of their own as they move with the body and underline gesture and pose. First brought from India (where they were worn mainly by men over their shoulders, in Kashmir), shawls became a fashion accessory for European women at the end of the eighteenth century. The market was dominated by the British East India Company, and once Britain and France were at war, shawls became forbidden and increasingly expensive commodities for the French to obtain; the situation was made even more difficult by the Continental blockade of 1806. Already costly, the clandestine

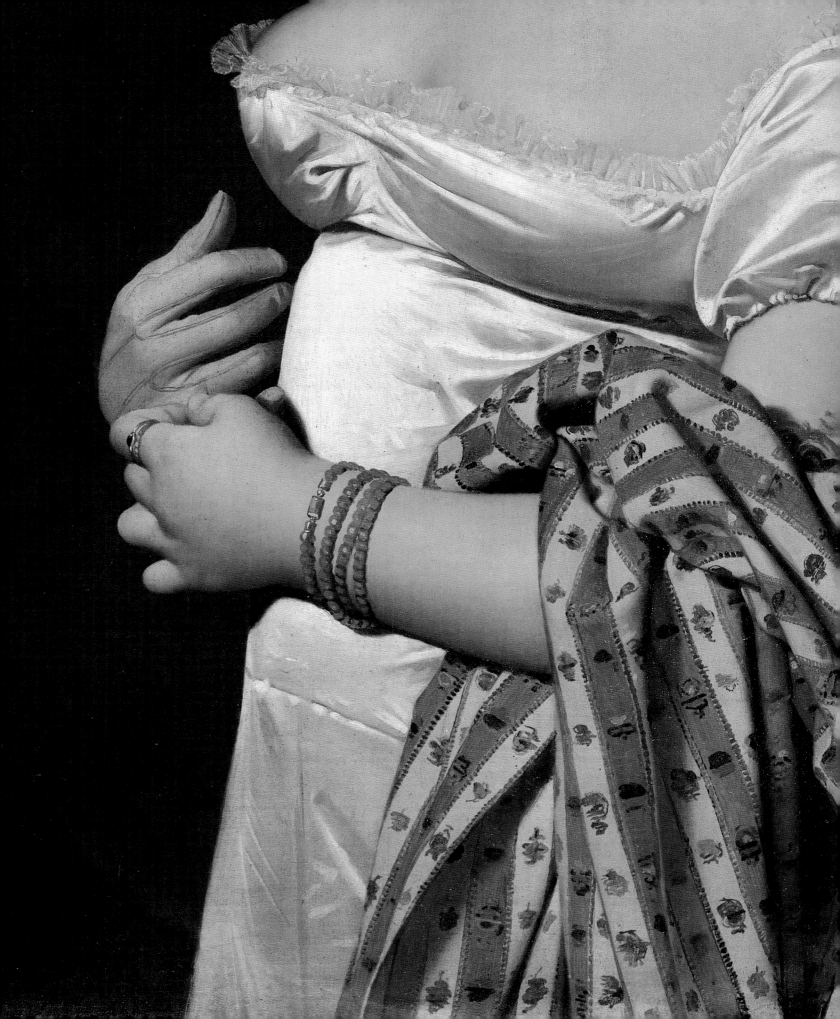

market pushed the prices up even higher, as every woman of fashion coveted these rich and luxurious items that were the perfect complement to the neo-classical dresses in vogue, 'the elegance of a woman can be equated with the quality of her shawl, or rather, of its price', stated the *Journal de Paris* in 1805.[15] On all counts, Madame Rivière (pl. 78) must be one of Ingres's most elegant sitters. Ingres loved the sculptural qualities of fine cashmere as it draped on and around the body; in particular he seems to have liked the pale cream shawls with wide borders woven with a stylized pine-cone motif, known widely, if inaccurately, as a Paisley design.[16] These are the shawls that Madame Rivière wreathes around herself (pl. 158), that Madame de Senonnes has let fall casually on to the yellow satin cushions of her sofa (pl. 156) and Madame de Tournon drapes on the arm of her chair (pl. 157). Such shawls are softer and more malleable than those with an all-over woven pattern (sometimes known as Persian shawls, according to the *Journal des dames et des modes*, 1809) of the kind that Madame Panckoucke carries over her arm.

Although by the second decade of the nineteenth century, the French were producing imitation cashmere shawls in fine wool, and with more 'European' designs – Ingres's *Madame Leblanc* (pl. 159) has such a one – they were never as fine or delicate as the Indian originals. After the end of the First Empire, cashmere shawls became freely available and their popularity soared; fashion magazines and contemporary novels testify to female cravings for these 'schalls' – according to Stendhal they could be a menace to virtue as women would do anything to obtain one. The *Règne de la mode* (1823) satirizes the obsession with shawls with a catechism; after every question, the answer is 'a cashmere'. So, for example:

> What is the first desire of a young woman as soon as she has reached the age of coquetry, which precedes the age of reason?
> A cashmere.
> What does a woman desire more than a husband and always prefers to him?
> A cashmere.[17]

Such shawls, according to the *Petit Courrier des dames* of 1840, were symbolic of a world of luxury and pride; they signify material wealth in poetry, novels and plays, as they do in real life.[18] In Flaubert's *A Sentimental Education*, Marie Arnoux's shawl represents her taste (and by implication her husband's wealth) and her sexual appeal as it is described encircling her body. When Frédéric Moreau first meets Marie in 1840, on board a ship, she appears to him like the heroine of a romantic novel; every item of her clothing assumes sentimental significance, including 'a long purple-striped shawl [which] dangled over the brass handrail behind her back. How often, on damp evenings during long sea voyages, she must have wrapped it round her, covered her feet with it, even slept in it'.[19] Ingres's sitters do not treat their shawls in this way, for cashmere

155 Detail of pl. 76.

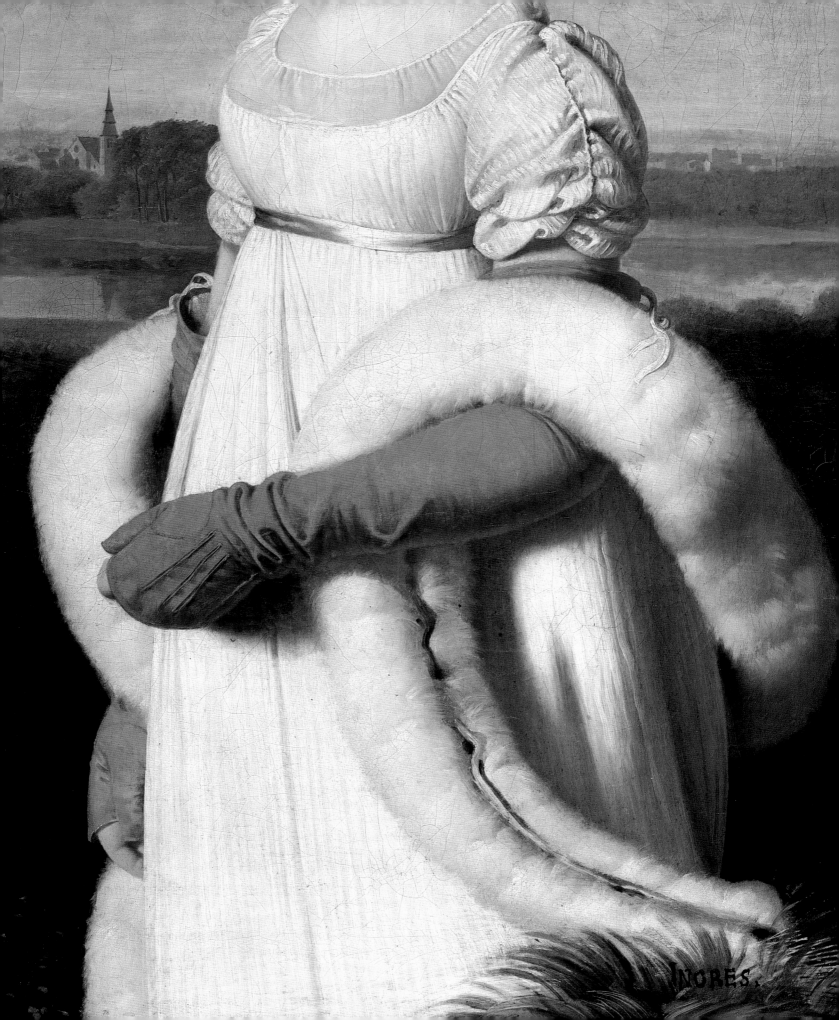

156 Detail of pl. 107.

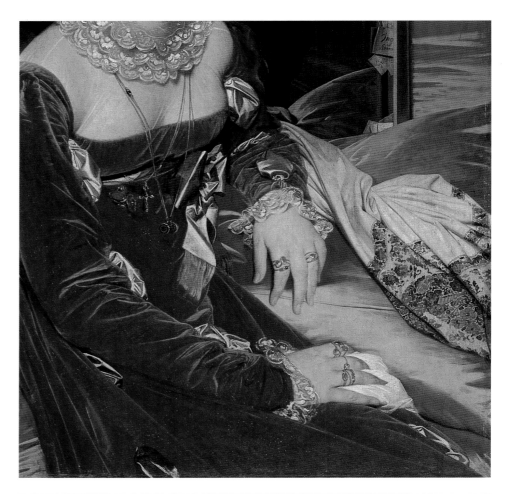

157 Detail of pl. 105.

158 (*facing page*) Detail of pl. 78.

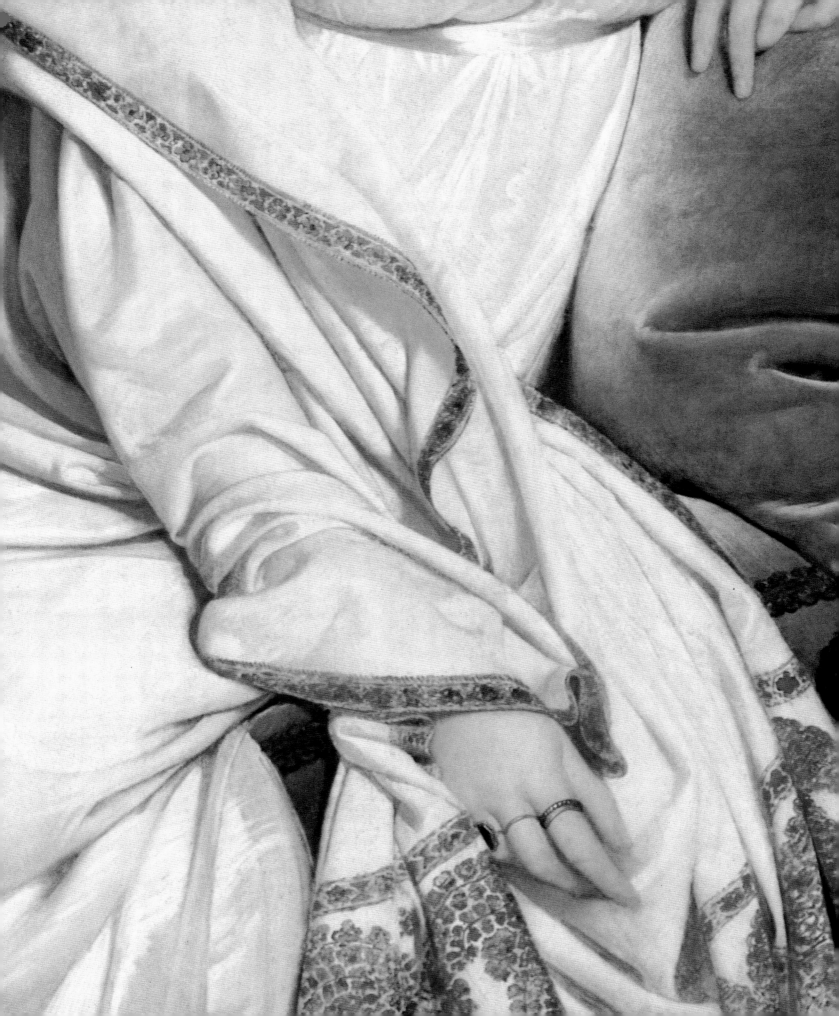

was far too expensive and luxurious (Marie Arnoux's shawl was almost certainly not cashmere), but there is the same sense, as in the novel, that women's bodies are defined – perhaps made even more feminine – by the curves, the colour and the comfort of their shawls. Ingres appreciates the way in which the shawl draws attention to the body, and almost takes on the personality of the wearer.

Among other accessories, the most personal items are jewels – sometimes these are sentimental trinkets such as lockets containing hair or a miniature, sometimes they are expensive objects made of precious stones, possibly family heirlooms re-set in the current taste. While it could be said that women were constrained to follow the main trends in dress (although colour and fabric could vary), greater individuality and freedom could be expressed in the choice of jewellery. Ingres was well aware of the importance jewellery had in putting the final touches to an outfit; even in his drawings, the jewels are sometimes heightened with touches of gold. He knew how to select the kind of jewels that would enhance the character of a portrait and complement the costume. His choice ranges, for example, from the delicate hair necklace and bracelet of *Madame Devauçay* (pl. 152), which subtly reinforces her 'Renaissance' image as well as being unusual and modest in accordance with neo-classical taste, to the imposing – even ostentatious – designs in precious and semi-precious stones worn by Madame Moitessier (pl. 138), typical of the mid-nineteenth-century vogue for an abundance of rich and heavy jewellery often in revivalist style.

Ingres explores the possibilities of long chains which loop round the neck and over the torso; this was a style particularly in fashion during the 1820s, as is evident from Madame Marcotte de Sainte-Marie's silver chain and eye-glass (pl. 160), and the satisfyingly heavy gold link necklace that Madame Leblanc wears (pl. 159), which outlines the shape of her prominent bust and ends in the watch pinned to the belt of her dress. The artist loves also to paint the soft gleam of pearls, which were constantly in fashion and flattering to all complexions: Madame Ingres in 1859 wears a lustrous pearl bracelet with a large cabochon garnet clasp (pl. 141), and earlier in that decade, Madame Moitessier, dressed in black, toys moodily with a long pearl chain (pl. 98).

What saves the depiction of jewellery from being conventional, even boring, is the way in which Ingres arranges it on the body with the creative skill of a designer or a fashion photographer. He will put two bracelets on one wrist (Madame Marcotte de Sainte-Marie's bands of gold mesh (*or tricoté*) with their large amethysts); he brings the clasps of necklaces from back to front (*Madame Rivière*, pl. 16, and *Madame Aymon*, pl. 104); he sometimes uses a necklace as a bracelet, twining it round the wrist to create asymmetrical movement (Madame de Broglie's pearls, looping unevenly round her left arm, pl. 143). In the portrait of Madame de Senonnes, Ingres takes the fine gold chain from which hangs a diamond cross, and removes one side of it, tucking it into her belt as a kind of disappearing trick (pl. 156); it may be that this chain supports the bunch of seals hanging at her waist.

159 Detail of pl. 94.

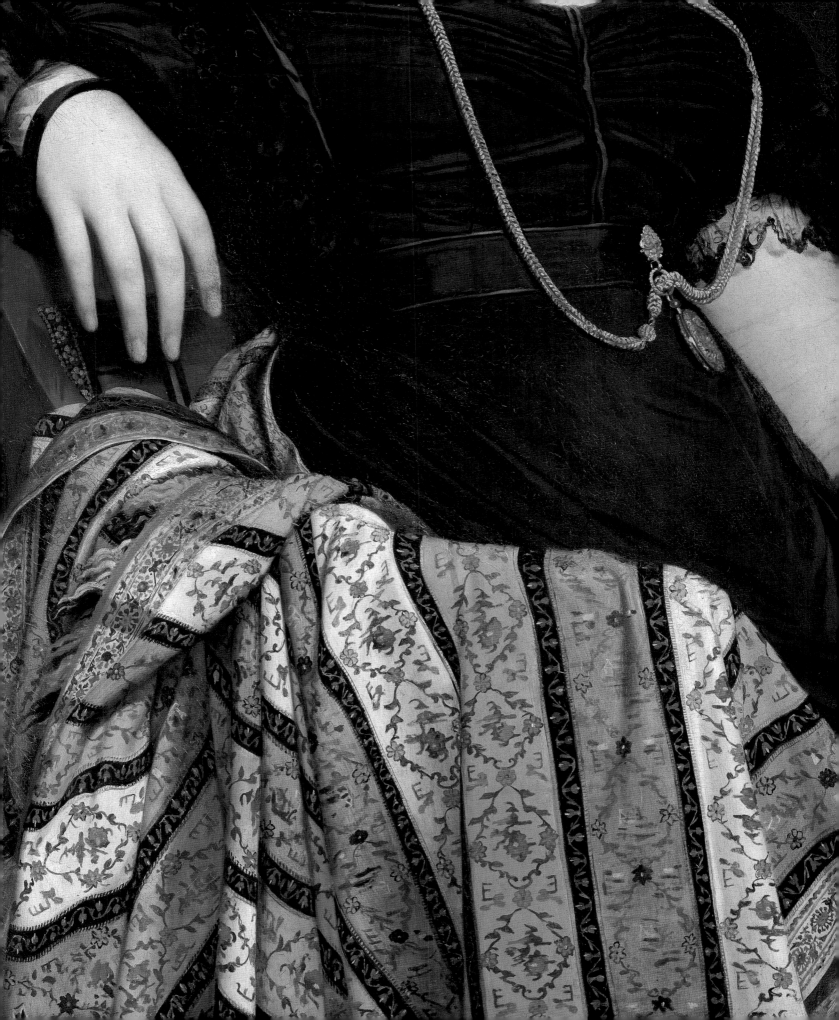

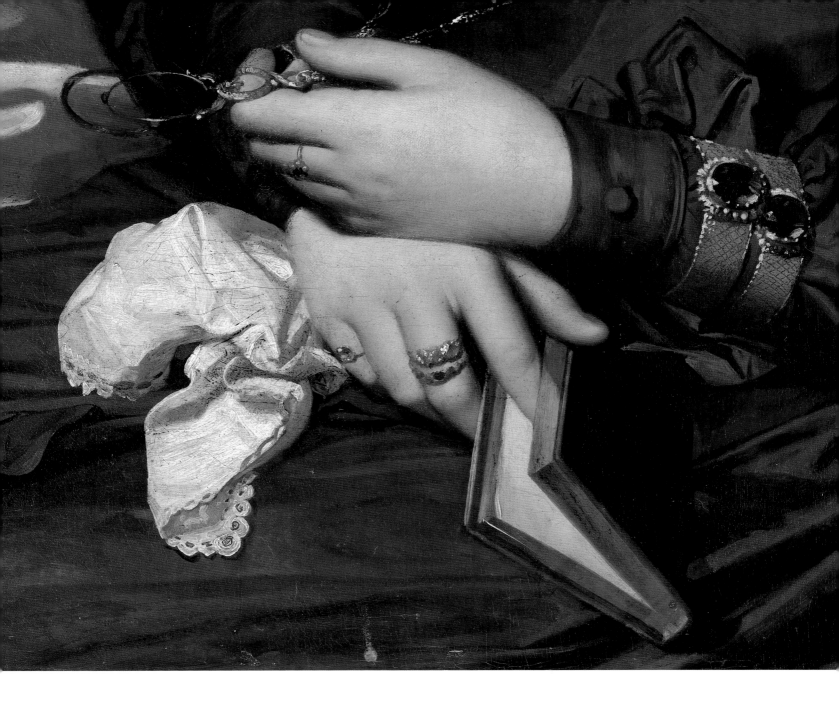

160 Detail of pl. 113.

The jewellery in Ingres's portraits is real, painted with an intensity owing more to the sensual appreciation of luxury than to a bourgeois assessment of its worth and cost. Ingres loved the virtuoso depiction of the different colours and qualities of precious stones, a skill that he employs not just in portraits, but in the idealized beauties of his odalisques, where the jewellery is invented and where the artist's imagination can have full sway. Ingres's imagination, however, is always based firmly on artistic precedents; in the *Grande Odalisque*, for example, the ruby, diamond and pearl ornament in her hair is inspired by Renaissance brooches, and the stunning still-life of the discarded gold girdle by

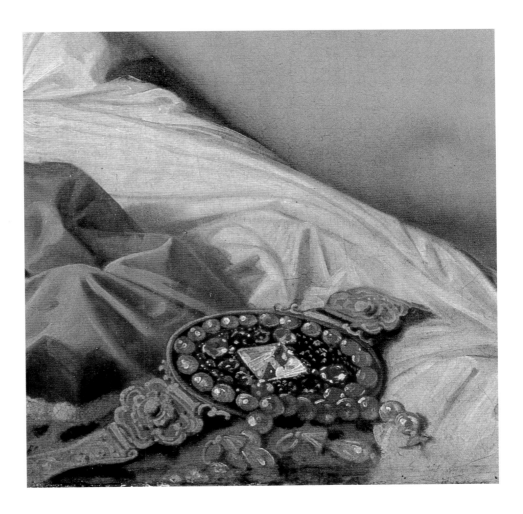

her side, fastened with a huge clasp, also of pearls, rubies and diamonds (pl. 161), is reminiscent of the kind of vast jewelled morse (the clasp of an ecclesiastical cope) that we see in van Eyck's figure of God in the Ghent Altarpiece.

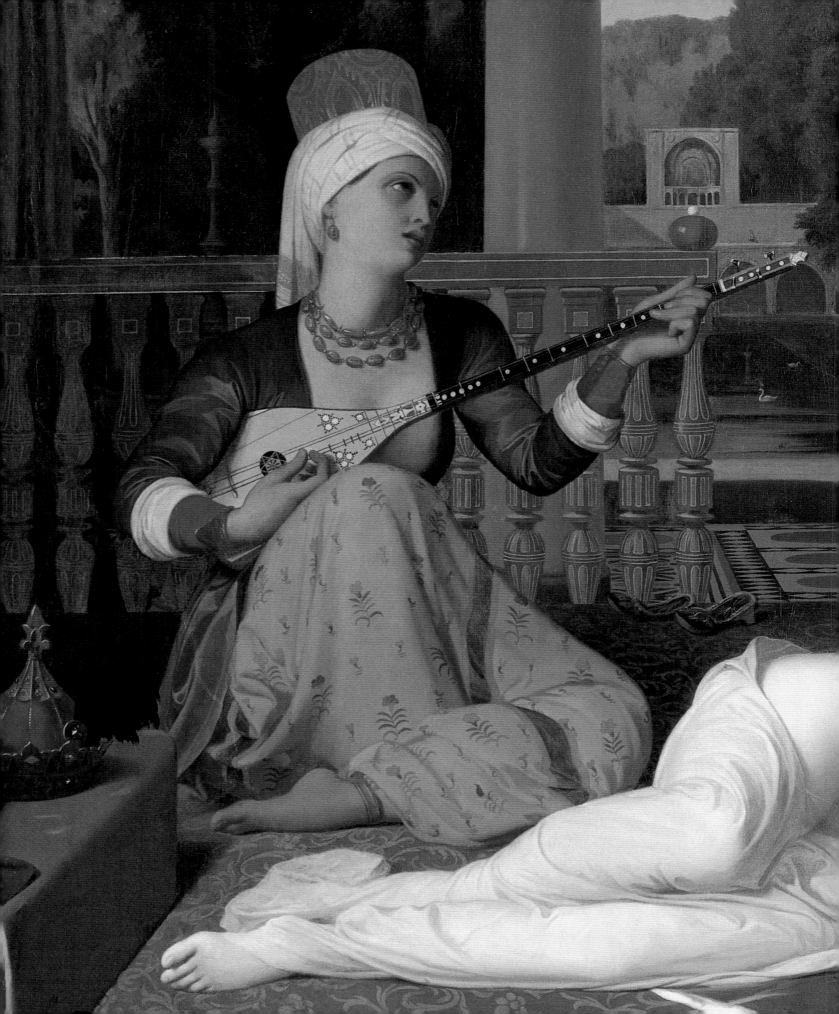

Ingres's Orientations

IN INGRES'S IMAGES OF BATHERS and odalisques, East meets West; they are clearly western women clothed (or, rather, barely clothed – perhaps decorated would be a more accurate word) in various kinds of European and Turkish textiles and accessories, set within an oriental context – the bath and the harem. They are women in whose bodies and surroundings Ingres marries his love of fashion, luxury and sensuality to his sense of history in the recalling of the great Renaissance nudes and to his imagining of the East.

After a few remarks on Ingres's attitude towards the idealized female nude, this part considers the background to the portrayal of his bathers and odalisques. It is concerned with the long-established conventions of western artists depicting the Orient, and the impact made by the East – Turkey in particular – on nineteenth-century French culture, including costume and accessories. The cult of the bath and the concept of the harem – aspects of Ottoman society that fascinated the West – are discussed in the context of European perceptions of them. How Ingres interpreted these themes in his art forms the subject of chapter 11. The artist, who never visited the East, conjures up – with the aid of costume books and literature (Montesquieu's *Lettres persanes* and the *Letters* of Lady Mary Wortley Montagu, for example) – luxury furnishings and textiles – the Orient of his imagination. His bathers and odalisques are fantasies – albeit solidly corporeal – of the East, of the Renaissance nude, and of a Platonic ideal of female beauty. For some fifty years, Ingres experimented with 'oriental' themes, often reusing his images as though endlessly fascinated by his own absorbing interest in an oriental imaginary world.

162 Detail of pl. 188.

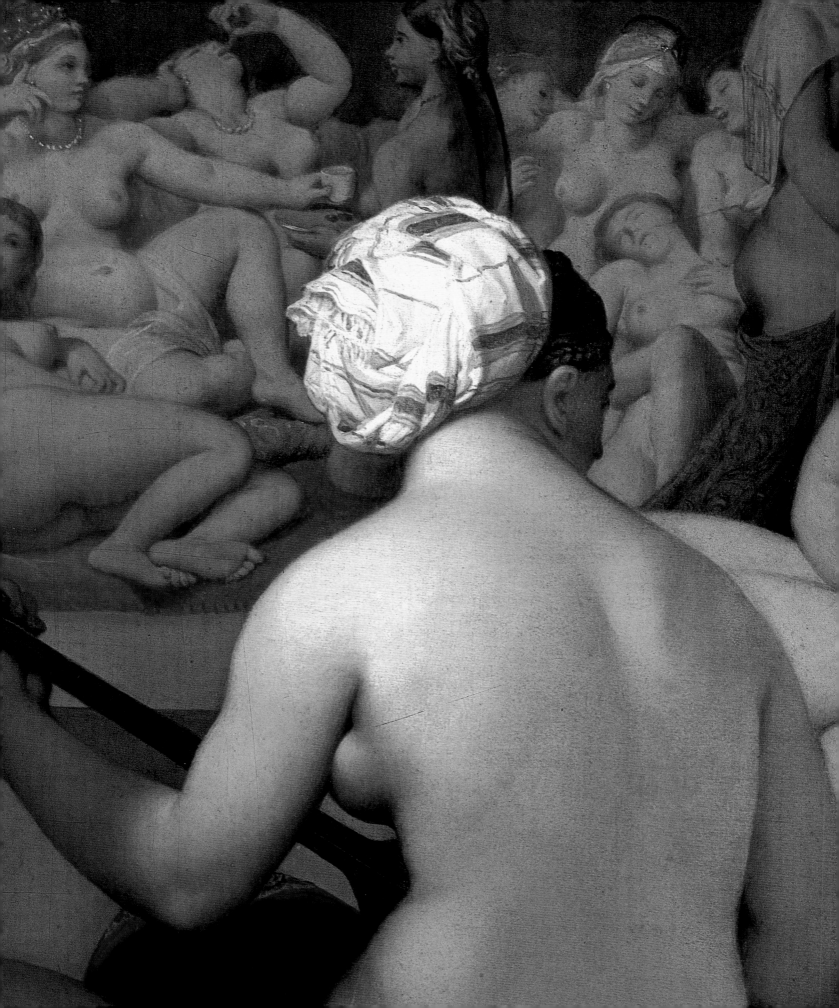

10 Eastern Promises

And the women?

Théophile Gautier, *Constantinople* (1853)

FROM THE TIME THAT Constantinople fell to the Turkish armies in 1453 – an event that brought the Ottoman Empire into Europe – (and created a military threat that lasted until the late seventeenth century), Turkey was to be an endless source of fascination to the West. The European imagination, for hundreds of years, fed on a diet of exotic travellers' tales about the fables of the Orient, created works of art around their perceptions of Ottoman life and culture.

Since the early sixteenth century France had been the principal European ally of the Ottoman Empire, and an important trading partner; colonies of French merchants and their families were established in Constantinople from the late seventeenth century, often adopting Turkish costume and ways of living. Further interest in the Near and Middle East and in Arab culture was created by Napoleon's Egyptian campaigns at the end of the eighteenth century, and French colonial expeditions to North Africa from 1830 onwards. Against a background of political and commercial considerations, the French sphere of influence extended to the Middle East; in its wake came topographical and archeological exploration and a new interest in Biblical studies, alongside a more scientific and organized investigation of oriental cultures and civilizations. Important political events such as the Greek War of Independence (1821–30) – which caught the imagination of writers and artists – focused attention on the wider Ottoman Empire, an empire in decline but still colourful, magnificent and – above all – romantic.

The romance of the East was nurtured by a wide range of artists and writers from the second quarter of the nineteenth century onwards, flourishing during the adult career of Ingres, whose 'oriental' scenes were created from research and imagination and not from travel to the East. Delacroix, on the other hand, visited Algeria and Morocco in 1832, and his famous painting *Women of Algiers in their Apartment* (Musée du Louvre, Paris) was one of the talking points of the 1834 Salon. Unlike the often escapist fantasies of many orientalist artists, Delacroix's work reveals accuracy in detail (of costume, pose and interiors), allied to an intensity of vision that is truly Romantic and individual. Some orientalist art, however, is far less subtle, pandering to the European notion of

164 Detail of pl. 185.

165 A. Zo *'Le Rêve du croyant'*, *c.*1870. Oil on canvas. Musée Bonnat, Bayonne.

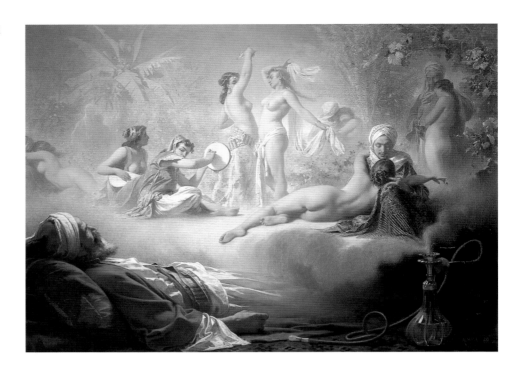

the constant sexual activity in eastern cultures, and in particular the perceived Muslim conception of Paradise as an unlimited number of beautiful and available women. Achille Zo's *'Le Rêve du croyant'* (pl. 165) of about 1870 is typical of the genre; the dream of a sleeping believer issues in a cloud of steam from the hookah at his side, and centres around a group of mainly naked, nubile and fair-skinned young women (houris) cavorting with handsome (and fully dressed) young men. Blatant sexual and racial stereotyping can occur in some orientalist art, barely disguised (and perhaps even enhanced) by a veneer of academic research into local colour and costume. In contrast, Ingres merely hints at the possibilities of sexual encounters in his images of the Orient; there is no need to assault the spectator with heavy innuendo, nudges and winks.

One of the ways in which artists and writers entered the world of oriental imagination was through costume and textiles, which were so different from the clothing and accessories of the West. Sometimes travellers to the East wore local costume, as though by assuming an exotic outside they could also take on an exotic inside, a different non-European persona where new experiences – even sexual encounters – were possible. When, after the 1830 Revolution (of which he strongly disapproved, being at that stage in his life an ultra-royalist) the poet Lamartine travelled to the East, he adopted Turkish dress on a visit to Constantinople, and he has much to say about the 'barbaric magnificence' of the various kinds of female oriental costume that he saw on his journeys.[1] A decade or so later, the poet and visionary Gérard de Nerval travelled to the East, in search (like Flaubert) of exotic or erotic sexual experiences, and at the

same time in quest of the eternal female, as unlike as possible to western women with her materialism and constantly changing fashions. In his *Journey to the Orient*, a strange mixture of truth and poetic fancy, this longing is revealed:

> There is something extremely captivating and irresistible in a woman from a faraway country; her costumes and habits are already singular enough to strike you, she speaks an unknown language, and has, in short, none of those vulgar shortcomings to which we have become only too accustomed among the women of our own country.[2]

It is true that while a number of writers and artists who travelled in the East were often uncomfortable with the different religious and cultural traditions they found there, they discovered much to admire, especially when they compared oriental civilization with the problems of industrialization and urbanization in western European society. Although it is not clear how much such travellers understood in depth of the places they visited, they were, on the whole, tolerant and usually unpatronizing. They responded in different ways to their experiences in the East, and they helped to establish a set of references and a cultural climate in which the artistic imagination could flourish. More immediately, as was the case with an artist such as Ingres, they gave new impetus to the depiction of the female nude who was now surrounded by oriental as distinct from western finery.

A long-established theme in European attitudes towards the East was that of the hidden, delectable woman (perhaps one of many) who was only available to her lord and master, the Sultan. In the eighteenth century – when *turquerie* was very much in vogue – Boucher painted odalisques in attitudes of sexual invitation or post-coital indolence; lying on her stomach on a blue velvet sofa, the Louvre *Odalisque* (pl. 166) of the 1740s has her legs apart and her white shift falling off her shoulders and rumpled up above her waist. The placing of the shift serves to heighten the sexuality of the figure which would be lessened if she were totally naked. The spectator can almost experience the textures of the fabrics next to her skin – the softness of the linen shift and the firmer slightly furry pile of the lustrous velvet on which she is displayed. Boucher, like Ingres, never travelled to the East, and there is little of the Orient in his odalisque's appearance, except for a slight hint in the feathered headdress, and perhaps in the discarded striped dress – in contemporary textile terminology striped fabrics were often given oriental names (Ingres's *Odalisque with Slave* has a striped silk cushion under her head). In comparison to the blatantly sexual image of Boucher's odalisque (much franker than any nineteenth-century equivalent), the majority of eighteenth-century artists preferred to depict the clothed figure *à l'orientale*, thus expressing their fascination with the details of the dress and accessories of Turkish women which is such an important aspect of *turquerie*, a more delicate art form than nineteenth-century orientalism. Liotard's *Woman in Turkish Costume* (pl. 167), which probably dates from the 1740s, shows

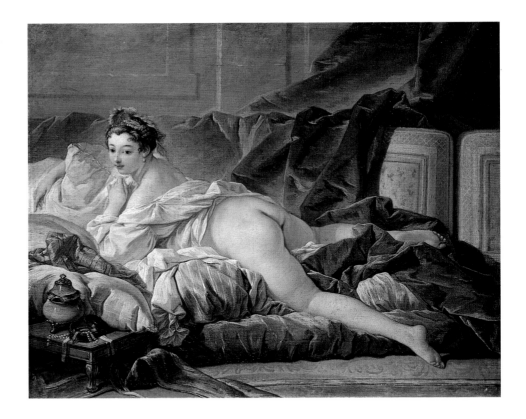

accurate Turkish dress, comprising a transparent silk shift over striped trousers and a caftan with hanging sleeves. Liotard travelled in Turkey from 1738 to 1743 and his depictions of local costume as well as the versions worn by the European women he portrayed (residents of Constantinople as well as fashionable sitters in the West) made him an invaluable source of information on Turkish costume for his contemporaries and for later artists.

Those sitters who did not travel to the East, required a range of visual and literary source material to help them evoke a world of oriental splendour, and by Ingres's time there were many illustrated books, costume plates and travellers' accounts which could provide the background information an artist would find useful. It is certain that Ingres consulted at least four of these books.

Nicolas de Nicolay's *Les Quatre Premiers Livres des navigations et peregrinations orientales*, was published in Lyons in 1568; the plates are illustrated by the author and etched by Louis Daret. Nicolay accompanied a French embassy to Constantinople in 1551, and spent much time taking down details of all the costumes he saw worn by the very diverse inhabitants of one of the first great multicultural cities. Although of course he was not allowed to see the royal harem, his friendship with one of the palace eunuchs enabled him to see the kind of costume worn by the odalisques, for this employee of the Sultan arranged for 'two publique Turkish women' (the quotation comes from the

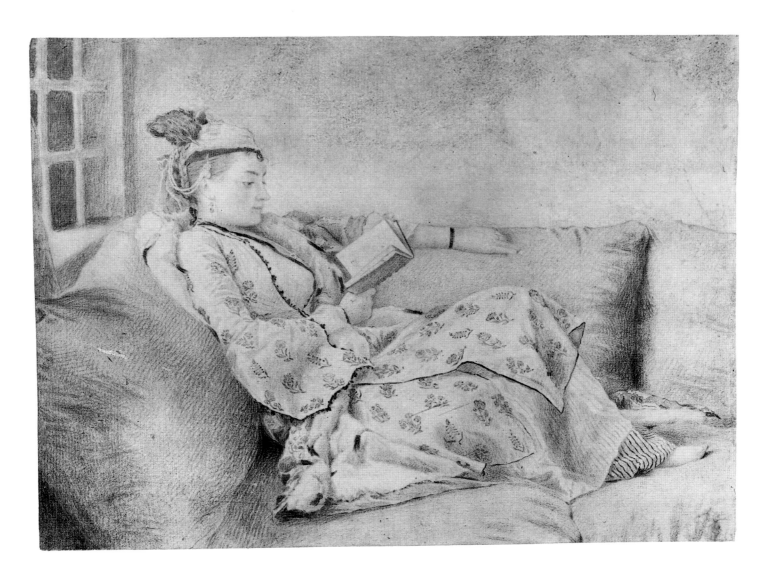

167 J.-E. Liotard, *Woman in Turkish Costume*, *c*.1746. Red and black chalk. National Gallery of Victoria, Melbourne, Felton Bequest.

English translation of 1585) to wear it so that drawings could be made. Nicolay's book was the first serious work in which Turkish costume was discussed and depicted accurately; translated into a number of European languages, it was crucial in the dissemination of Turkish imagery into European art. Rubens used it in his famous *Costume Book*, now in the British Museum, and Ingres certainly had access to a copy.

The *Recueil de cent estampes representant differentes nations du Levant*, was published in Paris in 1714. This sumptuous volume of coloured engravings was commissioned by the French ambassador to the Sublime Porte, Charles de Ferriol, who was fascinated by the range of clothing worn by the Turkish and non-Turkish inhabitants of a far-flung empire. He chose an artist long resident in Constantinople, Jean-Baptiste Vanmour, to paint a selection of costumes, and these were then engraved by a number of different artists. The accuracy and the high artistic content of the plates ensured that they were a major source

of inspiration to artists (and to theatre and masquerade designers) throughout the eighteenth century and well into the nineteenth, Ingres among them.

Ingres also knew Francis Smith's *Eastern Costumes* of 1769. Smith accompanied an English aristocrat, Lord Baltimore, on a visit to Turkey in 1763–4, and produced a series of vignettes of Turkish life and costumes which were engraved by a number of artists. (Lord Baltimore, incidentally, was so taken with the notion of the harem, that on his return to England he tried to establish his own; however an action was brought against him for rape in 1768, and although he won the case, he went to live abroad.)

The most famous written source that Ingres used was the *Letters of Lady Mary Wortley Montagu*, which were published in 1763 (French translations appeared in 1763, 1764 and 1805). Lady Mary visited Turkey with her diplomat husband from 1716 to 1718. She travelled round the country and – being a woman – was able to get access to the harem and to the female public baths; she was the first western woman to discuss in some detail the private lives of Turkish women, contributing vivid word pictures (which inspired Ingres) 'of uninterrupted pleasure, exempt from cares, their whole time being spent in visiting, bathing, or the agreeable amusement of spending money and inventing new fashions'.[3] While in Turkey, Lady Mary had a complete Turkish costume made for herself, and was also painted *à la turque*. Like many other travellers she brought back some Turkish costume to the West, thus helping to promote the vogue for *turquerie*. Later in the century Liotard also brought back a selection of Turkish costumes and accessories which were used as studio props; they may have been borrowed by other artists as a more direct and informative source than paintings and engravings, however precise.

Collecting was a passion during the late eighteenth century and early nineteenth century. Some of the more important and homogeneous collections were to become the bases of the great museums of the period; others – smaller and perhaps more quirky – remained private concerns. Among the latter was a collection formed by the dilettante artist Jules-Robert Auguste (1789–1850) who, in his eastern travels, had amassed oriental clothing, textiles, arms and armour, and furniture, among other things. Delacroix mentions in his *Journal* the visits he made to Auguste, and the costumes he borrowed for his paintings. Auguste also knew Ingres and owned some of his drawings;[4] it may be that Ingres was loaned oriental textiles and accessories for such works as the *Odalisque with Slave*, which is particularly rich in décor and detail (pl. 168).

There were also other local sources from which an oriental *mise-en-scène* could be created on the canvas. The Parisian shops could provide such fashionable accessories as scarves and turbans, jewelled ornaments and feathers, silks and velvets; the theatre and the carnival were places where oriental costumes – of varying accuracy – were on show. Louis Réau claimed that Ingres was happy to utilize 'accessories from the bazaar or the masked ball; turbans, striped cotton scarves, fly-whisks and hookahs' in his painting.[5]

168 Detail of pl. 186.

head to foot. Occasionally, like his friend and predecessor Maxim DuCamp (who travelled to the East with Flaubert and published his *Souvenirs et paysages d'Orient* in 1848), Gautier visited the Sweet Waters of Asia (the Asian side of the Bosphorus) in order to catch a glimpse of women from the court harem who were sometimes allowed out on excursions to the pleasure gardens there. When their light floating all-embracing mantles, known as *feridjes*, were blown aside by gusts of wind, he was able to admire their 'breasts as white as marble'. He confesses to a fantasy (unachieved) of meeting 'a sultana dripping with gold and precious stones, whose smile suggests voluptuous promises, soon to be realized'.[13]

What, then, was the harem, the idea of which occupied the minds of so many writers and artists? It was, one recent account states: 'The separate, protected part of a household where women, children and servants live in maximum seclusion and privacy . . . It is a place in a noble and rich house, guarded by eunuch slaves, where the lord of the manor keeps his wives and concubines'.[14] The word comes from the Arabic *haram*, meaning that which is holy, protected, and forbidden. To the West, it was a world within a world, especially the harem belonging to the sultan, envisaged as a vast collection of beautiful, richly dressed (or undressed) women with legendary sexual skills. To the European imagination the very word conjured up a host of potent images concerning the perceived sexuality of Islam – images that were at the same time appealing and slightly shameful, even threatening.[15] Deriving (authorities differ) from Muslim notions of polygamy and Byzantine ideas that women should be secluded, the harem was the focus of life at the Ottoman court; from 1541 it was located in the Seraglio, the palace complex belonging to the sultan and the centre of government, until it was abolished in 1909.[16]

This quintessential harem, housing hundreds of women, was situated between the sultan's private apartments, and those of the *khislar aga* or chief black eunuch, who ruled the harem along with the *sultana validé*, the Sultan's mother. The *khislar aga* was also responsible for maintaining the complicated sumptuary laws of the harem, which distinguished Muslim from non-Muslim, and underlined status and hierarchy within this large and secret world. Symbolic items of clothing marked sexual encounters between the sultan and his harem; he dropped a handkerchief before the woman of his choice, who, after ceremonial bathing, was presented with a silk shift (*gömlek*) and trousers (*shalwar*) which she put on before being led to the royal bedchamber. After this visit she received the title of *ikbal* or favourite, and then that of *khadine* if she gave birth to a living boy. At any one time in the harem there would be a number of *khadines*, one of whom took on the prerogatives of a wife (she was known as the *sultana asseki*) and often had considerable power.

The female inhabitants of the harem were also known as odalisques; the word comes from the Turkish *odalik*, meaning 'belonging to the chamber'. Such women were virtually slaves, and since in theory Islam did not allow

slavery within its own religion, the majority of the girls (they were usually teenagers) were non-Muslim, often sent as gifts by the regional governors of the Ottoman Empire's Christian territories; the most beautiful were reputed to be Georgian and Circassian. They were trained as courtesans, and educated to a certain level; they were able to write verse, to play music and to dance. As in a medieval *hortus conclusus*, their lives were passed in an impregnable garden of paradise (there was no returning once a girl entered the sultan's harem through the 'Gates of Felicity'), eating, drinking, bathing, pampering the body, discussing clothes and jewellery, engaging in intrigues and rivalries, and sometimes alleviating the boredom of a hedonistic, captive existence by the use of opium from the white poppy which grows in abundance in Turkey. European visitors were intrigued by what they interpreted as the mindless and indolent happiness of the harem, as these typical comments indicate: 'Women spend the greatest part of their day reclining on their divans';[17] 'This ineffectual and passive happiness is the only thing Turkish women aspire to, and the only one they are capable of appreciating'.[18]

A great part of female existence in the harem revolved around clothes. The main items of women's dress were the shift (*gömlek*) which fastened with small jewelled buttons at the front and reached to the ankle, the wide voluminous trousers (*shalwar*) which were often made of rich fabrics like brocaded or embroidered silk, and then various caftan-like upper garments which could be short or long, loose or tight-fitting, and with hanging sleeves of varying lengths. The long gowns were often tucked up asymmetrically into a wide girdle which rested on the hips and which could be made of cashmere, or of gold fastened with a richly jewelled clasp. For visits outside the harem, women wore in winter a kind of furred mantle known as a *kurk*, and in milder weather a wide-sleeved billowing cloak called a *feridje*; the wearing of the double veil (*yasmak*) completed the incognito which religious and cultural custom dictated, and which proved so frustrating to the male European gaze. Lavish displays of jewellery and various types of headdress – turbans, small fez-like caps, feathers and silk scarves – put the final touches to harem chic.

It is a fallacy to suppose that such a costume was unchanging, although by the standards of restless European fashion it appeared to be static, thus delighting dress-reformers in the West. Women in the harem were aware of western dress, which had begun to penetrate Constantinople from the early nineteenth century to the annoyance of the more romantic European travellers. Information about western costume reached the harem through fashion plates and from the dressmakers (often Jewish) who had access to the Seraglio. European fabrics as well as the high-quality silks woven in Turkey were ordered for the inhabitants of the harem, and Gautier commented that Constantinople was as fashion-conscious as Paris: 'Constantinople has its fashions as Paris does. In the leisured indolence of the harem, women's imagination works overtime: – whether she is French or Turkish, what does a

172a and b Ingres, two drawings of
Turkish women. Pencil on tracing paper.
Musée Ingres, Montauban.

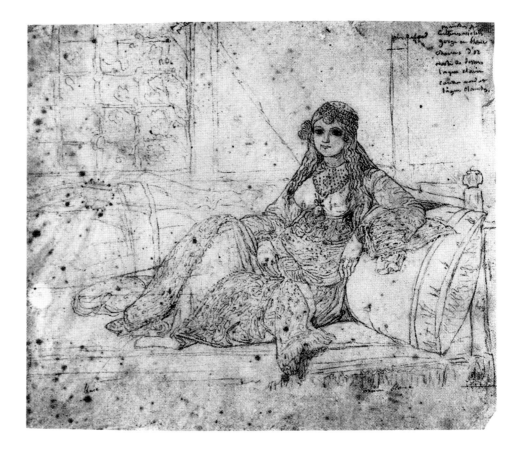

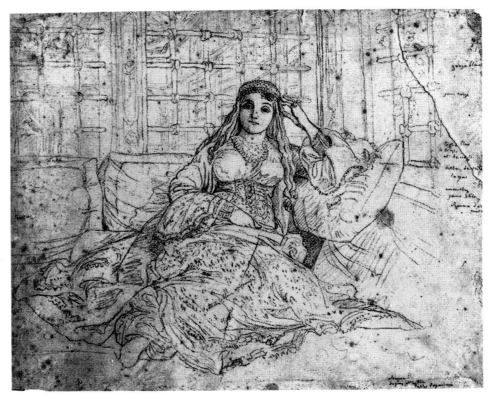

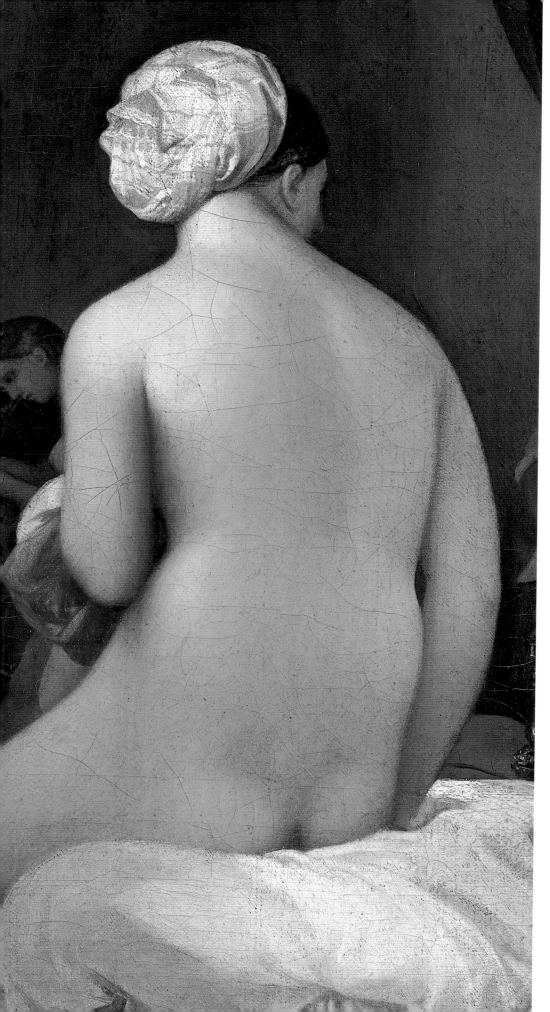

woman dream about? – her clothes'.[19] As well as dreaming about clothes, women's lives in the harem were dictated by the cult of the bath and of the body beautiful; this was not just a way of passing time, but a means to catch the eye of the sultan. Various unguents and cosmetics smoothed and whitened the face and body, of which the most famous was Balm of Mecca which exfoliated the skin (Lady Mary Wortley Montagu tried it in 1717 with disastrous results – her skin became red and sore). According to Auguste Carons's *The Lady's Toilette* (1808), the trick was 'slightly [to] anoint' the hands and face with the balm at night; next morning 'minute scales are detached from the skin in every part on which this precious balm has operated. This renovation of the skin renders it incomparably white', and gives the women of Constantinople 'the loveliest bloom in the world'.[20] Depilation was an important part of the toilette, all body hair being removed, according to Auguste Debay's *Hygiène de la beauté* (1846), by potions of cocoa butter and honey; afterwards jasmine water smoothed the skin and gave it, claimed Debay, a satin polish like the ivory tablets used by miniature artists.[21]

Make-up then gilded the lily, especially round the eyes and the eyebrows, the latter being pencilled or painted so that they almost touched; this was a fashion which Europeans universally condemned – 'cette mode bizarre' is Debay's comment. In *La Turquie: moeurs et usages des orientaux* (a series of plates

with captions by Camille Rogier, and with an introduction by Gautier) there are descriptions of the way in which women in the harem made up their eyes, painting upper and lower lids with a powder or a liquid made either from kohl (antimony) or from oak-gall. The perfumes of the East were famous; in Europe scents were marketed on the basis that they were either used in the harem or were fit to do so, and given Turkish names. According to Rogier, the founder of Islam was supposed to have said that God created two things for man's happiness – women and perfumes: 'Le Prophète disait souvent, "Dieu a crée deux choses pour le bonheur de l'homme: les femmes et les parfums".'[22]

Perfume was used not just in liquid form, but incorporated into body lotions and oils; the skin was scented and also the hair which was dressed, as Debay puts it, with an exquisite art unequalled by even the most famous French hairdressers.[23]

All the cosmetic arts of the harem were secondary to the use of the bath, which was the focal point of women's lives there as it was outside the Seraglio, either in private houses (a wealthy man would provide a bathing area in his harem) or in the public baths (*hamam*) which every major city in the Ottoman Empire possessed. When the English traveller Julia Pardoe visited Constantinople in 1836 she attended the public baths and saw how much time and attention women spent on bathing and personal grooming; she particularly admired the 'soft white velvety skin for which they are indebted to the constant use of the bath', although she herself was impatient with the lengthy ritual involved.[24] Sterner critics claimed that too much indulgence in bathing created bodies that were unhealthily plump, although it was admitted that Turkish men preferred their women to be more corpulent than would be found attractive by the European eye. More seriously it was sometimes implied (although rarely spelled out) that the culture of public bathing and the enervating atmosphere of the harem could encourage women to take pleasure in each other; this was often said apropos the imperial harem, for only a small number of inmates had sexual relations with the sultan. It is with this background in mind – the European perception of the harem as a garden of earthly delights, a celebration of female-ness – that we can now turn to Ingres's images of bathers and odalisques.

173 Detail of pl. 177.

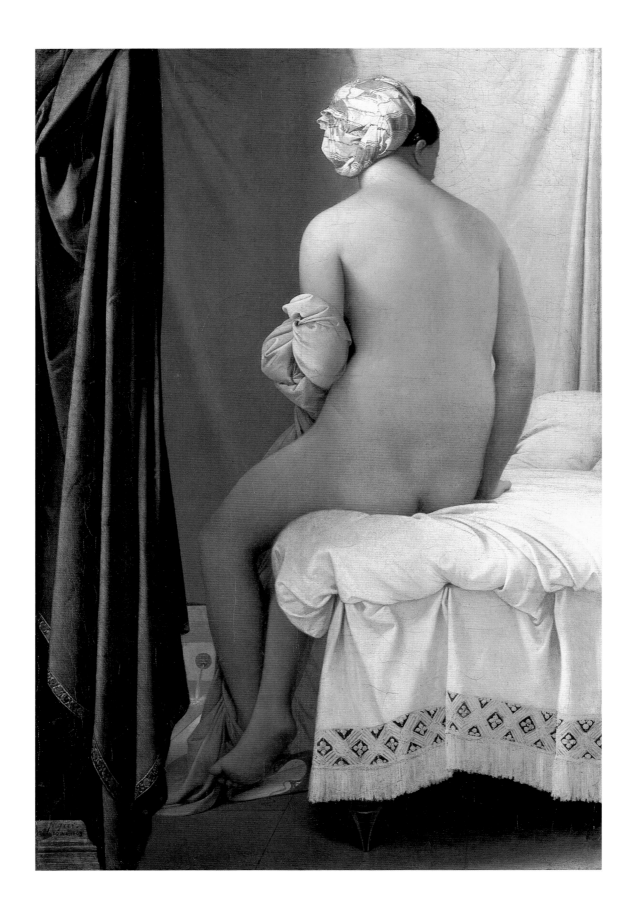

11 Ingres Imagines the Orient

Ingres's odalisques would make the Turkish Sultan jealous, for all the secrets of the harem seem familiar to the artist.

Théophile Gautier, *Portraits contemporains* (1874)

IN THE WORLD OF Ingres's oriental imagination, bathers are seen as central to the concept of the harem. The second of Ingres's images of bathers (the first is the small *Bather* of 1807 at Bayonne) is the *Bather of Valpinçon* (1808; pl. 174); arguably the most beautiful, she is the epitome of stillness – the silence is hardly broken by the small, plashing water-spout. She is Ingres's ideal female body (her figure is a recurrent theme in his later bathing scenes) but she is also a real woman, probably based on one of the artist's Italian models.[1] The erotic charge of the painting lies in her unawareness of, and even indifference to, the spectator's gaze. Absorbed in her own thoughts, there is a complete absence of coquetry; she is not concerned with any thoughts of sexual dalliance, but with the practicalities of the bath. On her head is a striped cotton scarf, twisted in the form of a turban; cotton is a fabric ideally suited to the humid atmosphere of the bath, for it stays on the head – unlike the silk scarf which almost falls off the head of the Bayonne *Bather*, who looks, incidentally, more like a naked Italian nymph in a landscape. The Bather of Valpinçon, naked except for her turban, clutches her shift, which is partly wrapped around her left arm, to her body. The shift is a garment of ancient origin, and has connotations of both purity and sexuality. Always white, it symbolizes a woman's virtue and respectability;[2] worn next to the skin, it has the practical purpose of protecting the clothing from perspiration. It is the last garment to be removed from the body to reveal its nakedness.

The painting of the fabrics that surround the figure testify to Ingres's skill; the voluminous shift is of the finest linen (it has an almost glaucous colour as it drapes on the floor near her feet), the bedclothes are of matte white cotton, and on the left a woollen shawl with an embroidered border acts as a hanging, drawing attention to the enclosed and protected space in which the bather sits.

There is little that is specifically oriental about the *Bather of Valpinçon*; at this point in his career, Ingres (a recent winner of the Prix de Rome) demonstrates his knowledge of the great Renaissance nudes. Just as the striped turban is Italian, so too are the red slippers with their trailing laces and rounded toes which Ingres must have copied from early sixteenth-century painting; in a

174 Ingres, *Bather of Valpinçon*, 1808. Oil on canvas. Musée du Louvre, Paris.

175 (*right*) Francis Smith, *Turkish Dancer before her Master*, 1769. British Museum, London. European attitudes towards these famous dancers varied. The *Recueil de cent estampes representant differentes nations du Levant* (1714) commented that 'their dancing is flirtatious and their attitudes immodest', but in the 1830s Julia Pardoe noted: 'It is the grace and art displayed in the carriage of the body and arms which form the perfection of their dancing.'

176 (*far right*) J.B. Vanmour (engraving after), *'Fille turque à qui l'on tresse les cheveux au bain'*. Private collection.

177 Ingres, *Small Bather, or Interior of the Harem*, 1828. Oil on canvas. Musée du Louvre, Paris.

Turkish bath, as visitors noted, high wooden shoes were necessary to protect one from the wet floors, and from slipping on damp surfaces.

Ingres's further essays in this genre – the *Bather* of 1826 (Phillips Collection, Washington) and the *Bather* of 1828 (pl. 177) – place the figure in the context of a public bathing scene, albeit as the *primus inter pares*. In both paintings, the Bather's costume is more explicit – a white shift (the drawstring on the sleeve is clearly detailed) and a red silk dress, along with the slippers first seen in the *Bather of Valpinçon*; the turban-like scarf reappears in white and gold.

However, while the Phillips *Bather* is clearly inspired by a kind of Giorgionesque *fête champêtre*, the *Bather* of 1828 – two years later – is ensconced in an oriental setting. She still retains the air of quiet contemplation which Ingres gave her some twenty years earlier, but she is now part of a group of bathers in the harem. Ingres's research into the customs and costume of Ottoman Turkey is clearly evident here, and some of his sources can be identified. The seated woman in the background on the left, wearing a large turban, is taken from one of the engravings to Francis Smith's *Eastern Costumes* of 1769 – the figure of a tambourine player accompanying a Turkish dancer (pl. 175). Next to her, a woman with her legs stretched out and clutching a shift to her breast, was copied from a plate entitled *Fille turque à qui l'on tresse les cheveux au bain* (Turkish girl having her hair plaited after the bath) (pl. 176), from the *Recueil de cent estampes representant differentes nations du Levant*, of 1714.

At the end of his life Ingres decided to incorporate his bather (and her acolytes) into a work that would encapsulate his visions and dreams of bathers in the harem; this painting was *Le Bain Turc* of 1862 (pl. 181)[3]. Ever since Ingres had read the *Letters* of Lady Mary Wortley Montagu, he had been obsessed with

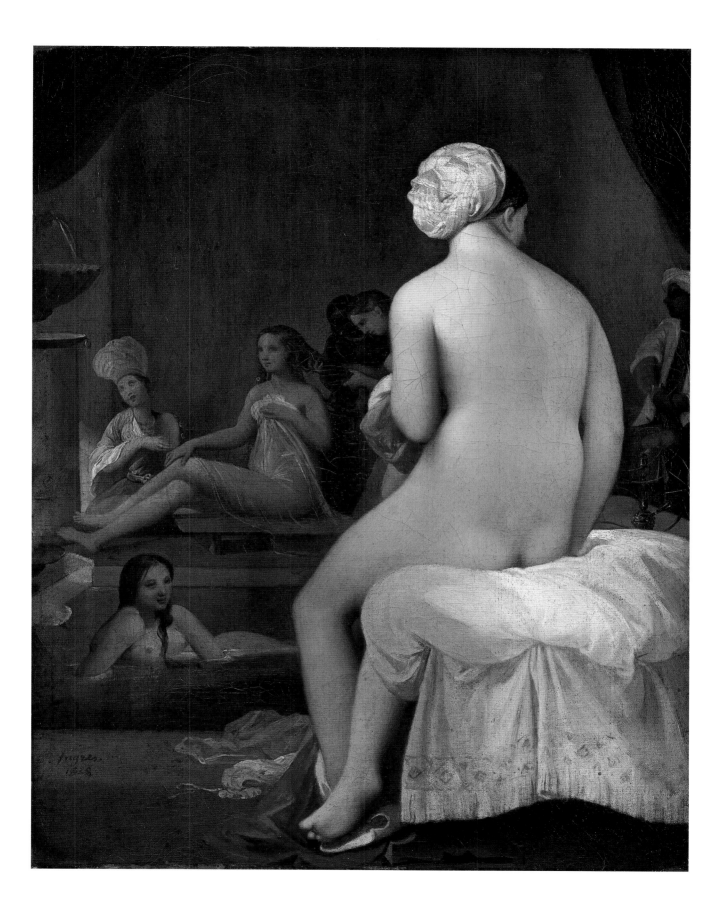

the idea – so claimed Lapauze – of creating a visual poem to the harem; Lapauze describes the painting thus:

> It's an accumulation of naked women with opulent, tepid flesh. They languish and become irritable in the moist perfume-saturated air. Their bodies writhe, or stretch, or curl up, according to their impatience or their drowsiness. One of them plucks the strings of a mandolin. The high-pitched, trembling and yearning notes affect them with thrilling shivers, or hypnotize them into panting ecstasy.[4]

Among this heap of enervated women (Lapauze finds this image both exciting and unsettling), he picks out the only lively individual, a blonde with a piquant type of beauty ('une blonde aux traits piquants') that is rarely seen in Ingres's work; she has irregular features, and an ironic, somewhat disillusioned air. By what chance, wonders Lapauze, has this girl with her sense of western disquiet found herself among her fatalist and resigned oriental sisters? One recent writer on Ingres wonders if the artist intended, apropos this figure, to represent Lady Mary Wortley Montagu.[5] A more plausible theory may be that the blonde women having her hair scented represents Aimée Dubucq de Rivery (cousin of Josephine Beauharnais, the future empress), who was captured by Algerian corsairs in 1784 on her way back to Martinique from France and taken to Constantinople where she entered the imperial harem and became one of the favourites of Sultan Hamid I. The idea of a western woman as captive in the harem of the Sublime Porte captured the European imagination, and adds a certain frisson to Ingres's *Le Bain Turc*.

178 D. Chodowiecki, 'Lady Mary Wortley Montagu at the Public Baths'. Engraved frontispiece to the *Letters* of Lady Mary Wortley Montagu, 1781. British Museum, London.

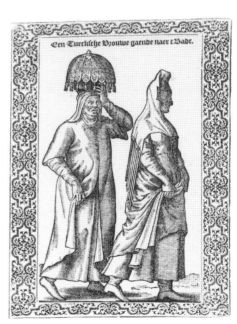

179 (*right*) J.B. Vanmour (engraving after), *'Fille turque à qui l'on tresse les cheveux au bain'*. Private collection.

180 (*far right*) 'Turkish Woman Going to the Baths' Etching from Nicolay's *Quatre Premiers Livres des navigations et peregrinations orientales*, 1576. British Museum, London.

181 (*facing page*) Ingres, *Le Bain Turc*, 1862. Oil on canvas. Musée du Louvre, Paris.

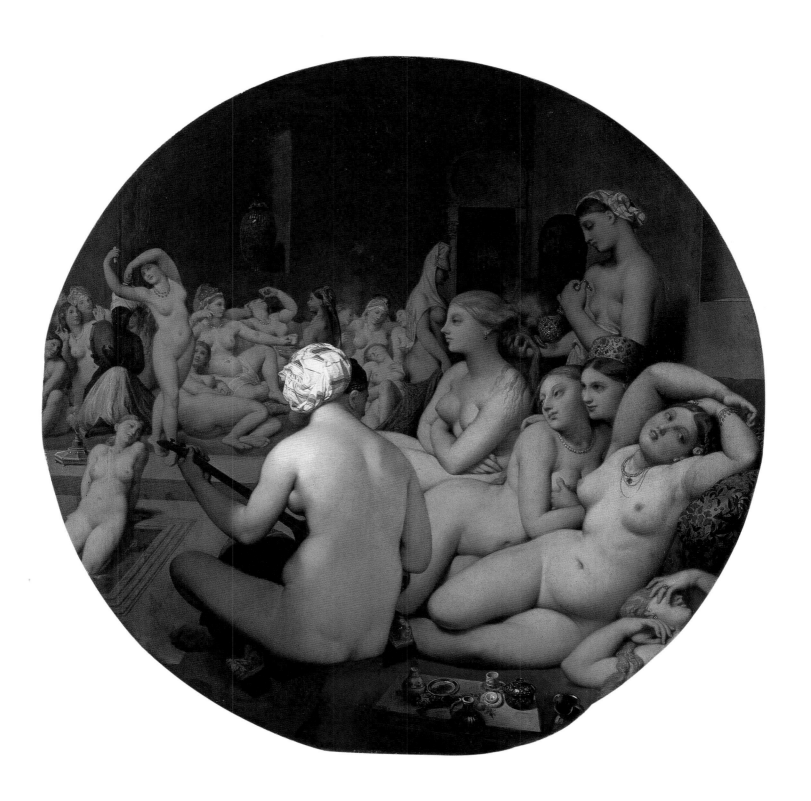

At some point – probably before the *Bather* of 1828 – Ingres came across the *Letters* of Lady Mary Wortley Montagu, and copied extracts from them into one of his notebooks (from the French translation of 1805). In a famous passage Lady Mary described her visit to the public baths in Adrianople in 1717:

> There were two hundred women there (I was in my travelling costume). The first sofas were covered with cushions and rich carpets on which sat the ladies while their slaves dressed their hair, all naked in a state of nature. However there was not the least indecent gesture nor lewd attitude among them . . .

She was particularly struck by the beauty of the women with their dazzling white skin, and by the way they dressed their hair, which was plaited with ribbons and pearls. When it was suggested that she join them in the baths she refused, opening the shirt of her riding habit (her 'travelling costume') to reveal her whaleboned corset – her interlocutors immediately interpreted this rigid breast-suppressing garment as a contraption into which she had been locked by her husband, and refrained from further persuasion. Lady Mary was charmed by their politeness and good manners, and records her appreciation of how, as a signal mark of consideration, two slaves in the hamam perfumed her hair, her clothes and her handkerchief.[6] This celebrated visit, an encounter between West and East, was recorded by Daniel Chodowiecki in an engraved frontispiece to an edition of Lady Mary Wortley Montagu's letters of 1781 (pl. 178); Lady Mary wears a fashionable riding costume and feathered hat of the early 1780s, and the naked bathers reclining on cushions look more like neo-classical Greek maidens than the more corporeal figures that Ingres depicts in *Le Bain Turc*. Chodowiecki was a prolific artist whose engravings were well known, and it is quite likely that Ingres knew this particular image.

Ingres's painting has attracted extremes of praise and censure, with earlier critics appreciating it more than those of the late twentieth century. Lapauze described it as the artist's complete and perfect vision of oriental beauty; Momméja expressed his sorrow that the only two critics who would have really appreciated *Le Bain Turc* – Gautier and Baudelaire – did not write about it; and the artist J.-E. Blanche declared that it had the same feverish hold on the imagination as Baudelaire's poetry. From the contemporary viewpoint, it is more difficult to understand what some critics now see as merely a blatant display of expressionless sexuality; 'this masterful piece of vacuous pornography'[7] is the comment of one recent writer, and feminist authors have drawn attention to what they see as an image of depersonalized bodies, little better than a *Playboy* centrefold.[8]

It is a difficult painting to get to grips with, and although it derives from, in Blanche's words, 'the erotic vision of an old man who was the impassioned priest of feminine beauty'[9] it diminishes the work to describe it as the result of male voyeuristic pleasure, a concept which serves only to perpetuate the clichés of the harem.

Standing in front of the painting in the Louvre, it comes across as a hauntingly beautiful work of art; at first glance it appears rather hallucinatory with its abrupt changes in scale and odd perspective, but after a while one begins to understand the harmony of the composition, and the way in which the main figure – based on the *Bather of Valpinçon* – is picked out with extraordinary clarity as the light falls on her turbaned head and golden flesh (pl. 163); the other women offering themselves up for contemplation have paler skins and seem to lack the quality of inner content which the musician, her back to us, possesses. With Lady Mary Wortley Montagu as a guide, Ingres depicts his bathers as totally naked, although it is not clear whether this would in fact have been the case, contemporary comments being somewhat ambivalent. According to the *Recueil de cent estampes representant différentes nations du Levant*, women wore shifts when they bathed; the explanation of a plate entitled '*Femme turque qui repose sur le sopha sortant du bain*' (pl. 179) includes the comment 'Their linen for the bath is extremely clean. After bathing, they pass into a room adjoining the baths, where they rest on a sofa, and often sleep there'.[10]

When Julia Pardoe visited the public baths in Constantinople in the 1830s, she 'witnessed none of that unnecessary and wanton exposure described by Lady M. W. Montagu. Either the fair Ambassadress was present at a peculiar ceremony, or the Turkish ladies have become more delicate and fastidious in their ideas of propriety'.[11] Her own experience was that women bathed wearing fine linen 'wrappers' and turbans, but she admitted that this costume soon became 'so perfectly saturated with vapour that it revealed the whole outline of the figure'.[12] In the heavy sulphurous steam of the hamam, the senses became disorientated, and Pardoe imagined herself to be in a 'phantasmagoria', a dream-like vision of shifting optical illusions with figures that hovered between reality and the imagination. This, too, is an element that can be seen in *Le Bain Turc*.

In this painting there are a number of references to Ingres's earlier bathers and to his odalisques. Like a leitmotiv in Ingres's work, we can pick out the small, 'Raphaelesque' plait of hair over the ear, first seen in the *Bather of Valpinçon*, then in *La Grande Odalisque*, and then in *Le Bain Turc*, where it features in the hairstyles of a number of the bathers, most prominently the mandolin-player and the two women on the far right of the painting. Both these last two figures recall, with their uplifted arms, that of the sultana in Ingres's *Odalisque with Slave* (pl. 186). The mandolin-player's striped turban of white, red and gold brings together the red and white scarves of the early *Bathers* and the gold and white scarves of the 1820s *Bathers*.

Here, too, are quotations from the costume books that Ingres used in his earlier works. The figure on the right with uplifted arms, heavy breasts and a rounded stomach (she may be either, or both, of Ingres's wives) was probably inspired in her pose by the engraving of the *Femme turque* (pl. 179). Ingres clearly had problems with the right arm of the 'Madame Ingres' bather; he was

unable to decide whether to place the arm on her thigh (as in the early eighteenth-century engraving) or to raise it above her head – his indecision can be seen in a study for this figure (Musée Ingres, Montauban), where there are two right arms. The final choice of pose is not very successful, for the arm as it now exists does not call into play the pectoral muscles which should lift up the right breast; furthermore – Ingres's problem once more – this arm does not convincingly join on to the body.

In the background and on the left side of *Le Bain Turc*, two figures – the black tambourine player and the balletically posed standing women – show how Ingres reused Smith's engraving of a Turkish dance (pl. 175). Both these figures appear in the two watercolours after *Le Bain Turc*, which Ingres painted in 1864; one is at the Fogg Art Museum,[13] and the other (pl. 182) is at the Musée Bonnat. The superb Bayonne watercolour lays particular emphasis on the high-quality decoration of the sequence of rooms that formed the bathing area, and brings to mind the words of Lady Mary Wortley Montagu, which Ingres wrote down: 'One entered into a vestibule paved with marble whose design formed the most beautiful mosaic. From there, one proceeded to a room surrounded by sofas, on which one could rest before entering the bath . . .'[14]

In addition to eighteenth-century engravings of Turkish costume, Ingres also used one of the most famous sixteenth-century series of illustrations, Nicolay's *Quatre Premiers Livres des navigations et peregrinations orientales* of 1568. Plate 180 (from the Flemish edition of 1576) shows a Turkish woman going to the *hamam* attended by a servant; in the centre background of *Le Bain Turc* there is a half-dressed standing figure whose fringed *yasmak* derives from this image, as does the curious umbrella-like object (in reality a decorative and protective container for cosmetics and preparations for the bath) which seems to hover in a doorway set in to the far wall.[15]

As well as the oriental references (both to his own earlier images, and to the costume plates by other artists), Ingres also in a kind of valedictory gesture, 'quotes' from a number of his famous portraits of woman. The pose of the seated woman on the left, in the background, holding out a cup to an Indian slave, is similar to that of the London *Madame Moitessier* (pl. 135); the pink rose in the hair of the reclining 'Madame Ingres' figure in the right foreground is a subtle reference to the headdress worn by Madame Moitessier in black (pl. 146). With regard to the jewellery, there are many echoes of the earlier portraits – the 'Madame Ingres' bather wears a fine gold chain like that in *Madame Rivière* (pl. 16), and a ruby pendant surrounded by diamonds which recalls the clasp of the bracelet worn by Madame de Rothschild (pl. 125). On the far left of the painting the coral beads worn by the dancing girl bring to mind Madame Panckoucke's necklace (pl. 82), and the woman nearby seated next to the tambourine player and holding up her hands, wears a gold 'Etruscan' necklace similar to that in the portrait of Madame de Broglie (pl. 132). Such details must

182 Ingres, *Bather*, 1864. Watercolour. Musée Bonnat, Bayonne.

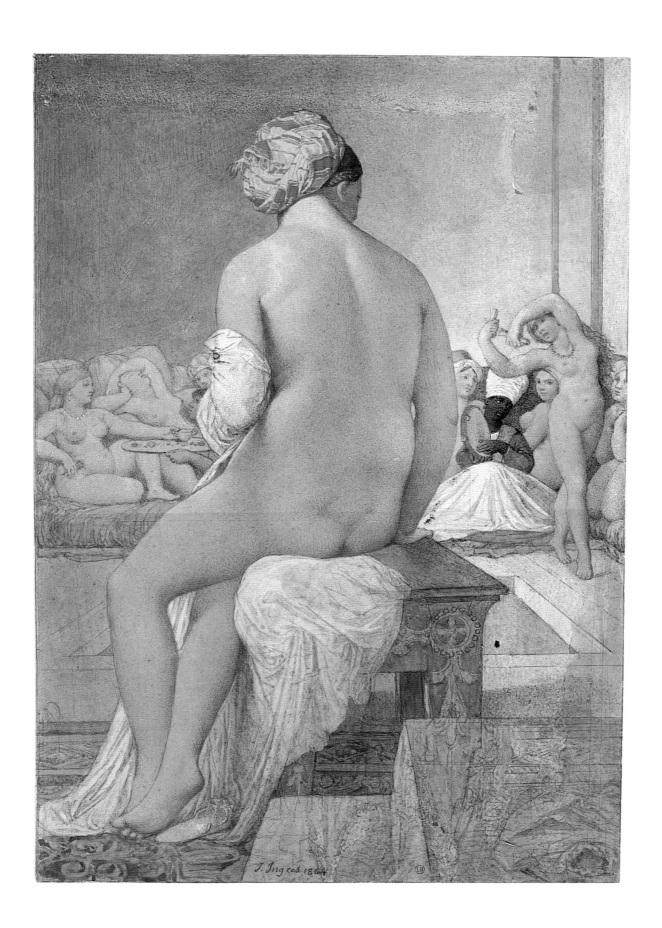

183 Ingres, study for *Raphael and La Fornarina*, c.1814. Pen and wash. British Museum, London.

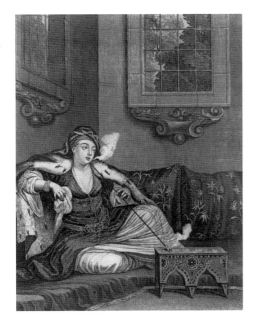

184 J.B. Vanmour (engraving after), *'Femme turque qui fume sur le sopha'*. Private collection.

surely be a deliberate recollection in tranquillity of favourite themes, accessories in particular, that the artist had pleasure in painting.

Le Bain Turc, as suggested, is not an easy painting to like; on the one hand it could be thought too self-indulgent in the display of flesh, and on the other hand too austere, lacking the supporting cast of luxurious clothes (even when thrown aside) and textiles of Ingres's more immediately appealing and accessible odalisques.

Of all Ingres's oriental images, his *Grande Odalisque* of 1814 (pl. 185), which was commissioned by Queen Caroline of Naples as a pendant to the lost *Sleeper* of 1808 painted for her husband,[16] is the painting that has captured the public imagination. It runs the risk – as do such works of art as Frans Hals's '*Laughing Cavalier*' – of gracing calendars and boxes of chocolate, although in the odalisque's case it is more likely to be dictionaries of erotica.

When first exhibited in the Salon of 1819, the *Grande Odalisque* was famously criticized for her boneless, elongated right arm, and – most of all – for the extra vertebrae in her long curving back. In later years when the painting was shown, the same criticism resurfaced, that the figure was unnatural, even sinister; when, for example, the *Grande Odalisque* was on view in 1846, George Sand recalled (in a conversation with Delacroix) the callowness of her earlier judgement when she 'admired that first odalisque with her greenish contours and her back like a white leech'.[17]

In spite of complaints about anatomical inaccuracies (such attacks dogged Ingres throughout his life) there was also much praise for a work of art that was regarded as a direct descendant of the great Renaissance nudes, such as those by Titian; in fact Ingres was later to copy Titian's *Venus of Urbino*, in 1822.[18] The name of the great Venetian artist was invoked by contemporary critics, not just because of the subject – a reclining nude – but because the Grande Odalisque is clearly, as *L'Artiste* remarked in 1855 'une Italienne déguisée'. Her body is – unlike those of Ingres bathers and his later odalisques – completely occidental, reflecting the delicate and high-waisted look of early nineteenth-century fashion. But her hair and headdress are clearly derived from the kind of Renaissance beauties painted by Raphael and his contemporaries (pl. 161). Her hair is centrally parted, waving over her ears *à la madone*, and on her head she wears what has often been described as a turban but is in fact a long pleated tube of striped and embroidered silk, edged with heavy gold tassels, beautiful as an artistic conception, but not totally convincing in structure. In shape it relates to the *scuffia*, a cap-like headdress of striped material (possibly knitted in origin) worn in Venice and the Veneto in the early sixteenth century; a similar headdress to that worn by the Grande Odalisque appears in Ingres's painting *Raphael and La Fornarina* of 1814 (Fogg Art Museum, Harvard University) – it was clearly a style which, being both exotic and historical, appealed to the artist's educated eye and underlined the refinement and luxury of these legendary female beauties. Balzac may have had Ingres's *Grande Odalisque* in

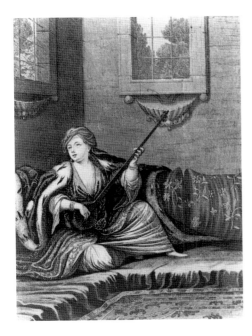

187 J.B. Vanmour (engraving after), *'Fille turque jouant du téhégour'*. Private collection.

En dépit des vertus malingres
En dépit des maigres pudeurs.

.

Sa tête penche et se renverse;
Haletante, dressant les seins,
Aux bras du rêve qui la berce,
Elle tombe sur ses coussins.

Ses paupières battent des ailes
Sur leurs globes d'argent bruni;
Et l'on voit monter ses prunelles
Dans la nacre de l'infini.[30]

The indolent Georgian/with her supple nargileh/stretching out her opulent hips/one foot tucked under the other.

And like Ingres's odalisque/arching the curve of her back/in defiance of sickly virtue/in defiance of false modesty . . .

Her head tilts and lolls back/panting, lifting up her breasts/into the arms of the dream that cradles her/she falls on to her cushions.

Her eyelides flutter/on their globes of burnished silver/and you can see the pupils of her eyes/mount into the pearly infinite.

As with nearly all translations of poetry, the above is unsatisfactory and fails to convey the complex (and often elusive) word images that reflect Gautier's visual expertise (he trained as an artist); one recent writer, for example, picks out Gautier's choice of the word *cambrant*, which not only suggests

> the sinuous curve of the woman's back and buttocks in the Ingres painting, but also contains within it an implication of erotically suggestive movement on the part of a living woman. The reader is suspended between an interpretation of the text as a description of a work of art and an evocation of the fleeting mobility of life.[31]

As in Gautier's poem, the sense of the 'fleeting mobility' of life is underlined in Ingres's painting, for after the freeze-frame of this captured moment, life will go on – the eunuch will issue a command, the music will stop, and the odalisque will stir and be dressed in the finery that lies crumpled beneath her.

Ingres painted another version of the *Odalisque with Slave* (pl. 188) in 1842, the main difference being the background details. The wonderfully intricate inlays of the room at the back (which recall the decorative schemes of Crivelli) and the fountain that appear in the first painting, are replaced in the second version by a formal garden with a pool and a pleasure kiosk, painted by Ingres's pupil Paul Flandrin.

The rich decorative background in both paintings heightens the effect

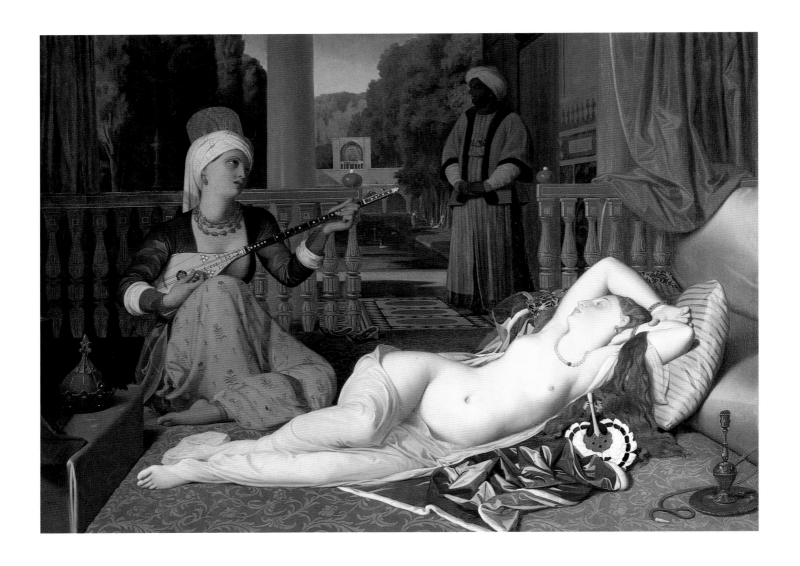

188 Ingres, *Odalisque with Slave*, 1842. Oil on canvas. Walters Art Gallery, Baltimore.

created by the contrapposto of the odalisque whose pearlized and almost deliquescent body flows across the canvas, just as her long, unravelled hair flows over her arm and on to the carpet. Our attention turns not just to her body, but to her dress and jewellery which reinforce its beauty. Her shift is of the finest gauzy silk, open down the front and edged with gold – there is a glimpse of this gold embroidery on the sleeve. The dress (or mantle) on which she lies is of blue and gold satin edged with miniver; blue was traditionally regarded as a 'Christian' colour (it was the colour of the Virgin's cloak), and Ingres may possibly have intended a reference here to a captive Christian or western odalisque, which her features and her jewellery would suggest. The bracelets of gold, pearls and rose-cut diamonds are in Renaissance taste, as are the pendant pearl earrings. Pearls form the necklace of the 1842 odalisque, whereas in the earlier painting the odalisque wears round her neck a fine gold chain with a tiny ruby.

Gautier describes the musician as an Abyssinian slave; this is somewhat fanciful (but poetic, Romantic English writers had the same fantasy, for example Coleridge's 'Abyssinian maid' playing her dulcimer in *Kubla Khan*), for Ingres's performer does not look Ethiopian; she may be a Muslim, for she wears green, the colour of paradise and associated with the Prophet. Her costume is typically Ingres-like, incorporating his notion of the East (the invented low-cut green satin gown), accurate detail (the baggy embroidered cotton trousers) and a faint memory of Venetian art (Carpaccio specifically) in the fez-like red velvet cap. For her necklace of what look like amber-coloured glass beads, Ingres again made use of Smith's *Turkish Dancer* (pl. 175); the colour of the beads complements the tawny-gold of her skin. Behind the slave in the later version of the painting is a beautiful still-life of her Turkish slippers (Ingres must have seen the real thing) which are wooden-soled and have velvet uppers embroidered in gold. In terms of the pose of the musician, Ingres resorted, once more, to the *Recueil de cent estampes representant differentes nations du Levant*; to the plate entitled '*Fille turque jouant du téhégour*' (pl. 187).[32]

In the background to the painting is the black eunuch whom Gautier describes as 'surly and suspicious' ('maussade et soupçonneux') as he keeps a watchful eye on the imprisoned odalisque. Gautier's reading of his presence in Ingres's painting is in line with the well-established European perception of the fearsome character of such functionaries. This is the kind of eunuch (in this context they were usually from Sudan, and by the sixteenth-century all-powerful in the imperial Ottoman harem) whom Montesquieu describes in his *Lettres persanes* (1721); often bitter and corrupt, such eunuchs were adept at intrigue and highly influential in the tortuous politics of the seraglio. According to an account of *Turkey, being a description of the manners, customs, dresses and other peculiarities characteristic of the inhabitants of the Turkish Empire* (1821), eunuchs signified the 'luxury and ostentation' of princely households, and were 'seldom met with except in the seraglio of the grand-signor and of the sultanas . . . To appear otherwise than with a look of the austerest gravity would be a punishable misdemeanour in a eunuch'.[33]

In Ingres's painting the eunuch's expression, in so far as it can be seen, is indeed grave, and his costume rich, comprising a fur-trimmed short gown and a flowered silk caftan (striped in the later version); this flowered silk is virtually identical to that covering one of the odalisque's cushions. As with all Ingres's depictions of bathers and odalisques, the senses play an important role. Looking at the 1839 *Odalisque with Slave*, the art historian John Connolly (in an article entitled 'Ingres and the Erotic Intellect') finds all five senses represented: the hookah is taste, the fountain sound, the censer smell, the musical instrument touch and the 'helmet' on the left – quite preposterously – is taken to be sight.[34] But, just as easily, the hookah with its bubbling sound could indicate the sense of hearing, as could the *tchéhégour*; the sense of touch could be the odalisque clasping her head and arm, or the feeling that the spectator has that her rippling

189 (*right*) Detail of pl. 188.

190 (*far right*) 'Noble Turkish Lady'.
Etching from Nicolay's *Quatre Premiers Livres
des navigations et peregrinations orientales*, 1576.
British Museum, London.

hair and the fur-trimmed satin are only just outside our grasp and that at any
moment it may be possible to lean into the canvas and stroke them. As for the
'helmet', it is in fact a beautiful gold and jewelled velvet hat decorated with a
black feather aigrette (pl. 189) and inspired by that worn by a 'Grand' Dame
Turcque' in one of Ingres's oriental sources, Nicolay's *Navigations et
peregrinations orientales* (pl. 190). In short, although it is great fun to play 'guess
the sense' (and all Ingres scholars enjoy this), it is important not to lose sight of
the whole picture which, of course, is about sensual appreciation, but also
tinged — as are so many great works of art — by a slight touch of melancholy.

12 La Touche d'Ingres

Of all the writers on Ingres who also knew the artist, the critic Charles Blanc was particularly suited to the task, for he had the advantage of being perceptive and knowledgeable about clothing. When, in 1870, he published his important work *Ingres: sa vie et ses ouvrages*, he linked the artist's manner of painting – 'la touche d'Ingres' – with his 'superlative skill' in the depiction of costume, especially that of women.[1]

Whatever Ingres's touch was – and opinions were often divided – it brought him acclaim and dislike in equal measure, as the *Revue des deux mondes* for 1846 acknowledged: 'a man who has such enthusiastic admirers and such passionate detractors, is certainly not an ordinary man'.[2] To this critic, Ingres was an artist for whom the term 'art for art's sake' might have been coined, and he defined the phrase as meaning 'an exclusive love of form and imagination'.[3] In the same year Thoré uses the same term to mean – apropos Ingres – an obsession with externals, especially dress and accessories, which were inimical to the soul and intellect of a painting. How can such seemingly contradictory statements be reconciled? Certainly Ingres loved form, the tangible reality of the body, and the shapes of the costume that clothed it. As we have seen, his portraits are not mere records of clothing placed upon the figure and likeness of an individual, but a fusion of dress and character; Ingres's pupil Amaury-Duval noted the way in which he studied the attitudes which the body gave to clothing in his portraits.[4] In depicting his bathers and odalisques Ingres used his knowledge and love of the female body together with his appreciation of luxury and the world of the senses to create imaginative visions of the East.

To the charge that Ingres relished the material world in his portraits, a plea of guilt is admitted. Like Gautier, Ingres was 'un homme pour qui le monde extérieur existe' (a man for whom the visible world exists), but he was conscious of the need to elevate the painting of costume and textiles in his work. This he does by infusing his work – both drawing and painting – with an almost religious ardour when he depicts the details of women's costume and their accessories. Sometimes this fierce concentration on the minutiae of fashion can overwhelm the image, for Ingres paints his clothed women with the relish that he devotes to his bathers and odalisques; the result is that both kinds of art are of their own time and timeless.

It is a paradox, perhaps, that attempts to construct deliberately 'timeless' images in art – the nude figure, draperies or various types of historical costume – rarely work satisfactorily; they often look self-conscious and even absurd. In

contrast, there is a mysterious process of time that renders contemporary fashions, both in life and in art, once they have gone through a cycle of being up-to-date and then out-of-date, beautiful and timeless. Thus it is with Ingres's portraits and with his bathers and odalisques, where loving attention is paid to real accessories and luxury objects.

Kenneth Clark points out that 'the grandes toilettes of any epoch distil such a quintessence of the fashionable life of their time that they give to any painter *who is prepared to take them seriously*, a positive style'. It was, he continues, part of Ingres's greatness that he took himself and his art seriously; art for Ingres existed in its own right and should not be used to criticize society. As for his sitters:

> He simply wished to turn them into art, and that meant taking seriously every ribbon on a corsage or every stitch in a shawl. It was precisely his egotistical detachment that allowed him to make a material and frivolous age seem timeless.[5]

In an age of flamboyant genius, Ingres remains somewhat reticent, even inaccessible; he lacked what today we would call charisma. Yet it is largely owing to the variety and quality of his work that so much information on fashion and the female appearance can be retrieved. A final touch of Ingres – when in Florence he had a studio in the via delle Belle Donne, a fitting place for the man who gave us such lasting images of beautiful women.

Notes

Unless otherwise indicated, the translations from the French in the text and in the notes are the author's.

Introduction

1 Baudelaire (1964), p. 13.
2 Berger (1972), p. 11.
3 See, for example, Silvestre's famous comment about Ingres: 'M. Ingres n'a rien de commun avec nous; c'est un peintre chinois égaré, au XIXᵉ siècle, dans les ruines d'Athènes' (M. Ingres has nothing in common with us; he's a Chinese painter mislaid, in the 19th century, in the ruins of Athens); Silvestre (1856), p. 33.
4 In the *Revue des deux mondes* (1846) the critic 'F. de Lagenevais' (Frédéric de Marcey) declared that Ingres was not a portraitist by vocation, but that necessity forced him to be one (p. 538).
5 Delacroix (1971), p. 268.
6 Blanche (1919), p. 171. The Goncourts, who did not much like Ingres's work, admitted how much effort went into his painting: 'Il cherche son âme et sa gloire à la sueur de l'effort' (He searches for his soul and for glory in the sweat of effort); Goncourt (1893), p. 194. The contradictions in Ingres's work continue to perplex. In 1990 the artist Victor Pasmore chose Ingres's *Madame Moitessier* from the National Gallery, London, for a selection of paintings entitled *The Artist's Eye*. On Ingres he makes the comment, 'On the one hand he was a militant idealist and Neoclassical reactionary, but on the other a subjective romantic, sensual realist and independent painter'; V. Pasmore, *The Artist's Eye*, National Gallery, London 1990, p. 32.
7 Rosenblum (1990), p. 19.
8 Babin (1898), p. 22.
9 Berger (1972), p. 54.
10 I. Julia, 'Daughters of the Century', in *La France: Images of Women and Ideas of Nation 1789–1989*, exhibition catalogue, Hayward Gallery, London 1989, p. 88.

11 Goncourt (1971), p. 65.
12 Bell (1926), p. 129.
13 Davies (1936), p. 268.
14 Baudelaire (1965), p. 83, and Bryson (1984), p. 124.
15 Perhaps he learnt a lesson from his teacher David that politics was a dangerous game for an artist, and what might be assumed from his love of honours and his preference for the traditional art establishment is that Ingres probably preferred the hierarchy of a monarchical regime. His career, other than that as an artist, was that of an academic and an administrator, roles where he could carry out his paternalist and authoritarian instincts. Only in 1830, the year of the July Revolution, when, as Stendhal remarks in his novel *Le Rouge et le noir*, 'If your characters don't talk politics . . . then they're no longer Frenchmen of 1830', was Ingres actively involved in political events. With other artists, he guarded paintings in the Louvre in case of mob violence; appropriately, given his adoration of Renaissance art, the Italian school was in his care. This was also a suitable conjunction, for Ingres spent much time in Italy; from 1806 to 1824 he was a student and then a struggling young artist in Rome and Florence, and from 1835 to 1841 he was Director of the French Academy in Rome. Although profoundly, almost jingoistically patriotic, such extended absences from France may have contributed to a sense of semi-detachment from the politics of his native land. Some feeling of being an outsider in his early years, may have contributed to Ingres's sensitivity to criticism, and his reluctance to show his work regularly. When he did exhibit, much interest was aroused, particularly later in his life when his dogmatic views on art and his dislike of the new made him a legend. The critic Paul Lacroix, visiting the Ingres room at the 1855 exhibition in Paris, noted that the forty-five works on show evidenced a single-minded, unchanging and uncompromising vision: 'Chose rare et digne de louange! Pendant plus d'un demi-siècle, au milieu d'une époque extrêmement agitée . . . M. Ingres est demeuré imperturbable dans sa propre inspiration.' (Something rare and worthy of praise! For more than half a century, in the middle of a violent and agitated epoch . . . M. Ingres has remained unruffled and guided by his own inspiration) (P. Lacroix, 'M. Ingres à l'exposition universelle', *Revue universelle des arts*, 1855, p. 202). Ingres's fidelity to his firmly held views was both a strength and a weakness. The weakness lay in his stubborn avoidance of new ideas, both intellectual and technical; this entrenched him in the barren land of reactionary and academic art from which it was, and is, difficult to struggle free. There are few pilgrims to his bleak and unregarded tomb in Père-Lachaise.
16 On Ingres's use of bodily 'deformation' to create ideal, abstract and timeless forms, see Toussaint (1985), p. 9.

Chapter 1

1 Stendhal, *De l'Amour*, trans. G. and S. Sale, and intr. J. Stewart and B.C. J. G. Knight, London 1975, p. 69.
2 'Blonde' is a *silk* lace, as distinct from linen lace.
3 Taine (1875), p. 24.
4 Taine (1870), pp. 80–81.
5 E.-J. Delécluze, *Exposition des artistes vivants*, Paris 1851, p. 152.
6 E.-J. Delécluze, *Les Beaux-Arts dans les deux mondes en 1855*, Paris 1856, p. 279.
7 Prevost (1884), p. 40.
8 Gautier (1858), p. 18, and Gautier (1874), p. 329.
9 Baudelaire (1964), pp. 13, 30–31. For Baudelaire's concept of the inseparability of women and fashion, and the way in which from the mid-nineteenth century onwards fashion struggled to become an art, see R. G. Saisselin, 'From Baudelaire to Christian Dior: The Poetics of Fashion', *Journal of Aesthetics and Art Criticism*, vol. XVIII (2), 1959 pp. 109–15.

10 Quoted in de Marly (1980), p. 116.

Chapter 2

1 On Reynolds and David, see A. Ribeiro, *The Art of Dress: Fashion in England and France, 1750–1820*, New Haven and London 1995.
2 Delpierre (1975), p. 21.
3 About (1858), p. 39–40.
4 See Fortassier (1988).
5 M. Tilby, '"Telle main veut tel pied". Balzac, Ingres and the Art of Portraiture', in Collier and Lethbridge (1994), p. 128.
6 Ibid., p. 115.
7 M. Levey, 'Ingres at Cambridge and Paris', *Master Drawings*, VI, 1968, p. 44.
8 Rosenblum (1990), p. 32.
9 Gautier (1874), p. 287: 'S'il sait plisser admirablement une draperie grecque, Ingres n'arrange pas moins heureusement un cachemire . . .'
10 Baudelaire (1965), pp. 38 and 83.
11 Ibid., p. 38.
12 Roux (1996), p. 23.
13 Silvestre (1856), p. 3.
14 Ingres's original self-portrait showed the artist in a square-necked 'Renaissance' doublet, a vast grey coat over his shoulder (see pl. 2, above, which is an engraving of this portrait); a copy of the original portrait painted by Marie-Anne-Julie Forestier (to whom Ingres was once engaged) is in a private European collection.
15 About (1855), pp. 117–18: 'Ce beau portrait, le plus vivant et le plus coloré de cette galerie, représente un petit homme brun, intelligent et têtu. Sa chevelure noire et robuste s'ébouriffe avec une remarquable indépendance . . . Ce petit homme campé dans son manteau, en face d'un chevalet et le crayon blanc à la main, semble dire aux regardants: "Je serai un grand peintre, parce que je *veux*". Il a tenu parole. Volonté, travail, étude, obstination, patience, voilà les éléments dont se compose le talent de M. Ingres'. See also the comments made apropos this self-portrait by Blanc (1870), p. 9, and Lapauze (1911), p. 44.
16 Gautier (1874), p. 282. Ingres's pontifical air was recalled also by the artist Jules Breton, who arrived in Paris as a student in 1847: 'Ici nous croyons voir un pape de génie'; see J. Breton, *La Vie d'un artiste*, Paris 1890, p. 182.
17 R. de la Sizeranne, *Ingres*, Paris 1911, p. 106.
18 Silvestre (1856), p. 31.
19 Ibid., According to Amaury-Duval, Ingres had similar trouble with his portrait of the duc d'Orléans of 1842 (Versailles); he urged his august sitter, without success, to wear a muted version of a general's uniform, surely a contradiction in terms. Unlike his master David, Ingres never felt at ease with rich embroidery on men's clothes; there is nothing in Ingres's work to match the sumptuous embroidered blue velvet and white satin costume worn by David's *Comte Français de Nantes* of 1811 in his uniform as Conseiller d'Etat (Musée Jacquemart-André, Paris).
20 Gautier (1858), pp. 13–14.
21 Ibid., p. 11.
22 Loménie (1840), II, p. 20.
23 Blanc (1870), p. 98: 'L'expression interrogative de son oeil perçant, le léger désordre de ses cheveux, le noeud lâche de sa cravate, l'ampleur de son gilet que remplit le développement de la poitrine, la tournure d'une vaste redingote dont les plis trahissent les habitudes d'un corps toujours grossissant, les larges manches d'où sortent des mains boudinées aux doigts fuselées et délicats.'
24 Quoted in Tilby, op. cit., p. 115.
25 Amaury-Duval (1878), p. 177.
26 About (1855), p. 126.
27 J.-A.-D. Ingres, *Pensées*, Paris 1922; pp. 85–6: 'Pour exprimer le caractère, une certaine exagération est permise, nécessaire même quelquefois, mais surtout là où il s'agit de dégager et de faire saillir un élément du beau.'
28 Silvestre (1856), p. 30: 'de peindre l'un après l'autre les cheveux . . . de tisser fil par fil la soie comme un canut . . . de rivaliser enfin avec l'orfèvre et le lapidaire dans la ciselure des bracelets et la coupé des pierres.'
29 Blanc (1870), p. 170.
30 Baudelaire (1965), p. 191.
31 Ibid., p. 132.
32 Ibid., p. 84. Curiously, Baudelaire picks out Ingres's *Madame d'Haussonville* – alongside his odalisques – a work 'of a deeply sensuous nature'.
33 Ibid., p. 132.
34 Richardson (1958), p. 132.
35 Gautier (1855), p. 164. See also Olivier Merson, who stated that if a photographic record only was required, then Daguerre would suffice, but an artist such as Ingres provided, in addition to the exact representation of the exterior of an individual, the intellectual side as well; he painted a country, a race, an age ('il peignait un pays, une race, une époque'); Merson (1867), p. 80.
36 Ingres, *Pensées*, op. cit., p. 134.
37 Blanc (1870), p. 168.
38 Ibid., p. 169: 'Une mèche de cheveux, la forme précise d'un ongle, l'accident d'une cravate, le tour d'une dentelle, rien n'était pour lui indifférent, rien n'était inutile à l'accentuation du caractère.'

Chapter 3

1 Debay (1857), p. 5: 'elle se rit de la sagesse, se moque de la raison . . . elle renverse les grands, élève les petits, fait et defait les réputations . . . elle embellit ce qui est laid, rend le vice attrayant, pare le charlatanisme des couleurs de la vérité . . .' There are many such contemporary comments on the subversive and destructive force of fashion. One example will suffice, an anonymous satire on fashion, *Le Règne de la mode*, in which a series of allegorical characters discuss its importance. *Folie* (Madness) argues, for example, that fashion is 'the most beautiful and the most terrible thing in the world'; ('la plus belle, la plus terrible chose du monde'); it is an angel, a demon, a source of pleasure and of unhappiness; it has both a creative and a destructive power. *Le Règne de la mode*, Paris 1823, p. 13.
2 Balzac (1830), p. 14.
3 Both Balzac and Ingres tapped in to a new feminine ideology which placed domestic pursuits and fashion at the heart of the new bourgeois aesthetic created in reaction to the aristocratic society of the *ancien régime* and its pale imitator under the First Empire. The perceived libertinage and worldliness of the eighteenth century, along with its dangerous toying with political philosophy, was thought to have contributed to the French Revolution. In reaction to the independence of the eighteenth-century aristocratic woman, who could pursue a public and a private life without her husband (who led a separate life), the concept of family was promoted by later, post-revolutionary governments; women were trained for home and family rather than for life at court. (See M.H. Darrow, 'French Noblewomen and the New Domesticity, 1750–1850', *Feminist*

Studies, vol. V, 1979. In this context Darrow also notes the impact made on Restoration society by the émigrés returning from England where they had come into contact with a society imbued with a bourgeois and domestic ideology.)

At the same time there was a growing debate on the role of women generally, which was fuelled by their unrealized political aspirations created by the revolutions of 1789, 1830 and 1848; feminist hopes for greater emancipation, both political and social, were kept alive through the establishment of debating societies and journals. Feminist writers, and male sympathizers such as the writer Ernest Legouvé, lamented the female predicament of being forced to submit to laws and taxes they had had no part in voting for. (E. Legouvé, *La Femme en France au XIXᵉ siècle*, Paris 1873, p. 123. Legouvé argues that the only career open to women is the family). Women, Legouvé claimed, were perfectly suited for careers in administration, in medicine and in the arts. Similar claims were made by Marie-Elisabeth Cavé who in her book *La Femme aujourdhui et la femme autrefois* (1863) urged the establishment of a women's college to be called Notre Dame des Arts in which girls could be taught, *inter alia*, music, fine arts, medicine and fashion. Her argument was that if young women were to be taught the history of costume, they would be encouraged to become fashion designers (replacing men, who, in reversion of the natural order of things, dominated the profession) and, moreover, creators of clothing that would be modestly fashionable without such excesses as the crinoline; there is, clearly, a note here of the dress-reformer in protest not just at certain exaggerated styles of dress, but at the fashion system itself. However, on the whole, Cavé's writings define her as a woman of sensible moderation and quiet perception. She was also a friend of Ingres. (His beautiful oil sketch of her head in profile (Metropolitan Museum of Art, New York) is like an antique cameo. It dates from 1844, the year in which she married Edmond Cavé, who was Inspector, later Director, of Fine Arts at the Ministry of the Interior until the 1848 Revolution; the couple were great friends of Ingres and his wife.) Cavé included the artist's wife among the women who had offered their support to her projected college.

Contemporary criticisms of fashion serve to underline the importance of the subject, whether to wealthy women who could afford the creations of famous designers and *modistes*, or to those lower down the social scale whose aspirations were more modest. A recent study has pointed out the passion among numberless women for the feel of such fabrics as silk, cotton and linen, which were increasingly widely available thanks to technological developments in the textile industries. Women were 'initiated very early on into a whole range of olfactory and tactile sensations; in particular they became familiar with a universe of textiles, shimmering and colourful – linen and other fabrics, ribbons, trimmings, cottons and printed chintzes . . . the longing for these or the greedy possession of them was an expression of female sensuality' (Duby and Perrot (1992), p. 180).

4 Karr (1853).

5 Quoted in Bergman-Carton (1995), p. 19.

6 Along with manuals of etiquette, fashion journals 'spoke in an authoritarian, threatening manner that transformed writing about clothing into an assertion of value . . .' Perrot (1994), p. 87.

7 H. de Balzac, *Lost Illusions*, trans. and intr. H. J. Hunt, London 1971, p. 159.

8 A. Jardine and A.-J. Tudesque, *Restoration and Reaction, 1815–1848*, trans. E. Forster, Cambridge 1983, p. 372.

9 Janin (1840), p. 6.

10 Ibid., pp. 1–2. A zone is a wide belt often with a large and elaborate buckle; it was particularly popular in the 1820s (see, for example, Ingres's *Madame Marcotte de Sainte-Marie*, pl. 113) and the 1830s. Prunella is a strong silk or worsted used for the uppers of women's shoes.

11 O. Uzanne, *La Femme à Paris*, 1897, quoted in Simon (1995), p. 189.

12 T. Delord, *Physiologie de la Parisienne*, Paris 1841, p. 23. Balzac (*Traité de la vie élégante*) says that only by being in Paris can one achieve true elegance.

13 Trollope (1836), I, p. 75, and II, pp. 1, 5.

14 R. Barthes, *The Pleasure of the Text*, trans. R. Miller, Oxford 1990, pp. 9–10.

15 See, for example, the quasi-oriental *mise-en-scène* created by Balzac in *Splendeurs et misères des courtisanes*, when Esther Gobseck, waiting for her lover Lucien, lies on a brocaded silk divan, dressed in a transparent Indian muslin gown (therefore wearing no corset) and with red silk slippers on her feet; the candles are lit, and the hookah ready. H. de Balzac, *Splendeurs et misères des courtisanes*, Paris 1993, p. 113. In Balzac's *Père Goriot* (1834–5), the young Eugène de Rastignac admires the beautiful Countess Anastasie de Restaud, whose fine, loose, woollen gown reveals that she has 'no need of the aid afforded by a corset'. *Old Goriot*, trans. M.A. Crawford, London 1951, p. 81.

16 R. von Krafft-Ebing, *Psychopathia Sexualis*, London 1899, pp. 16–17.

17 Michelet's *L'Amour* (1858) quoted in C.G. Moses, *French Feminism in the Nineteenth Century*, New York 1984, p. 159. Michelet speaks of women as though they were an alien tribe: 'She does not do anything like us. She thinks, talks and acts differently. Her tastes differ from ours . . . She does not breathe like us. In expectation of pregnancy and the consequent uplifting of the interior organs, nature has caused her to breathe principally in the area of the four upper ribs . . .' and so on.

18 A. Carons, *The Lady's Toilette*, London 1808, p. 266.

19 L. Tolstoy, *War and Peace*, trans. and intr. R. Edmonds, London 1982, p. 237.

20 The unknown author of *Essais historiques sur les modes . . .* (a dictionary in verse of male and female costume) says about the corset:

Dans un corset, l'élastique baleine
Doit comprimer avec l'art et sans peine
Les doux contours d'un sein ambitieux
En lui donnant un air voluptueux.

(In a corset the elastic baleine/must compress with art and painlessly/the soft contours of the ambitious breast/while giving it a voluptuous air)

Chevalier de ★★★ (1824), I, p. 41. *Baleine*, which is often translated erroneously in English as 'whalebone', is, in fact, the flexible plates in the mouth of the whale which allows it to filter food. At this time, the word 'elastic' meant a fabric made of stretchy silk or cotton. Proper elastic (i.e. a rubberized fabric) did not appear until 1840.

21 H. de Balzac, *Cousin Bette*, trans. M.A. Crawford, London 1965, p. 410.

22 G. Flaubert, *Madame Bovary*, trans. A. Russell, London 1982, p. 293.

23 Debay (1857), p. 178.

24 For the *Almanach de la mode parisienne* (1817) see Simond (1900–1901), I, pp. 377–8.

25 E.F. Celnart (Elisabeth-Félicie Bayle-

241

Mouillard), *Manuel des dames*, Paris 1827, p. 158.

26 *Journal des dames et des modes*, 1824, p. 194: 'C'est là qu'une femme élégante fait admirer son goût dans la choix d'une mousseline imprimé, dans la garniture ou la broderie d'une robe de mousseline de l'Inde . . .'

27 Perrot (1994), p. 90.

28 Feydeau (1866), p. 53. He argues that if fashion were to be regulated by any kind of sumptuary law, it would die, causing the demise of Worth and Gagelin, and the decline of such resorts as Trouville and Biarritz. For a detailed contemporary discussion of the importance to the French economy of the luxury trades, see H. Baudrillart, *Luxe et travail*, Paris 1866.

29 See n. 3 above.

30 Much of the discussion on luxury arose from a speech made by M. Dupin, Attorney-General, in the Senate in 1865, in which he linked the growth in high-class prostitution with excess in fashionable dress; his speech was published shortly afterwards under the title 'Le Luxe effréné des Femmes' (The unbridled luxury of women). Various authors then rushed into print saying, in effect, that if courtesans could afford the latest fashions this fact should not debar honest women from dressing in the creations of Palmyre and Worth. A number of women denounced the hypocrisy of men who on the one hand attacked women for luxurious costume and on the other hand were attracted to them precisely because of their fashionable *toilettes*.

31 Baudelaire (1964), p. 33.

32 Gautier (1858), pp. 29–32.

33 de Marly (1980), p. 27.

34 See, for example, the *Journal de Paris* of 14 Messidor an VIII (2 August 1800), p. 1359. For a list of the main *magasins de nouveautés* see Paris: Musée de la Mode et du Costume (1992).

35 Perrot (1994), p. 217.

36 Ibid. p. 72. The French Revolution abolished restrictive practices in the dress-making trades, and this led to some confusion and overlapping of functions during the following years and well into the nineteenth century. The grand couturiers/ couturières specialized exclusively in individual couture, but those operating on a smaller scale could also sell some ready-made garments on their own premises, and to shops.

37 Balzac, *Lost Illusions*, op. cit., p. 263.

38 *Revue des deux mondes*, June 1855, p. xxx.

Chapter 4

1 Balze (1880), p.10.

2 From the journal *La France littéraire*, quoted in Richardson (1958), p. 140.

3 For Flaxman's influence on Ingres, see S. Symmons, *Flaxman and Europe: The Outline Illustrations and their Influence*, New York and London, 1984, pp. 157-192. On Ingres's love of Watteau, see Blanc (1870), p. 14.

4 The drawing is in a private collection. Many artists were attracted to the colourful and picturesque regional costumes of Italy, and illustrated them in genre scenes or in collections of prints. Among the latter, a useful compilation is Romano Pinelli's *Raccolta di dodici motivi di costumi pittoreschi di Roma*, Rome 1813.

5 Baudelaire (1965), p. 2

6 See Naef (1971). There is another drawing by Ingres of the back view of an unknown woman, dated 1807 (private collection) which it is tempting to think may be one of the Harvey sisters; she wears a similar muslin dress but with embroidery at the hem, and a bonnet with ostrich feathers.

7 Quoted in O. Uzanne, *The Frenchwoman of the Century*, London 1886, p. 103.

8 See A. Ribeiro, *Horace Vernet: Incroyables et Merveilleuses,* Hazlitt, Gooden and Fox London 1991.

9 There is a similar hat to that worn by this sitter in the *Journal des dames et des modes*, 1808, pl. 892. There is another drawing by Ingres of Madame Guillaume Guillon Lethière, which is of 1808, in the Metropolitan Museum of Art; she is shown with her son Lucien. Here, also, there is some distortion in the way Ingres has drawn her left arm, which is bulkier than the right arm. She wears a muslin dress with a ruffled flounce at the hem, and round her shoulders a silk scarf which is pinned in place just above her waist – a detail typical of Ingres's perceptive eye.

10 In Renaissance Italy this was known as a *lenza*.

11 A similar drawing in the Louvre (RF 5046) shows the fur cape arranged in a slightly different way without the lining being revealed. At about the same time, c.1814, Ingres produced the only oil painting of his first wife (Bührle Collection, Zurich); it is an unfinished sketch which depicts the sitter in a low-necked dress, the sleeves of which come well over her wrist, a *blonde* lace ruff and a shawl over her shoulders.

12 There is a great deal of confusion over the names of dress and textiles, which is exacerbated by different languages. For example, the words *bonnet* and *blouse* mean slightly different things in French and English, so I have used italics when the more recondite French meaning is indicated. With regard to the names for the various types of bodice popular during the early and middle years of the nineteenth century, the following descriptions may confuse more than they enlighten:
canezou: a short bodice that could be worn *over* the dress (like a spencer), or a kind of fichu/kerchief worn either *over* or *under* the dress (usually the latter), crossed over at the waist, and to which was attached a collar or a ruff.
spencer: a short-sleeved/sleeveless jacket or bodice.
chemisette/*guimpe*: always an under-garment and usually of cotton or linen trimmed with lace, broderie anglaise, etc., it was a kind of sleeveless bodice open down the sides and tying with strings at or above the waist.

13 Blanc (1870), p. 44.

14 Momméja (1905), p. 413.

15 Madeleine Delpierre found what she claimed to be a similar hat in the *Journal des dames et des modes*, 1816, pl. 1537 (Delpierre, 1975, p. 151), but the brim is different, and one cannot say with any degree of confidence that this is the hat turned round; similar hats occur during the first two decades of the nineteenth century in the *Journal des dames et des modes*, and pl. 1537 could equally be related to Ingres's *Madame Guillon Lethière*, c.1808 (pl. 25).

16 Ingres's notebooks indicate a wide range of clients from many nations, not all of whom have been identified. According to some commentators, Ingres's urgent need of money at this time impelled him to pay a small fee to touts for every portrait commission they brought him; at the same time he supposedly hated the contem-porary description given to him by tourists in Rome, as the 'dessinateur de portraits': see Ford (1939).

17 A third drawing of this sitter is in the Musée Bonnat at Bayonne; she is depicted with her husband. In this drawing she wears a smocked spencer similar to that in

Originally, in the seventeenth century, it took the form of a flowering plant; in the eighteenth century it became a vase of flowers; by the early nineteenth century it had evolved into a pine-cone shape with a slightly hooked tip. This last-named variant was made famous by the weavers of Paisley; such designs could be woven or printed on wool.

17 *Le Règne de la mode*, Paris 1823, pp. 174–5: Quel est l'objet du premier désir d'une demoiselle aussitôt qu'elle a atteint l'âge de la coquetterie qui précède l'âge de la raison?
Un cachemire.
Qu'est-ce qu'une femme exige avant un mari et lui préfère toujours?
Un cachemire.

18 The cashmere shawl 'représente tout le monde de luxe et d'orgueil, il est au sommet . . . il figure, il règne dans la poésie, dans le roman, dans le drame comme dans la vie réelle'. *Petit Courrier des dames*, April 1840, p. 149.

19 Flaubert, *A Sentimental Education*, op.cit., p. 7.

Chapter 9

1 See the essay entitled 'Eroticism and Female Imagery in Nineteenth-Century Art', in Nochlin (1989), p. 138.

2 Gautier (1858), p. 6.

3 Blanche (1919), p. 191.

4 T. J. Clark, *The Painting of Modern Life: Paris in the Art of Manet and his Followers*, London 1985, p. 126.

5 Bryson (1984), p. 134.

6 Lapauze (1905), p. 386.

7 Leeks (1986), p. 34. Leeks makes a rather tentative link between images of the Madonna in the Renaissance (particularly by Raphael), and Ingres's bathers and odalisques. But Ingres, who is very careful of the nuances of clothing, gives his bathers/odalisques secular turban-like headdresses, and avoids the more generalized veiled headdresses that Raphael – with one or two exceptions such as the Madonna della Sedia – depicts the Virgin wearing.

8 Blanc (1870), p. 27.

9 Leeks, quite rightly, criticizes the simplistic and fabricated theory developed by Wildenstein (1956), in which he sees a perverted sexuality in Ingres's bathers/odalisques, a kind of revenge for being disappointed in love. Leeks (1986), p. 29. There is also some irrelevant discussion of Ingres's imagined sexual obsessions in Bryson (1984).

10 Barry (1979), p. 436.

11 Leeks (1986), p. 30.

Chapter 10

1 See Lamartine's *Souvenirs d'Orient* (1835), translated into English as *Lamartine's Visit to the Holy Land or Recollections of the East*, trans. T. Phipson, 2 vols., London 1847. He was particularly delighted with the way women dressed their hair with flowers and jewels, 'as though a cabinet of blossoms and gems had been carelessly emptied over their perfumed and shining locks' (I, p. 131). While in the Levant, he met, in 1832, the celebrated Lady Hester Stanhope, who had settled on Mount Lebanon for many years, adopting eastern manners and dress – she figured prominently on the itinerary of Romantic artists and writers. When he saw her (he records an unintentionally comic conversation in which poet and hostess both claimed that mystical influences had determined their meeting), Lady Hester was dressed *à la Turque* in a white silk gown with loose sleeves, over a floral dress; she wore a white turban, yellow Turkish boots of embroidered leather, and a yellow cashmere scarf was draped around her (I, p. 150).

2 G. de Nerval, *Journey to the Orient*, trans. and ed. N. Glass, London 1973, p. 60.

3 R. Halsband, *The Complete Letters of Lady Mary Wortley Montagu*, 2 vols., Oxford 1965, I, p.405.

4 See C. Saunier, 'Un Artiste romantique oublié: monsieur Auguste', *Gazette des beaux-arts*, June 1910, pp. 441–60, and July 1910, pp. 53–67.

5 'Il se contente d'accessoires de bazar ou de bal masqué: turbans, madras, chasse-mouches et narghilés': L. Réau, *L'Ere romantique: les arts plastiques*, Paris 1949, p. 111.

6 *Le Règne de la mode*, Paris 1823, p. 88. In order to encourage business, some of the shopkeepers claimed to be oriental; possibly some really were, as the fashion journal *Almanach des modes* (1814) states that one of the best shops for cashmere shawls, off the rue St. Honoré in Paris, was owned by a 'Sieur Gabriel, turc d'origine' (p. 117).

7 *Petit Courrier des dames*, Oct. 1840, p.180: 'Ses mouchoirs fussent dignes d'être choisis pour les faveurs du plus beau des harems.' The shop was in the rue de la Paix.

8 *Le Règne de la mode*, Paris 1823, p.88.

9 *The Lady's Newspaper*, Feb. 1848, p. 104. The implication here is that such a head-dress is particularly suited to women with 'Semitic' features.

10 Flaubert, *Madame Bovary*, trans. A. Russell, London 1982, p. 276.

11 G. Flaubert, *A Sentimental Education*, trans. and ed. D. Parmée, London 1989, p. 75.

12 Ibid., pp. 279–80.

13 Gautier (1853), p. 196: 'une sultane ruisselante d'or et de pierreries, dont le sourire vous fait des promesses voluptueuses bientôt réalisées.' See also DuCamp (1848), for similar trains of thought. Gautier himself, in spite of his – admittedly muted – praise of modern male clothing in *De la mode*, was often bored with its 'hopeless uniformity', and often added colourful touches to his own appearance. He wore Egyptian costume in Paris in the 1830s, and purchased a burnous from a visit to Algeria in 1845; he strongly regretted not buying a cherry-coloured jacket with hanging sleeves (*dolman*) when he was in Constantinople. The Goncourts, among others, noted how he liked to sit, Turkish fashion, on a carpet.

14 Croutier (1989), p. 17.

15 See B. Melman, *Women's Orients: English Women and the Middle East, 1718–1918*, London 1995. Melman finds that the notion of the harem threatened traditional Judaeo-Christian notions of sexuality and the relationships between the sexes, and at the same time presented an appealing alternative to established convention. She notes how the West 'feminized the East and eroticized it. Like the female body in the West, the Orient served as the site of mixed feelings, attraction and repulsion, intimacy and a sense of shame' (p. 4).

16 There are no accurate contemporary illustrations of the sultan's harem. Some sense of the size and complexity of the harem – a city within a city – can, however, be seen in Antoine-Ignace Melling's informed and imaginative illustrations in his *Voyage pittoresque de Constantinople* (1819). Melling was – as much as a European ever could be – an insider at the Ottoman court; he was architect to the sister of Sultan Selim I, and designed a number of buildings in Constantinople and

along the Bosphorus.

17 C. Rogier, *La Turquie: moeurs et usages*, Paris 1847, p. 11.

18 W. A. Duckett, *La Turquie pittoresque*, Paris 1855, p. 202.

19 'Constantinople a ses modes comme Paris. Dans l'oisiveté du harem, l'imagination des femmes travaille: – à quoi peut penser une femme qui rêve, Française ou Turque? – à sa toilette'. Gautier's introduction to *La Turquie: moeurs et usages*, p. 3.

20 A. Carons, *The Lady's Toilette,* London 1808, p. 124.

21 Debay (1864), pp. 156–7. He also refers to a skin lotion used in the seraglio, called 'pommade des Sultans'; it included Balm of Mecca, powdered baleine and olive oil (p. 36).

22 Rogier, op.cit., p. 11.

23 Debay (1846), pp. 155-6. Julia Pardoe (1837, I, p. 19), claimed that the immoderate use of the bath caused women's hair to weaken and fall out, and that consequently, much false hair was worn.

24 Pardoe (1837), I, p. 19.

Chapter 11

1 The Fogg Art Museum has a copy of the *Bather of Valpinçon* (1943.377). It may be a copy by one of Ingres's pupils, or a replica made by the artist himself and submitted – as a winner of the Prix de Rome – to the Académie as evidence of progress in his art.

2 See, for example, the comment made by Casimir Daumas in 1861: 'A woman's chemise is something to respect, not to criticize. White symbol of her modesty, it must not be touched or observed too closely', quoted in Perrot (1994), p. 150.

3 *Le Bain Turc* was painted for Prince Napoleon, but his wife objected to its abundant nudity. Ingres took the painting back, and made various alterations, which included turning it from a square into a round canvas. It was eventually sold – appropriately – to the Turkish ambassador, Khalil Bey, and entered the Louvre in 1911. Georges Vigne in an article 'Ingres a-t-il peint un second exemplaire du *Bain Turc*?' (*Revue du Louvre*), no.3, 1992, pp. 56–63) wonders if the artist painted another version of the *Bain Turc*; a photograph of 1860 shows a slightly changed version of the original, and a fragment (on panel) of this supposed painting exists in a private collection in Paris.

4 Lapauze (1905), p. 389. 'C'est un entassement de femmes nues aux tièdes chairs opulentes. Elles s'alanguissent et s'énervent dans l'air moite saturé de parfums. Leurs corps se tordent, s'étirent ou se ramassent, au hasard de leur impatience ou de leur assoupissement. L'une d'elles pince les cordes d'une mandoline. Les notes aiguës, grelottantes, nostalgiques, les traversent de spasmodiques frissons ou les hypnotisent en une haletante extase . . .'

5 Vigne (1995), p. 300.

6 Lapauze (1911), pp. 506–8. For Lady Mary's visit to the *hamam* in Adrianople in 1717, see R. Halsband, *The Complete Letters of Lady Mary Wortley Montagu*, 2 vols., Oxford 1965, I, p. 314. Leeks (1986) finds Lady Mary Wortley Montagu's description of her visit somewhat voyeuristic, seeing the bathers as 'other, as Oriental and exotic'; but, by revealing her stays she acknowledges a shared sense of female identity (p. 31).

7 Hemmings (1987), p. 182.

8 'The faces of Ingres's women are as close to being bodies as they can possibly be without suffering a complete metamorphosis . . . they are as devoid of intelligence or energy as breasts and buttocks.' Nochlin (1989), p. 107.

9 Blanche (1919), p. 194: 'la vision érotique d'un vieillard qui fut un prêtre exalté de la beauté féminine.'

10 *Recueil de cent estampes représent différentes nations du Levant*, Paris 1714, p. 16.

11 Pardoe (1837), I, pp. 134–5.

12 From Julia Pardoe's *Beauties of the Bosphorus*, London 1839, quoted in Croutier (1989), pp. 81–3.

13 The Fogg Art Museum watercolour (1956.244) is painted over an engraving of the *Bather of Valpinçon* of 1851, which has extra figures in the print adapted by the artist from the 1828 *Bather* and *Le Bain Turc*. The Bayonne watercolour is virtually the same, apart from a slightly different arrangement of the white drapery, and a more complex and beautifully patterned marble floor.

14 Vigne (1995), p. 222.

15 Nicolay's plate '*Gentille Femme turcque estant dans leur maison ou serail*' may also have been the source for the cone-shaped headdress with a veil worn by the seated woman in the background who holds out a cup to an Indian slave-girl.

16 Ingres's *Sleeping Odalisque* in the Victoria and Albert Museum (Ionides Collection,

no. 57) may be a sketchy replica of Murat's *Sleeper of Naples*.

17 Barry (1979), p. 266.

18 Ingres's painting is at the Walters Art Gallery, Baltimore; the figure of Venus is beautifully painted, although somewhat more boneless than Titian's original, but the clothed figures in the background are less happily depicted, for the costume has not been understood or reconstructed. Titian's painting, as T. J. Clark points out in *The Painting of Modern Life. Paris in the Art of Manet and his Followers*, London 1985, was regarded in the nineteenth century as a portrait of a courtesan, although in fact it was possibly a wedding portrait from Guidobaldo della Rovere to his young bride Giulia Varano in 1534 (pp. 93–4).

19 H. de Balzac, *A Harlot High and Low*, trans. and intr. R. Heppenstall, London 1970, p. 52. Ingres's *Grande Odalisque* has the refined delicacy of a Raphael madonna, and what Julia Pardoe describes as 'the sweet, sleepy, fascinating expression of the Turkish beauties'; Pardoe (1837), I, p. 169.

20 Gautier (1855), pp. 157–9.

21 *Recueil de cent estampes . . .*: 'Les Femmes Turques fument volontiers; elles sont assises fort commodément sur leur sofa avec un tabouret à leurs pieds, sur lequel elles appuyent leurs pipes qui sont très longues.'

22 Pardoe (1837), I, pp. 238–9. Gautier also refers to the 'sybaritisme du fumage' (1853, p. 111).

23 It is worth commenting here on the Metropolitan Museum of Art's grisaille painting of the *Grande Odalisque*, which is a beautiful, ghostly work, variously attributed to Ingres or to his studio. The date is unclear; it is clearly not a preparatory study for the famous painting (as has been claimed), and Ingres included it in a list of works he had done between 1824 and 1834. But if it is by Ingres's own hand I would suggest that there would be more sensitivity to pattern and detail in dress and accessories. When compared with the *Grande Odalisque*, the 'gown' of the grisaille is mere drapery, the 'belt' a strip of fabric(?) with a buckle added, and there is no hint of a pattern on the headdress.

24 Thoré (1868), p. 249.

25 *Revue universelle des arts*, Paris 1855, p. 212.

26 *L'Artiste*, Paris 1856, p. 176: 'Cette femme abandonnée sur les coussins, qui se laisse aller avec l'insouciance d'une favorite du gynécée oriental à l'enivrement des par-

fums et de la musique, la bouche humide, les yeux perdus au ciel, la chevelure denouée, donne un dementi formel à ceux qui ne voudrent accorder à M. Ingres qu'un talent austère.'

27 Ingres speaks of the painting as *baroque*, i.e., full of the colour and ornament which he thought of as Turkish; in a letter to Marcotte he says it will be 'aussi baroque que possible (car c'est du turc), c'est-a-dire tout ce que vous trouverez d'ornements qui se rapprochent du style du pays . . .' Quoted in Delaborde (1870), p. 237.

28 Gautier (1855), p. 159.

29 A drawing at the Musée Ingres (867.2030) of the odalisque is inscribed with the model's name, 'Mariuccia' and the address 'via Marguta 106'; could this be Ingres's favourite model from his early days in Rome, as illustrated in plate 11? Another drawing related to the *Odalisque with Slave*, at the Petit Palais, Paris, has the inscription 'Mericuccia' and the address 'via della Vita 58'. Whether this is the same model or a different one, it is clear that she was Italian. Furthermore, at Montauban there is a sketch of the proposed painting (867.2029), where the odalisque is identified both as a *sultane* and as an Italian woman taking a siesta.

30 The definitive edition of *Emaux et Camées* was published in 1872. I have used the Gallimard edition of 1981.

31 D. Kelly, 'Transpositions', in Collier and Lethbridge (1994), p. 179.

32 *Recueil de cent estampes* . . . The description of plate 187 states that the 'Tchégour' [*sic*] is 'une espece de Guitarre à cinq cordes, dont on jouë avec un morceau de baleine'.

33 *The World in Miniature, Turkey, being a description of the manners, customs, dresses and other peculiarities characteristic of the inhabitants of the Turkish Empire*, London 1821, pp. 112, 114.

34 See J. Connolly, 'Ingres and the Erotic Intellect', in Hess and Nochlin (1973). He suggests that the helmet derives from the Persian tale of Khosm and Shirin (unidentified seventeenth-century Persian miniatures are mentioned in this context); when bathing in a mountain pool, Shirin removes her dress and 'helmet', thus allowing Prince Khosm to be struck by her beauty. By a somewhat tortuous process of reasoning, Ingres's odalisque becomes the bather, and as 'we behold this bather, we are Khosm who sees Shirin for the first time . . .' (p. 23). Connolly's comments are just as speculative apropos the *Grande Odalisque*. He declares that it was Ingres's intention to include all five senses in the painting, even though he can only find three – the censer (smell), the hand with the fly-whisk (touch), the odalisque's gaze (sight). However, in the Magimel selection of engraved works (1851) the odalisque now has a still-life (taste) in the foreground, and a font or water-spout on the right (hearing). This kind of analysis, while entertaining, has a slightly desperate air when it becomes the fulcrum for argument, the only basis for discussion.

Chapter 12

1 Blanc (1870), p.228. He was the author of *L'Art dans la parure et dans le vêtement*, Paris, 1877.

2 *Revue des deux mondes*, Paris 1846, p. 514.

3 Ibid., p. 522. The critic was 'F. de Lagenevais' (Frédéric de Marcey).

4 *L'Artiste*, Paris 1856, p. 176. Ingres's portraits, claims Amaury-Duval, are such heightened versions of reality that whenever someone sees a person painted by the artist, he thinks that person resembles the portrait, and not vice versa.

5 Clark (1971), pp. 364–5.

Select Bibliography

About, E. *Voyage à travers l'Exposition des Beaux-Arts*, Paris 1855

About, E. *Nos artistes au Salon de 1857*, Paris 1858

Alazard, J. *L'Orient et la peinture française au XIXe siècle*, Paris 1930

Alazard J. *Ingres et l'ingrisme*, Paris 1950

Amaury-Duval (A.-E.-E. Pineu-Duval). *L'Atelier d'Ingres*, Paris 1878

Babin, G. 'Madame de Senonnes par Ingres', *Gazette des beaux-arts*, vol. XIX, 1898, pp. 21–6

Balzac, H. de. *Traité de la vie élégante*, Paris 1830

Balze, R. *Ingres: son école, son enseignement du dessin*, Paris 1880

Barry, J. *George Sand in Her Own Words*, London 1979

Baudelaire, C. *The Painter of Modern Life and Other Essays*, trans. and ed. J. Mayne, London 1964

Baudelaire, C. *Art in Paris, 1845–1862. Salons and Other Exhibitions Reviewed by Charles Baudelaire*, trans. and ed. J. Mayne, London 1965

Bell, D. 'Ingres', *Burlington Magazine*, vol. XLIX, 1926, pp. 124–35

Berger, J. *Ways of Seeing*, London 1972

Bergman-Carton, J. *The Woman of Ideas in French Art, 1830–1848*, New Haven and London 1995

Blanc, C. *Ingres: sa vie et ses ouvrages*, Paris 1870

Blanche, J.-E. *Propos de peintre: de David à Degas*, Paris 1919

Boyer d'Agen. *Ingres, d'après une correspondance inédite*, Paris 1909

Brookner, A. 'The Resonance of Mme Moitessier', *Times Literary Supplement*, 21 January 1977

Bryson, N. *Tradition and Desire: From David to Delacroix*, Cambridge 1984

Byrde, P. *Nineteenth-Century Fashion*, London 1992

Cassou, J. 'Ingres et ses contradictions', *Gazette des beaux-arts*, vol. II, 1934, pp. 146–64

Cavé, M.-E. *La Femme aujourd'hui et la femme autrefois*, Paris 1863

Chevalier de ★★★. *Essais historiques sur les modes et la toilette française*, 2 vols., Paris 1824

Clark, K. 'Ingres: peintre de la vie moderne', *Apollo*, vol. XCIII, 1971, pp. 357–65

Collier, P. and Lethbridge, R. (eds.). *Artistic Relations: Literature and the Visual Arts in Nineteenth-Century France*, New Haven and London 1994

Courthion, P. *Ingres: raconté par lui-même et par ses amis. Pensées et écrits du peintre*, 2 vols., Geneva 1947

Croutier, A. L. *Harem: The World Behind the Veil*, New York 1989

Cummings, F. 'Romantic Portraitist: Three Drawings by Ingres', *Bulletin of the Detroit Institute of Arts*, vol. XLIV, 1965, pp. 70–77

Davies, M. 'A Portrait by the Aged Ingres', *Burlington Magazine*, vol. LXXVIII, 1936, pp. 257–68

Debay, A. *Hygiène de la beauté*, Paris 1846

Debay, A. *Les Modes et les parures*, Paris 1857

Delaborde, H. *Mélanges sur l'art contemporain*, Paris 1866

Delaborde, H. *Ingres: sa vie, ses ouvrages, sa doctrine*, Paris 1870

Delacroix, E. *Selected Letters, 1813–1863*, trans. J. Stewart, London 1971

Delpierre, M. 'Ingres et la mode de son temps, d'après ses portraits dessinés', *Bulletin du Musée Ingres*, 1975, pp. 21–6

Delpierre, M. 'Ingres et la mode du châle cachemire d'après ses portraits féminins dessinés et peints', *Actes du colloque: Ingres et Rome*, Musée Ingres, Montauban 1986, pp. 75–83

DuCamp, M. *Souvenirs et paysages d'Orient*, Paris 1848

Duby, G. and Perrot, M. (eds.). *Power and Beauty: Images of Women in Art*, London 1992

Feydeau, E. *Du luxe des femmes, des moeurs, de la littérature et de la vertu*, Paris 1866

Ford, B. 'Ingres's Portrait Drawings of English People at Rome, 1806–1820', *Burlington Magazine*, vol. LXXV, 1939, pp. 3–13

Ford, B. 'Ingres's Portraits of the Reiset Family', *Burlington Magazine*, vol. XCV, 1953, pp. 356–9

Forster, C. de. *Quinze ans à Paris, 1832–1848*, 2 vols., Paris 1848–9

Fortassier, R. *Les Écrivains français et la mode*, Paris 1988

Froidevaux, G. *Baudelaire: représentation et modernité*, Paris 1989

Gautier, T. *Constantinople*, Paris 1853

Gautier, T. *Les Beaux-Arts en Europe*, Paris 1855

Gautier, T. *De la mode*, Paris 1858

Gautier, T. *Portraits contemporains*, Paris 1874

Gernoux, A. *Senonnes. Pages d'histoire attachantes: la belle Madame de Senonnes*, Chateaubriant 1931

Goncourt, E. and J. de. *Etudes d'art*, Paris 1893

Goncourt, E. and J. de. *Paris and the Arts, 1851–1896. From the Goncourt Journal*, trans. and ed. G. J. Becker and E. Philips, Ithaca and London 1971

Hemmings, F. W. J. *Culture and Society in France, 1789–1848*, Leicester 1987

Hess, T. B., and Nochlin, L. (eds.). *Woman as Sex Object: Studies in Erotic Art, 1730–1970*, London 1973

Janin, J. et al. *Pictures of the French: A series of literary and graphic delineations of French character . . .*, London 1840

Karr, A. *Les Femmes*, Paris 1853

Lapauze, H. 'Le "Bain Turc" d'Ingres d'après des documents inédits', *Revue de l'art ancient et moderne*, vol. XVIII, 1905, pp. 383–96

Lapauze, H. *Ingres: sa vie et son oeuvre d'après des documents inédits*, Paris 1911

Leeks, W. 'Ingres Other-Wise', *Oxford Art Journal*, vol. IX, 1986, pp. 29–37

Loménie, L. de. *Galerie des contemporains illustres*, 2 vols., Paris 1840

London: National Gallery: *Painting in Focus: Ingres's 'Madame Moitessier'*, ed. M. Wilson, 1977

London: Royal Academy of Art. *The Orientalists: Delacroix to Matisse. European Painters in North Africa and the Near East*, ed. M. Stevens, 1984

Lough, J. and M. *An Introduction to Nineteenth-Century France*, London 1978

Louisville, KY: J. B. Speed Art Museum. *In Pursuit of Perfection: The Art of J.-A.-D. Ingres*, ed. D. Edelstein, 1983

Mackenzie, J. M. *Orientalism: History, Theory and the Arts*, Manchester 1995

Magimel, A. *Oeuvres de J.-A. Ingres*, Paris 1851

Maigron, L. *Le Romantisme et la mode*, Paris 1911

Marly, D. de. *Worth: Father of Haute Couture*, London 1980

Melling, A. I. *Voyage pittoresque de Constantinople*, 3 vols., Paris 1819

Merson, O. *Ingres: sa vie et ses oeuvres*, Paris 1867

Momméja, J. 'Le portrait de Madame Destouches par Ingres', *Gazette des beaux-arts*, vol. XXXIII, 1905, pp. 411–13

Momméja, J. 'Le "Bain Turc" d'Ingres', *Gazette des beaux-arts*, vol. XXXVI, 1906, pp. 177–98

Mongan, A. 'Ingres et Madame Moitessier', *Bulletin du Musée Ingres*, 1957, pp. 3–8

Munhall, E. *Ingres and the Comtesse d'Haussonville*, Frick Collection, New York 1985

Munhall, E. 'Two Portraits by Ingres: Princesse de Broglie and Comtesse d'Haussonville', Frick Collection, New York 1986

Naef, H. 'Ingres's Portrait Drawings of English Sitters in Rome', *Burlington Magazine*, vol. XCVIII, 1956, pp. 427–35

Naef, H. 'Monsieur Ingres et ses muses', *L'Oeil*, 1957, pp. 48–51

Naef, H. 'Ingres's Portraits of the Marcotte Family', *The Art Bulletin*, 1958, pp. 336–45

Naef, H. 'Ingres und die Familie Hittorff', *Pantheon*, vol. XXII, 1964, pp. 249–63

Naef, H. 'Eighteen Portrait Drawings by Ingres', *Master Drawings*, vol. IV, no. 3, 1966, pp. 255–83

Naef, H. 'New Material on Ingres's Portraits of Madame Moitessier', *Burlington Magazine*, vol. CXI, 1969, pp. 149–50

Naef, H. 'Henrietta Harvey and Elizabeth Norton: Two English Artists', *Burlington Magazine*, vol. CXIII, 1971, pp. 79–89

Naef, H. *Die Bildniszeichnungen von J.-A.-D. Ingres*, 5 vols., Berne 1977–80

Nochlin, L. *Women, Art and Power and Other Essays*, London 1989

Nochlin, L. *The Politics of Vision: Essays on Nineteenth-Century Art and Society*, London 1991

Ockman, C. *Ingres's Eroticized Bodies: Retracing the Serpentine Line*, New Haven and London 1995

Pardoe, J. *The City of the Sultan; and Domestic Manners of the Turks in 1836*, 2 vols., London 1837

Paris: Musée du Louvre, Cabinet des Dessins. *Dessins français du XIXᵉ siècle du Musée Bonnat à Bayonne*, ed. V. Ducouru and A. Sérullaz, 1979

Paris: Musée de la Mode et du Costume, *Au Paradis des dames: nouveautés, modes et confections, 1810–1870*, ed. F. Tétart-Vittu, 1992

Penzer, N. M. *The Harem*, London 1965

Perrot, P. *Fashioning the Bourgeoisie: A History of Clothing in the Nineteenth Century*, trans. R. Bienvenu, Princeton, 1994

Prevost, G. *Le Nu, le vêtement, la parure chez l'homme et chez la femme*, Paris 1884

Ribeiro, A. 'Fashion in the Work of Winterhalter', *Franz Xaver Winterhalter and the Courts of Europe, 1830–1870*, eds. R. Ormond and C. Blackett-Ord, exh. cat., National Portrait Gallery, London, 1987, pp. 66–71

Ribeiro, A. 'Concerning Fashion: Théophile Gautier's *De La Mode*', *Costume*, vol. XXIV, 1990, pp. 55–68

Richardson, J. *Théophile Gautier: His Life and Times*, London 1958

Ritchie, A. C. 'The Evolution of Ingres's Portrait of the Comtesse d'Haussonville', *The Art Bulletin*, vol. XXII, 1940, pp. 119–26

Rogier, C. *La Turquie: moeurs et usages des orientaux au dix-neuvième siècle*, Paris 1847

Rosenblum, R. *Jean-Auguste-Dominique Ingres*, London 1990

Roux, P. de. *Ingres*, Paris 1996

Silvestre, T. *Histoire des artistes vivants*, Paris 1856

Simon, M. *Fashion in Art: The Second Empire and Impressionism*, London 1995

Simond, C. *La Vie parisienne au XIXe siècle: Paris de 1800 à 1900*, 3 vols., Paris 1900–1901

Steele, V. *Paris Fashion*, Oxford and New York 1988

Stendhal [Marie-Henri Beyle]. *Mélanges d'art et de littérature*, Paris 1867

Taine, H. *The Ideal in Art*, trans. J. Durand, New York 1870

Taine, H. *Notes on Paris*, trans. J. A. Stevens, New York 1875

Thoré, T. *Salons 1844–8*, Paris 1868

Toussaint, H. *Les Portraits d'Ingres*, Paris 1985

Trollope, F. *Paris and the Parisians in 1835*, 2 vols., London 1836

Vanier, H. *La Mode et ses métiers: frivolités et luttes des classes, 1830–1870*, Paris 1960

Vigne, G. *Ingres*, New York 1995

Vigne, G. *Dessins d'Ingres: catalogue raisonné des dessins du musée de Montauban*, Paris 1995

Wildenstein, G. *The Paintings of J.-A.-D. Ingres*, London 1956

Photograph Credits

In most cases the illustrations are reproduced courtesy of the owners or custodians of the works. Those for which further credit is due are listed below:

© Roumagnac Photographie, Montauban: 2, 7, 11, 12, 31, 32, 89, 93, 101, 108, 114, 119, 120, 127, 128, 134

By Permission of the British Library (12314 a 20.14): 4, 6

Lauros-Giraudon, Paris: 8

Courtesy Richard Day Ltd, London: 9

Photograph © 1998 The Metropolitan Museum of Art: 10, 23, 26, 33, 34, 43, 69, 73, 75b, 94, 130, 131

© Photo RMN: 21, 35, 45, 49, 51, 60, 63, 67, 74, 78, 80, 95, 112, 113, 116, 126, 160, 165, 166, 174, 177, 181, 182, 185

© President and Fellows of Harvard College, Harvard University: 25, 27, 28, 38, 48, 68, 115, 118, 139, 186

© Hazlitt, Gooden & Fox, London: 36, 142

V&A Picture Library/© The Board of Trustees of the Victoria and Albert Museum: 37, 46

Photograph © Board of Trustees, National Gallery of Art, Washington: 39, 98, 170

Photographic Survey of Private Collections, Courtauld Institute of Art, University of London: 42, 63

© Photothèque des Musées de la Ville de Paris: 55, 59

© The Detroit Institute of Arts, 1997: 70

Photograph © 1997, The Art Institute of Chicago, All Rights Reserved: 71

Bridgeman Art Library, London/New York: 85

Giraudon, Paris: 86

Courtesy Christie's, London: 97

© Rouen, Musée des Beaux-Arts. Photographie Didier Tragin/Catherine Lancien: 104

Cliché A. Guillard – Musée des Beaux-Arts de Nantes: 107

Copyright © 1985 Founders Society Detroit Institute of Arts: 110

Copyright The Frick Collection, New York: 117

Index

Numbers in *italic* refer to pages with illustrations.

256

Guys, Constantin, 31, 88

hairstyles/coiffures, 40, 41, 49, 53–4, 55, 76,
 77–8, 100, 102, 119, 138, 141, 143, 146, 148,
 163, 173, 179–80, 228, 247n; *à la madone*,
 110, 179, 180; *à la Mancini*, 148; *à la Raphael*,
 179; *à la Sévigné*, 77–8, 148; *à l'antique*, 48,
 100; *à l'orientale*, 245n; Apollo knot, 76, 138,
 179; of bathers, 199, 210, 224, 225; coiffure
 Espagnole, 122; marabou coiffure, 160; red
 trimmings, 148
Hals, Frans, *The Laughing Cavalier*, 228
Hamid I, Sultan, 222
handbags and reticules, 54, 56, 114
harems, 197, 208, 210, 212, 213–17, 220, 222,
 224, 231, 247n
Harvey, Henrietta (pls 22, 24), 49, *51*
Haudebourt-Lescot, Hortense, 48
d'Haussonville, Louise de Broglie, comtesse
 (pls 5, 13, 103, 116–20, 122), 10, *10*, 17, 18,
 27, 29, 78, 94, 127, 128, *129*, 143, 143–8, *146*,
 148, 152, 154, 156, 158, 160, 168, 178, 180,
 184, 230, 245n
d'Haussonville, Othenin, vicomte, 143
haute couture, 10, 12, 43–4
Hayard, Charles, 54
Hayard, Jeanne Suzanne Alliou, Madame (pl.
 27), 54, *54*, 55
headwear/hats, 20, 39, 43, 45, 48, 49, 52, 58,
 62, *62*, 66, 68, *70*, 75, 76, 78, 84, 122, 132,
 148, *148*, 156, 160, 167, 173, *175*, 179, 180,
 182, 199, 214, 228, 235, 236, 242n, 246n; *à
 l'Italienne*, 160; *casque à la minerve*, 112, *112*;
 ferronnière, 54, *66*; marabou feathers, 156,
 160, 163, 182, 246n; *scuffia*, 228; straw,
 54, 56, *62*, 114, 176; toques, 154, 156, *175*,
 245n, 246n; *see also* bonnets; *bonnets*; caps;
 turbans
Hegel, Friedrich, *Aesthetics*, 24
Hennet, Alphonse, 78
Hennet, Elisabeth Pierrette Fromantin,
 Madame (pl. 60), 78, *79*, *83*, 182, 243n
Herbault, milliner, 246n
historical costumes, 10, 12, 15, 74–5, 237
history paintings, 1, 2, 17, 72, 74
Hittorff, Madame, 186
Hobsbawm, Eric, 78–9, 80
Holbein, Hans, 5, 245n
Hollar, Wenceslaus, 64
hookah, 235
Houdon, Jean-Antoine, 72
Hugo, Adèle Foucher, Madame (pl. 55), 75, *76*
Hugo, Victor, 33, 74, 78; *Les Orientales*, 210

Incroyables et Merveilleuses, 62
Ingres, Delphine Ramel, Madame (2nd wife:
 pls 67, 139, 149, 141, 149), 39, 48, 84, *84*,
 167, 173, *173*, 179, 182, *182*, 192, 200
Ingres, Madeleine Chapelle, Madame (1st wife:
 pls 29, 31, 56), 19–22, 54, *56*, 75, 76, *77*, 166,
 200, 242n, 243n

'jewelled cross' motif, *76*
jewellery, 41, 51, 54–5, 84, 89, 91, 100, 112,
 122, 123, 132, 134, 146, 152, 153–4, 156,
 160, 167, 168, 173, *175*, 176, 178, 180, 192,
 194–5, 199, 208, 214, 226, 230, 234, 245n;
 coral, 100; *épingles de tête*, 167, 173, 180;
 neo-medieval, 167, 173; turquoise, 148;
 turquoise, 148; Roman filigree, 48;
Joachim Murat, King of Naples, 112, 228
Jordan, Madame Augustin (pls 28, 144), 54–5,
 55, 179, *179*
Jordan, Gabriel (pl. 28), 54, 55
Josephine, Empress, 44, 96, 112, 222
Journal de Paris, 93, 94, 96, 127, 188
Journal des dames et des modes, 40, 56, 66, 68, *70*,
 96, *100*, *112*, *175*, 188, 242n
Journal des débats, 22
Journal des demoiselles, 168
Journal des jeunes personnes, *42*
'jupe à la Musulmane', 210
'jupons en crinoline' (petticoats), 83

Karr, Alphonse, 84; *Les Femmes*, 32, 108,
 167–8, 243n
Khalil Bey, Ambassador, 248n
Krafft-Ebing, Richard, 35–6
kurk (furred mantle), 214

lace, 44, 45, 54, 66, 75, 83, 119, 122, 134, 148,
 160, 167, 168, 175, *175*, 178, 179; black, 120;
 Brussels bobbin, 160; Caen, *77*, 125;
 Chantilly, 119, 120, 125, 244n; silk (*blonde*),
 132, 239
Lacroix, Paul, 231, 239n
Lady's Newspaper, 83, 148, *148*, 153, 210
Lamartine, Alphonse Marie Louis de, 204,
 247n
Lapauze, Henri, 60, 98, 110, 116, 122, 129,
 136, 137, 147, 158, 173, 200, 222, 224, 245n,
 248n
Lawrence, Sir Thomas, *Margaret Power,
 Countess of Blessington* (pl. 106), 132, *132*
Leblanc, Françoise Poncelle, Madame (pls 6,
 84, 90, 93–5, 159), *15*, *70*, 73, *107*, 110, 114,
 116, *116*, 119, *119*, 137, 188, 192, *192*
Leblanc, Jacques-Louis, 114
Leeks, W., 247n
Legouvé, Ernest, 241n
Leonardo da Vinci, 129; *La Belle Ferronnière*,
 Ingres's copy of (pl. 85), 54, 108, *108*; *Mona
 Lisa*, 110
Leroy, Louis-Hippolyte, 44, 112
Lethière, Alexandre, 53
Lethière, Letizia (pl. 26), 53, *53*
Lethière, Lucien, 242n
Lethière, Marie-Joseph-Honorée Vanzenne,
 Madame Guillaume Guillon (pl. 25), 29, 48,
 49, 52, *52*, 53, 242n
Lethière, Rosina Meli, Madame Alexandre
 Guillon (pl. 26), 53, 53–4
Levey, Michael, 17

Lewis, Jane, 186; *Woman with Sphere* (pl. 153),
 186
Liotard, Jean-Etienne, 5, 208; *Louise-Florence
 d'Esclavelles, Madame La Live d'Epinay* (pl.
 123), 125, *150*, 152; *Woman in Turkish
 Costume* (pl. 167), 205–6, *207*
Liszt, Franz, 81, 211
Loménie, Louis de, 23
Louis XVIII, King, 4
Louis-Philippe, King, 4, 44, 94
luxury, debate on, 42–3, 242n
Luynes, duc de, 78

Mackie, Dorothea Sophia Deschamps, Mrs (pl.
 40), 64, *64*
Madame Augustin Jordan and her Son Gabriel (pl.
 28), 48, 54–5, 55
Madame Hortense Reiset and her Daughter Marie
 (pl. 64), *81*
magasins de nouveautés, 44–5
Mancini, Marie, 148
Manet, Edouard, *Le Déjeuner sur l'Herbe*, 230;
 Olympia, 211
mantillas, 122
Manuel des dames, 40
Manuel des demoiselles, 176
Marcotte d'Argenteuil, Charles, 93, 148, 167,
 231
Marcotte de Sainte-Marie, Suzanne Clarisse de
 Salvaing de Boisseau, Madame (pls 111–14,
 147, 160), 26, 34, 137, 137–8, *138*, *140*,
 140–41, 179, 182, 192, 194, *194*, 241n
Marcoz, Marie *see* Senonnes, vicomtesse de
Marie-Amélie, Queen 44
Marie-Antoinette, Queen, 44
'Marioncia' (pl. 11), 26, *27*
Matisse, Henri, 15, 134; *Odalisque Seated with
 Arms Raised* (pl. 170), 211, *211*
Medici Venus, 231
Melling, Antoine-Ignace, *Voyage pittoresque de
 Constantinople*, 247n
Melman, B., 247n
men's dress in portraiture, 22–4
Merson, Olivier, 240n
Metternich, Princess, 160
Meurice, Madame *see* Granger, Mademoiselle
Meurice, Paul, 78
Michelet, Jules, 36, 241n
mirrors, Ingres's use of, 129, 146, 147, 148,
 167, 180
Miss Harvey Sketching (pl. 24), 49, *51*
models, Ingres's use of, 26–7, *27*, 29, 136, 249n
Moden Zeitung, 62
modistes, 12, 34, 44, 45, 84
Moitessier, Catherine, 164
Moitessier, Marie-Clothilde-Inès de Foucauld,
 Madame (pls 14, 96–100, 134–6, 138, 146),
 17, 25, 26, *31*, *42*, 119–20, *120*, 122–5, *123*,
 128, *150*, 154, 163–8, *164*, *168*, 180, *180*, 182,
 184, 192, 226, 230, 239n, 246n
Moitessier, Sigisbert, 166